Image and Spirit
in Sacred and Secular Art

Image and Spirit in Sacred and Secular Art

by
Jane Dillenberger

Edited by
Diane Apostolos-Cappadona

CROSSROAD · NEW YORK

1990

The Crossroad Publishing Company
370 Lexington Avenue, New York, NY 10017

Printed in the United States of America

Library of Congress Cataloging-in-Publication Data

Dillenberger, Jane.
 Image and spirit in sacred and secular art / Jane Dillenberger ;
 edited by Diane Apostolos-Cappadona.
 p. cm.
 Includes bibliographical references.
 ISBN 0-8245-1036-4
 1. Art and religion. 2. Art—Themes, motives. 3. Women in art.
 I. Apostolos-Cappadona, Diane. II. Title.
 N72.R4D45 1990
 701—dc20 90-41734
 CIP

Publication of this volume has been subvented in part by the
Center for the Arts, Religion, and Education, Berkeley, California.

All biblical quotations are from the Revised Standard Version
unless otherwise noted.

To Bonnie,
my daughter and colleague.
in art history

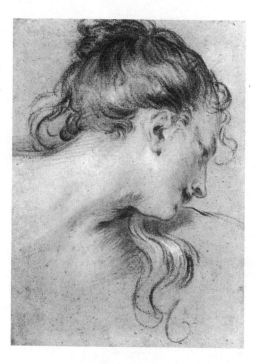

François Lemoyne, *Head of Omphale in Profile*, 1724. Red, black, and white chalk on paper; 9¹⁄₁₆ × 6½ inches. University Art Museum, Berkeley. Gift of Mr. and Mrs. John Dillenberger in memory of her son, Christopher Karlin.

Contents

Author's Preface

Most of the essays in this volume were originally created as lectures for the inquiring, intelligent adult who has little or no formal background in the visual arts. Though my training is that of an art historian and curator, my teaching career has been located entirely in theological seminaries. That setting fed my particular and long-standing interest in religious iconography, and in biblical studies and theology. Thus, my work has been in art *and* religion.

My procedure has been to lead the listeners and viewers into the sources of the iconography and to give them a way of analyzing works of art, with the hope that their intellectual resources may be enriched and their visual focus sharpened, thereby deepening their emotional sensitivity to works of art.

Michelangelo is reported to have said that great painting is "a music and melody which only the intellect can understand and that with great difficulty." This statement expresses a truth that calls for a deeper commitment to the work of art than is vouchsafed by present-day ways of seeing. These essays, by example rather than precept, show ways of informing the mind and focusing all of our latent sensual knowledge and experience upon the work of art.

Throughout all the papers the deeper purpose remains consistent: to draw the reader and the viewer into a lively conversation with the works of art, as a prelude to the seduction worked by the painting in its own right, as it becomes a part of our own world.

The materials in this book were prepared over a period of two decades for a series of occasions and for diverse groups. Thus readers with a scholar's interest in any of these themes must consult the footnotes for more extensive and recent bibliography. While most recent scholarship

would now lead to modifications and additions, I have included only those lectures in which I still consider the essential thrust to be valid.

Nine of the ten essays were originally prepared to be given as lectures. Only "The Image of Evil in Nineteenth- and Twentieth-Century Art" was initially written for publication. Of the four essays in this volume that have been previously published, all of the books in which they appeared are now out of print.

The delights of the world of ideas, of research and discovery, the labors of writing and speaking have been shared, throughout the years represented in this volume, with my husband, John. I thank him for these riches we have lived together.

This book was conceived of and brought into being by Diane Apostolos-Cappadona, to whom I wish to express my heartfelt thanks. Her skill, patience, and persistence in every phase of the selection and editing of the essays, and her generosity in securing the photographs and permissions have made this book possible.

I also wish to express my gratitude to my friends at Crossroad Publishing: Werner Mark Linz, whose support and generosity of spirit have been sustaining; to Frank Oveis, for his care, skill, and patience; and to Ulla Schnell for all her good work.

<div style="text-align: right;">

Jane Dillenberger
Berkeley, California
January 1990

</div>

Editor's Preface:
"Vision Does Not Perish"
by Diane Apostolos-Cappadona

In one of his letters to Clara, Rainer Maria Rilke wrote,

> Would that you were sitting with me in front of the van Gogh portfolio (which I am returning with a heavy heart). It did me so much good these two days: it came just at the right moment. How much you would see in it that I can't yet see. You probably wouldn't even have read the little biographical notes of no more than ten lines that precedes the table of contents; you would have simply relied on your ability to see.[1]

The poet—a creator of words—recognized the fundamental power of the visual modality in human experience. Reading much of Rilke's poetry, one becomes aware of the repeated references to seeing. The issue, for Rilke, is not the primacy of the sense of sight or the power of the image over the word, but the full integration of the human experience possible through a work of art.

In his formative essay on Pablo Picasso's *Guernica*, psychologist Louis Danz characterized the Spanish artist's work as haptic. Danz expanded the primary use of haptic, that is, pertaining to the sense of touch "to include all emotive body happenings which take place inside the body." Therefore, art, for Danz, and by extension for Picasso, was conjoined "with the immediate experiences of [the] body."[2]

The mode of entry for the haptic is the eye, as Plato indicated. Plato asserted, however, that it is not the eye that sees, rather the eye permits us to see. Seeing, thus, encompasses much more than looking. Seeing is a

disciplined exercise. Just as it is rare to find an artist capable of expressing haptically, so as it exceptional to locate an art historian whose primary mode of analysis is the discipline of seeing.

Jane Dillenberger's study of art has been premised on the centrality of seeing. A highly visual person herself, Dillenberger viscerally—perhaps I should say haptically—experiences each work of art she sees. She is able to transfer this "experiencing of art" into her written analyses of works of art. Thereby, she seeks to bring each student, and each reader, to that same moment of integration (anguished or ecstatic) that she herself has known before the work of art.

Interwoven within her commitment to the discipline of seeing are Dillenberger's scholarly studies in Christian iconography and the presentation of the human body in art. Her detailed examination of a particular work of art, specific symbol or theme, avails itself of a multidisciplinary approach integrating Scripture study, church history, theological analysis, and cultural history with art history.

Dillenberger's analyses always begin at the beginning, that is, with the work of art itself as a primary text. Through a careful visual encounter with a particular painting or sculpture, she proceeds to search our visual connectors in other works of art of the same or a related theme. In most cases her studies revolve around a Hebrew or Christian scriptural theme, thus requiring a reading and, perhaps, an interpretation of the scriptural passage.

Then cautiously considering the contemporary church historical and theological situations, Dillenberger studies the transformation of her theme, or symbol, through the varied cultural eras. In so doing, she mutually illuminates, as Émile Mâle would say, the interconnections between art, religion, and everyday life. As a result theological controversies, historical arguments, and cultural shifts are clarified. Art becomes life.

In her analyses, however, Dillenberger never offers a concrete conclusion or solution to her inquiry. Rather, in the socratic tradition, she offers both students and readers the method of a discriminating eye and allows the assembled evidence to speak for itself. Any conclusion is reached not by the investigator but by the student and reader who find themselves haptically engaged in the discipline of seeing. Thus, discretely, perhaps seductively, Dillenberger permits each of us the opportunity to become what Bernard Berenson would term "passionate sightseers."

Image and Spirit in Sacred and Secular Art brings together the breadth of Jane Dillenberger's research interests: Christian iconography, thematic transformations, and modern art's spiritual impulse. This collection of ten published and unpublished essays coherently argues for the centrality of the discipline of seeing.

As Paul Valéry indicated it is by one's choices that we come to know who a person is. Dillenberger's choices in the works of art analyzed in *Image and Spirit in Sacred and Secular Art* indicate a person committed to the sacramental quality of seeing and of art, that is, of the full embodiment of the human experience. The human body is her fundamental orientation to a painting or sculpture.

Image and Spirit in Sacred and Secular Art has been arranged into the major thematic categories of Dillenberger's scholarly interests: images of women in Western art; interpretations of the human body in sacred and secular art; iconographic studies in traditional Christian art; and the spiritual impulse in modern art. The essays, woven together in Dillenberger's own inimitable style, show how Scripture, symbolism, the human body, and the haptic quality of art are engaged by the discipline of seeing.

In the decisions to categorize the ten essays selected for inclusion in *Image and Spirit in Sacred and Secular Art*, a choice had to be made between a thematic or a chronological arrangement. Interestingly enough, the chronology revealed what became the thematic sections for *Image and Spirit in Sacred and Secular Art*. It is, however, appropriate to note that Dillenberger's studies have been unconsciously arranged thematically.

Her earliest essays, from the 1950s, were iconographic studies of traditional Jewish and Christian art. These were followed in the mid-1950s by attempts to decipher the spiritual impulse in modern art. Then, she began to examine the image of women in both secular and sacred art in the early 1960s. Her interests turned to the study of both American and northern European art in the 1970s. In the 1980s, Dillenberger returned to her study of the image of women.

Unfortunately, it was her basic and immovable devotion to the discipline of seeing that restricted Jane Dillenberger from publishing much of her writing. The restrictions on illustrations in scholarly journals and books were an unbearable demand upon someone whose goal is, to paraphrase the prophet Isaiah, to teach people that without vision they will perish. As a result, *Image and Spirit in Sacred and Secular Art* devotes one-third of its allotted pages to the images discussed in the text.

Since *Image and Spirit in Sacred and Secular Art* represents a lifetime of seeing art, each individual essay ends with a notation of the actual date it was written. Every attempt has been made to inform the reader of the most recent scholarship on each individual topic through a profusion of footnotes. Nevertheless, the general impression of *Image and Spirit in Sacred and Secular Art* leaves the reader with what the sculptor, Isamu Noguchi, once described as the ideal of art—"that each time I see a work, it should be like falling in love again for the first time."[3]

Looking for Style and
Content in Christian Art

Only great art can be great religious art. Many of the religious master-pieces of the past remain inaccessible to us today because the style and content of these works of art are unfamiliar to our eyes and to our knowing. The iconography, that is, the imagery and symbols that were part of the visual language of earlier ages, is no longer part of our visual vocabulary. Then, too, the slow, attentive, expectant perusal of a painting demands of us a discipline of seeing that is contrary to our habits in everyday living. We all look at the visible world in a selective way. The focus of our attention is determined by our past experience and present interests. The constant selecting of what is seen and how it will be seen is a kind of editorial activity of the conscious mind, an activity that ceaselessly shapes our individual seeing of the exterior world.

To abdicate consciously our own self-determined and self-centered way of seeing is not easy. Nothing less than a kind of self-abdication is demanded of us by a great work of art. It asks us to see it, if only for a few moments, in terms of the vision that is represents and expresses. Those who go to art galleries and museums confined within the vision of their own making, tend to respond to paintings with "I like this one, that one I don't like"—that is to say, this one accords with and confirms my own private, limited vision, whereas the second one does not.

"Dual Impressions: Looking for Style and Content in Christian Art" is revised from its earlier publication in *Bible Review* 3.4 (1987): 24–31. It is reprinted here in its revised form with permission. Both essays were extracted from Jane Dillenberger, *Style and Content in Christian Art* (New York: Crossroad Publishing, 1986 [1966]).

1

When we are willing to receive the meaning of the work of art in accordance with the artist's vision, we can experience an exhilarating expansion of understanding. Momentarily, we see with the artist's eyes and feel with the artist's pulsebeat. This moment is a truly creative interval for the beholder. The famous art critic and connoisseur, Bernard Berenson, described this experience:

> In visual art the aesthetic moment is that flitting instant, so brief as to be almost timeless, when the spectator is at one with the work of art he is looking at, or with actuality of any kind that the spectator himself sees in terms of art, as form and colour. He ceases to be his ordinary self, and the picture or building, statue, landscape, or aesthetic actuality is no longer outside himself. The two become one entity; time and space are abolished and the spectator is possessed by one awareness. When he recovers workaday consciousness, it is as if he had been initiated into illuminating, exalting, formative mysteries. In short, the aesthetic moment is a moment of mystic vision.[1]

One of the curious effects of this experience of aesthetic vision is that it makes artists of us, creating in us a new vision for everyday life. Berenson gave an example of this when he told of his visit to the Freer Collection in Detroit, Michigan, on a frosty, wintery afternoon:

> I had been looking for hours at Chinese pictures of trees in snowy landscapes. The light of the day was failing, and as no lamps or candles were permitted, there was nothing to do but to start going away. As I was getting up from the table I turned round, and without realizing that I was looking through a window at the out of doors, at natural objects and not artifacts, I cried out, "Look, look, these trees are the finest yet!" So they were, for how can man compete with "nature"? I had been enabled to feel this without the aid of an artist to reveal it.[2]

When seen in terms of their iconography, the succession of humdrum events of daily living and the impact of rare precious events are graced with significance and dignity because their symbolic possibilities are underlined. When we experience the kaleidoscope of daily visual experiences as changing form, design, and composition, they cease to be meaningless. When we, like the painter who creates a work of art, endow with significance the forms of our visual experience, we become artists in relation to the visible world about us.

Let us look closely at two paintings with the same subject matter, the Annunciation. We shall see how the Flemish artist Jan van Eyck (1380–

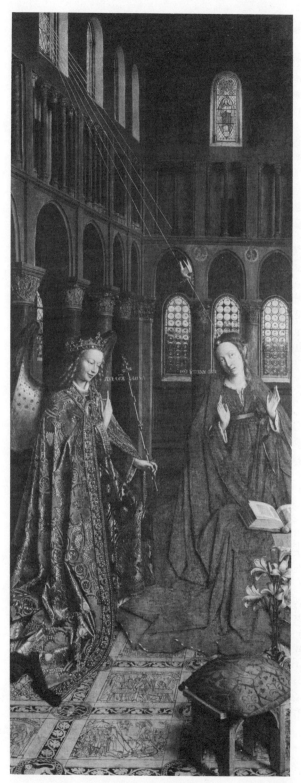

1. Jan van Eyck,
Annunciation, c. 1434–1436.
Oil on wood transferred to
canvas; 0.927 × 0.367
(36-1/2 × 14-7/16 in.). Andrew
W. Mellon Collection,
National Gallery of Art,
Washington, D.C.
(1937.1.39[39]).

1441) and the Italian artist Sandro Botticelli (1444–1510) differ in their artistic interpretations of the moment of the Incarnation.

Van Eyck's *Annunciation* (c.1434–1436; National Gallery of Art, Washington, D.C.) (fig. 1) exhibits the exquisite detail that a master's hand can achieve using the medium of oil paint, a relatively recent invention at the time. Van Eyck enclosed his two figures in a narrow, apselike end of a church. At the left, Gabriel, who seems to have just appeared, is richly garmented in a heavily brocaded, bejeweled mantle. His wings glow with the intensity and range of color of peacock feathers. He wears a crown and carries a scepter, both adorned with gems. Both crown and scepter are symbols of earthly rulership. Gabriel does not look directly at Mary, but as he speaks the words of greeting—"Ave Gr[ati]a Plena" (Hail, Full of Grace)—his lips curve into a cryptic, blissful smile.

Mary (fig. 2), who has been reading from the Scriptures open before her, raises her head and hands in a gentle gesture of reverent and bemused acceptance. The words of her reply to the salutation of Gabriel are visible in the painting "Ecce Ancilla D[omi]ni" (Behold, the Handmaid of the Lord). But they seem uttered involuntarily and to the heavens above, rather than to the angelic messenger whose presence Mary hardly perceives.

Neither Mary nor Gabriel is haloed, but the dove, symbolic of the Holy Spirit, is seen descending upon rays of light from a clerestory window above. The rays fan out in a clearly balanced pattern and are seven in number, a reference to the seven gifts[3] of the Holy Spirit, which at the moment of the Incarnation are communicated to Mary.

Mary is simply garbed, in a deep blue, heavy garment. We assume that she is kneeling before the bench that holds the book. Yet only her relative height in relation to the steeply angled floor is evidence for this conclusion. Her body is swathed in concealing folds; proportion and posture are indicated only by the belt that seems to encompass her narrow torso just beneath the highly placed, small breasts. Delicate and lovely are the narrow little hands raised in a gesture of surprise and acceptance. Her head, inclined to one side, is a narrow oval with a high forehead and small features that neither protrude generously nor recede deeply from the essentially egg-shaped surface.

Directly above Mary, a stained-glass window is illumined, and a representation of the Lord God of the Old Testament is seen, his feet resting on the globe symbolizing the earth. Thus, this painting has additional subject matter, namely, the Trinity—God symbolized in the window above, the Holy Spirit as the dove descending, and Mary, the bearer of the incarnate Word of God in the church.

The symbolic meanings in van Eyck's *Annunciation* are by no means

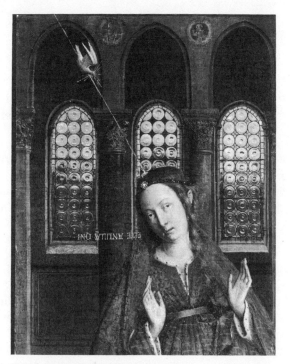

2. *Mary* detail from Jan van Eyck,
Annunciation. Detail of fig. 1.

3. *Floor Tiles* detail from Jan Van Eyck,
Annunciation. Detail of fig. 1.

exhausted by this description. Every inch of this little painting has details that refer to the central mystery of the Incarnation. The tiles of the floor (fig. 3) have Old Testament subjects, and in every case, the subject is seen as a prefiguration of events in the New Testament. David's victory over Goliath (foreground tile) is understood to be a prefiguring of Christ's victory over Satan; Samson's death, a prefiguring of the crucifixion of Christ.

This understanding of Old Testament events is foreign to most of us. It is difficult for those who inhabit twentieth-century space and time to understand the significance, power, and comfort that this kind of symbolic allusion had for late medieval people. To Christians in the medieval world, the Gospels were indeed the fulfillment of the Old Testament. Jesus had said, "Everything written about me in the law of Moses and the prophets and the psalms must be fulfilled."[4] Christian theologians searched the Old Testament to find analogies to the events in the life of Christ. The events of the Old Testament thus had a special relevance and a kind of poignancy for the Christian believer.

The lilies in the foreground are a common symbol for Mary's virginity and purity. Van Eyck places the lilies in a vase in the foreground near a brocaded footstool, making a very charming, exquisitely executed still life. In this detailed and painstaking way, he depicts "naturalized symbols"—symbols that are so much a part of the total environment that, collectively, they can be understood as a still life, or they can be interpreted in their symbolic functions, pointing beyond themselves to meanings well known to the Christian believer.

The composition of van Eyck's small *Annunciation* is organized around repeated perpendiculars. The high, narrow shape of the panel itself defines the space and confines our view of the scene. The two figures are essentially vertical in their emphasis and are enclosed by the repeated perpendiculars of the columns. The deviations from the vertical, such as the slender scepter held by Gabriel and the heavenly rays, only serve to accentuate the solidity of the perpendicular structure of the whole composition. Van Eyck loved descriptive detail and verisimilitude; he filled every inch of his panel with realistic detail.

One of the most arresting points in the painting is the disjunction between the figures and the space they occupy—they are enormously different in scale. How tiny the church would have to be for its columns to be only slightly taller than Mary and Gabriel! But because of the incredible realism of the many details that capture our attention and delight our senses, we see the lack of realistic space relationships only when it is called to our attention.

Van Eyck's single-mindedness in regard to space relationships has an

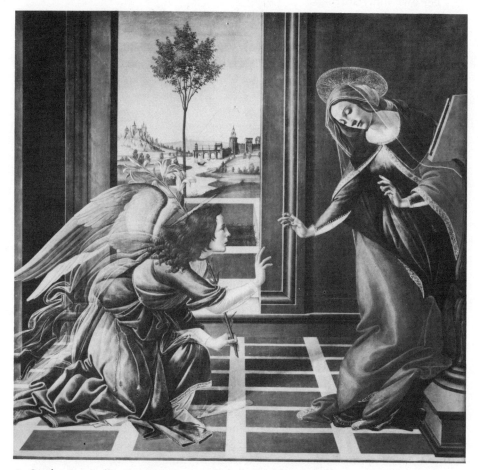

4. Sandro Botticelli, *Annunciation,* c. 1490. Tempera on wood;
150 × 156 cm. Uffizi Gallery, Florence. (1890, 1568).

analogy in the lack of emotional relationships between the figures. Gabriel smiles his secret, eternal smile and points heavenward. But his expression, gesture, and even his posture, have inner completeness. Mary, although her head inclines toward Gabriel, seems unaware of his presence. She looks dreamily at us and beyond us, seeming attentive only to her own inner stirrings.

It is a strange and wonderful little painting, showing an appetite for endless detail and a delight in the sensual—the texture and feel of exquisite fabrics, the gleam of precious jewels, the luster of fine marble and tile.

Botticelli's *Annunciation* (c. 1490: Uffizi Gallery, Florence) (fig. 4) also depicts the moment when the angel Gabriel's words are fulfilled:

> And the angel said to her,
> "The Holy Spirit will come upon you,
> and the power of the Most High will overshadow you;
> therefore the child to be born will be called holy,
> the Son of God."[5]

Botticelli vividly contrasted the assured urgency of the angel's forward movement with the yielding, trancelike bending of Mary. The angel's and the Virgin's hands, too, suggest their contrasted roles—the angel's hand erect and commanding, Mary's hands yielding, receiving. Mary's hips sway to one side as her head tilts forward like a flower on a windbent stem. The angel's garments are a complicated mass of folds and involuted contours, whereas Mary's garments are more sinuous, described with lines that are more slow-moving, and by areas that are larger and less complicated.

The symbols in the painting are naturalistically rendered as part of the scene, a typical renaissance characteristic. The details do not claim our attention as symbols only, they seem plausible as a part of the setting. The stalk of white lilies which the angel holds is botanically correct and in a proper scale in relation to the figures. Symbolic of Mary's purity and virginity, lilies are often seen in Annunciation paintings, but here they are naturalistically incorporated into the scene, losing their signlike character.

Botticelli's room opens upon a terrace. Beyond it is an enclosed garden with a single, slender tree rising gracefully just beyond the walled-in area. Although this scene can be enjoyed in itself as a poetic background setting, it too can be interpreted symbolically. The closed garden is a traditional symbol of Mary's virginity, and the tree beyond rises in fulfillment of Isaiah's prophecy, "And there shall come forth a rod of the root of Jesse: and a flower shall rise up out of his root."[6]

Ambrose[7] interpreted the tree in this way: the root is the family of

Jews, the stem is Mary, and the flower is Christ. The tree received an additional meaning in medieval and renaissance times. It recalled not only the genealogical tree of which Christ was the flower, but also the means of Christ's death. In the book of Acts, Paul speaks of Christ "whom they slew and hanged on a tree."[8] The tree thus became a symbol for the cross. Here at the joyous moment of the Incarnation, Botticelli reminds us of the sacrificial death to come.

Once the imagination is quickened by this kind of symbolic reference, it tends to expand the possible interpretations. The little vista beyond the garden suggests further meanings. We see a river undulating along the sloping banks, with a sailing ship afloat and reflected in its calm waters; we see crenelated city walls that terminate at the arched river bridge, and a many-towered edifice at the left. This complex of buildings, crowned by many spires and set amid rocky pinnacles, lies behind Gabriel and could refer to the heavenly Jerusalem, whereas the darker, more solid, walled city at the right might refer to the earthly Jerusalem. Gabriel, the heavenly representative, and the heavenly Jerusalem are then at our left; Mary, the earthly handmaiden of the Lord, and the earthly Jerusalem are at the right.

Gabriel's announcement takes place in a room that is empty except for a lectern. Like the lectern in van Eyck's painting, this lectern holds the Hebrew Bible. According to St. Bernard[9] when Gabriel appeared, the Bible that Mary was reading was open to Isaish's prophecy, "Behold, a virgin shall conceive, and bear a son."[10] Botticelli has constructed this room with great accuracy in terms of depth perspective. The tiled floor provides our eyes with a kind of template for determining exact relationships within space.

Like his contemporaries, Botticelli had achieved an understanding of the rules governing perspective, and he used his knowledge with skill and consistency. His command of space relationships was interestingly demonstrated in the way in which he depicted the halos. The Madonna's head is seen in three-quarter view and slightly bowed; her halo is depicted as being at exactly the same angle as the head. The angel's halo, like his face, is seen in profile.

Today the rules for perspective are so well known that art students can achieve effects that would have dazzled Botticelli and van Eyck. But the winning of the knowledge that permits an artist to convincingly render a depth dimension on a flat surface was a slow process. Though we tend to think of perspective as a mere tool used principally in academic or advertising art, for the Renaissance artist the rules of perspective served as the spelling out of the natural harmony of the laws of perception.

Let us now look at some contrasting elements in the two pictures. Van

Eyck's setting for the event of the Incarnation is a church. Both the shape of the painting itself and the church interior are tall and narrow. In contrast, Botticelli places the event in a wide, somewhat barren room, empty except for the Virgin's lectern, with a doorway open to the adjacent, enclosed garden. Botticelli's painting is almost square, the most stable of all mathematical forms. Light and air seem to flow into and about the Virgin's room. The light touches her forehead, cheeks, eyelids and hands, and the air lifts her veil and the angel's flowing sash. Stillness radiates from van Eyck's Gabriel and Mary; movement characterizes Botticelli's figures.

Van Eyck's picture has disparate perpendicular lines that define its composition. There is no single point from which the architectural setting and the figures are seen. We as the spectators seem to be above the floor, looking down on it, yet each of the figures is placed before the floor as if they are directly in front of us. Botticelli, on the other hand, used a single, unifying vanishing point from which we view the picture. This vanishing point is approximately where the turreted tower in the background projects upward somewhat to the right of a bridge over a winding river. The tile floor of Botticelli's room is laid out so that parallel lines receding from our eyes draw together at this point. The figures are also seen from the same viewpoint.

Van Eyck's Annunciation exhibits the artist's great ability to represent space, but it is a quite different space from Botticelli's. Botticelli constructed his room first, and then placed his figures in it. His figures are integrally related in size and placement to architecture. In van Eyck's panel, the amount of exquisite detail may obscure for us a fact that is nonetheless true: the spatial relationships are not realistic. The figures and objects in the foreground would have to be immense in size, and the church's nave would have to be tiny for us to see them as represented in the painting. Van Eyck focuses first on the individual details of persons, places and things, and only secondarily on their spatial relationships.

As is the case in most fifteenth-century Flemish paintings, the holy persons in van Eyck's Annunciation are not depicted with halos. (Botticelli, on the other hand, places halos on both the archangel and Mary.) For Flemish artists, like van Eyck, religious symbols are disguised as "scrupulously observed objects of the artist's own world and time."[11] Thus the details of the church interior in van Eyck's painting are faithful to the early architectural forms with which van Eyck was familiar. But each detail is saturated with references to the divine presence and the sacred significance of the moment of the Incarnation. God the Father is depicted in the stained-glass window and is flanked by wall paintings of the finding of Moses (which was viewed by medieval Christians as a

prefiguration of the nativity of Jesus) and of Moses receiving the Law. The prominent footstool in the foreground refers to Isaish's statement: "Thus saith the LORD, The heaven *is* my throne, and the earth *is* my footstool."[12]

The figures in van Eyck's painting reflect an inner serenity and completeness. By contrast, Botticelli's angel reflects an urgency and drama that are entirely absent from van Eyck's *Annunciation*.

If we imagined the words of the angelic salutation, "Ave Gr[ati]a Plena" (Hail [Mary], Full of Grace), and of Mary's reply, "Ecce Ancilla D[omi]ni" (Behold, I am the Handmaid of the Lord), added to Botticelli's painting, we would probably think them utterly inappropriate and incongruous. Yet they are in no way jarring in van Eyck's small serene, detailed panel. Indeed, van Eyck's ingenious literal-mindedness extends to a delightful detail. The words of the angel are given as if inscribed in front of our eyes, but Mary's reply is in mirror image and upside down, as if seen and read from the heavens above, from God's eye-view. The complicated symbolic references are part of the Flemish artist's tendency toward didacticism and storytelling, as opposed to the Mediterranean bent toward the dramatic. The unrelatedness of the two figures is another Flemish characteristic; van Eyck's Mary and Gabriel think their own thoughts and dream their own dreams, the agent of the Incarnation being the dove.

By contrast, in Botticelli's painting the urgent, tense movement of the angel is the occasion for the tender submissive movement of Mary. The angelic messenger and the handmaid of the Lord are bound together by their reciprocal roles and the high significance of the moment. Botticelli dramatized the event; van Eyck described it in endless, beautiful, serene detail, and pointed to the symbolic significance of this timeless moment.

Similarly, Botticelli conceived of the body as an organic structure that possesses the potentiality for movement. The urgent movement and gesture of his angel contrasts with the quiet, static posture of van Eyck's angel. We are in no doubt about the position of Botticelli's angel beneath its complicated garments, but the body of the van Eyck angel is difficult to discern. Is van Eyck's angel kneeling or standing? The posture of van Eyck's Mary is even more ambiguous. The textures of the ample robes of van Eyck's figures have been the focus of interest for the artist rather than the bodies' positions beneath these garments. But Botticelli was interested in the human body as an organic unity capable of movement (just as he is interested in the organic connections of space), and in his painting the garments accentuate rather than conceal the postures of Mary and Gabriel.

Botticelli's Mary and Gabriel have an ease of posture, an almost ballet-

like grace of gesture that is highlighted by the austerity of the empty room. But this grace cannot conceal the angel's nervous intensity and Mary's exaggerated movement, which create the drama of the moment.

Michelangelo is reported to have said that great painting is a "music and a melody which only the intellect can understand, and that with great difficulty."[13] It may seem strange that he should link the intellect with the understanding of music and melody. The present-day tendency to decry and dismiss the part the mind plays in an aesthetic response is summed up by the oft-repeated vulgarism, "I don't know anything about art but I know what I like." This simply is not true; the opposite is the case. The more we know about art in general, and about a particular painting, the more accessible that painting becomes to our understanding. The informed mind and attentive eye provide the "Open, Sesame" for the vivifying moment when the barriers between our world and the artist's vision disappear. Momentarily, then, we see with the artist's eye and feel with his or her pulsebeat.

<div align="right">1987</div>

Part 1

The Image of Woman in Sacred and Secular Art

1

Eve, the Mother of All Living

The images of Eve analyzed in this essay have been selected from the thousands that are extant in Western art. My analysis is arranged chronologically so that the transformations in the imagery of successive eras of Western history will be clear. This progression begins with the early depictions of Eve in which the scene of the Fall is reduced to an ideogram, operating more as sign than symbol, and continues with the medieval representations in which Eve is seen as the counterpart of the Virgin Mary and as *Mater Terra* or Mother Earth. With the art of the Italian Renaissance, especially that of Michelangelo, the dramatic, mythic, and psychological potentialities of Genesis 2 and Genesis 3 are explored. Renaissance artists were the first to depict the Fall as explicitly sexual in nature. From that time until our own day, the male-female sexual invitation and response becomes the central drama of the Adam and Eve event in art.

Though John Phillips assembled an appalling amount of evidence suggesting that the fathers of the Church and clerics of all past periods viewed Eve as the first sinner and the evil seducer, artists have not always seen Eve in this way.[1] For example, Michelangelo's Adam is clearly the aggressor while Eve is passive. Michelangelo is not alone in this pattern of representation; Titian and other artists put the onus on Adam, not on Eve.

Eve has been present from the very beginnings of Christian art, from the cursory and crude images of Dura-Europos and the catacombs where there are some twenty-four extant wall paintings with representations of

"Eve, the Mother of All Living" was first presented to the session, Images of Women from Scripture, 1987 Annual Meeting of the American Academy of Religion.

Adam and Eve, to the numerous carved figures on Christian sarcophagi.
The *Dogmatic* or *Theological Sarcophagus* (4th c.: Vatican Museums,
Vatican City) is an interesting example.[2] At the upper right corner, there
is a seated male figure gesturing toward a tiny doll-like female figure who
stands between him and a recumbent male figure—the freshly minted Eve
stands between her Creator and her mate-to-be.[3] This particular scene
puzzles art historians and theologians, because of the problem of the
identity of the two male figures standing near the Lord God. The one
with his hand on Eve's head, suggests to some Genesis 1:26, "Let us make
man in our image, after our likeness." Thus, some scholars interpret the
two males as members of the Trinity who are co-creators in all the events
of the first six days. For other scholars, the members of the Trinity are
often depicted as co-creators in medieval art, but not in early Christian
art; therefore, this identification is questioned.

The next three figures to the left are Adam and Eve now fully grown,
and the Lord God gives them a sheaf of wheat symbolic of "every plant
yielding seed which is upon the face of the earth" and a lamb, symbolic of
"every beast of the earth" over which the first man and woman were to
have dominion.[4] Just beyond Eve is the Tree of the Knowledge of Good
and Evil with a serpent. In later Christian art, the serpent is often
compounded of a woman's body with a long thick tail that is coiled about
the tree.[5] This species of female serpent will be seen again in
Michelangelo's frescoes for the Sistine Chapel ceiling. Both of these
serpents have as ancestors the mermaids and sirens of ancient Greek art
who also had long hair, a woman's torso, and a thick serpentine tail.

A more characteristic rendering of the Fall is found on the *Sarcophagus
of Junius Bassus* (c. 350: Vatican Museums, Vatican City) (fig. 5).[6] Adam
at the left clutches a great fig leaf over his genitals and looks disconsolately
away from the tree with its serpent entwined about it. Similarly Eve, at
the right, looks away from her mate and the wily serpent. Note the
frontal figures, symmetrically placed on either side of the tree, and the
subdued emotional content of this Adam and Eve. This Eve comes out of
the classical past as can be seen when we compare her posture with that of
the supple and sensuous type of Aphrodite that was well known in the
classical world from the multiple copies by Roman sculptors from the
Greek original. This type of female nude was part of the artistic vocabu-
lary of late antiquity, and was, thus, quite naturally adapted for the nude
Eve.

However, the manuscripts of the North (and of later centuries) present
a quite different image of Eve, and a quite different format. In the *San
Paolo Genesis* (875: Manuscript, San Paolo fuori le Mura, Rome), Eve is
lanky and graceless, and has thin pendulous breasts.[7] She is a character in

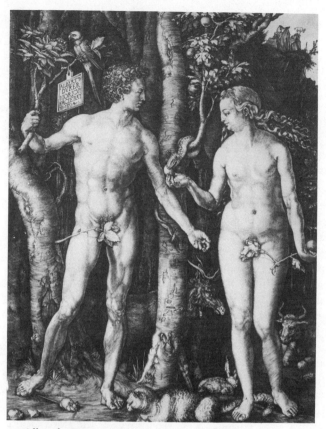

6. Albrecht Dürer, *Adam and Eve*, (Meder 1)
1504. Engraving. Rosenwald Collection,
National Gallery of Art, Washington, D.C. (B-6515).

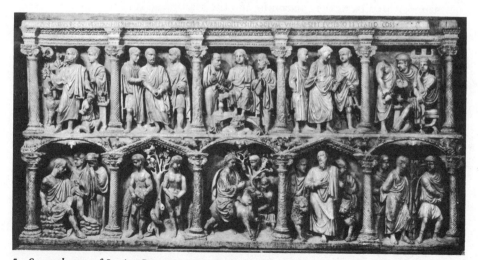

5. *Sarcophagus of Junius Bassus*, c. 350. Vatican Museums, Vatican City. Courtesy of
Office of the Director, Monumenti Musei e Gallerie Pontifici, Città del Vaticano.

a story that is told in amusing detail, serially as in our comic strips. Reading from left to right, the Lord God is seen as he touches Adam and breathes the breath of life into him. Then Adam stands before his maker, who anachronistically holds the Bible in his left hand. We also note that in this manuscript, as in many medieval works of art, it is the Logos, the second person of the Trinity, who is the Creator, for he is young and unbearded.

At the upper right, Adam reclines as the Lord God removes one of his ribs: then the creation of Eve is depicted, and the Lord God presents Eve to her mate. At the right in the middle register, is the Fall showing Adam holding an apple in one hand and clutching a large leaf to his genitals, as Eve converses with the serpent whose mouth is spewing insinuating utterances. The Lord God witnesses the sinners' forbidden meal and raises his arm, proclaiming a curse on their disobedience. Below, the pair are chased into this world by the cherubim; at the end we see Adam, toiling all the days of his life, and wearing, as does Eve, the coat of skins given them by the Lord God, and Eve suckling Cain, whom she bore and birthed in pain. So the story ends, and it is a story, told in continuous narrative style.

Moving from the ninth to the twelfth century we find the Creation mosaics in the Cathedral of Monreale, Sicily, a vast cycle akin to that of Michelangelo's Sistine Chapel Ceiling. The interior of the cathedral is completely sheathed in glowing mosaics with the creation cycle in the first register on the entrance wall. There we see the Lord God breathing life into Adam, drawing a joyous Eve from the side of the sleeping Adam, presenting Eve to her mate who greets her with outstretched arms, and then the Fall. The placing of Adam at our left, the tree with the entwined serpent in the center, and Eve at our right is the spatial arrangement which is most used from the catacombs and the sarcophagi through the Renaissance and baroque periods, as for example in Albrecht Dürer's engraving of *Adam and Eve* (1504: National Gallery of Art, Washington, D.C.) (fig. 6).

Adam and Eve after the Fall appear in Hubert and Jan van Eyck's *Ghent Altarpiece* (1425–1432: Cathedral of St. Bavo, Ghent), which is also known as the *Adoration of the Mystic Lamb*. Like the Monreale mosaics and the Sistine Chapel frescoes, van Eyck's altarpiece presents an integrated theological vision of humanity's creation and redemption. Our first parents stand, life-size and adjacent to the music-making angels, and at the same level with the Virgin Mary, Christ, and St. John the Baptist.[8] Among these heavily garmented figures of the heavenly zone, the guilty nudity of Adam and Eve (fig. 7) boldly claims our attention. Jan van Eyck has detailed the bulges and hollows of their bodies with a pitiless eye:

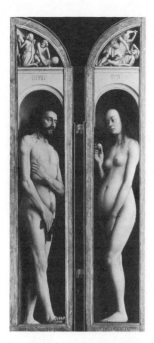

7. LEFT: *Adam and Eve* detail from Jan and Hubert van Eyck, *The Ghent Altarpiece*, c. 1425–1432. Oil on wood panel; 11' 5-3/4" × 15' 1-1/2" overall with wings. Cathedral of St. Bavo, Ghent. Copyright A.C.L. Bruxelles.

8. RIGHT: *Mary* detail from *The Ghent Altarpiece*. Copyright A. C. L. Bruxelles.

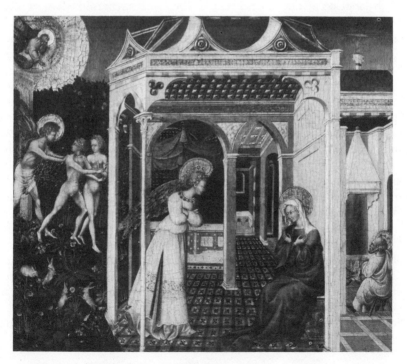

9. Giovanni di Paolo di Grazia, *The Annunciation*, c. 1445. Oil on wood; 0.40 × 0.46 (15-3/4 × 18-1/2 in.). Samuel H. Kress Collection, National Gallery of Art, Washington, D.C. (1939.1.223[334]).

Eve's small, round, highly placed breasts and pear-shaped belly, and Adam's awkward angularity. Eve's hair falls eglectfully and lankily across her misrepresented collarbone, as she holds the fruit before her. However, this is not the object of her attention, for her eyes are focused inwardly. A kind of vacant hopelessness shows in her eyes while a satisfied sensuality clings to her lips.

Her counterpart is, of course, the Virgin Mary (fig. 8) whose radiance is evident on cheek and lip and brow, as well as symbolized by her astonishing crown of jewels and lilies. The juxtaposition of Eve, "the mother of all living" with the Mother of God is purposeful. Eve is Mary's counterpart: as Christ is the New Adam, so Mary, as coredeemer, is the New Eve. Thus in many paintings of the *Annunciation,* such as that by Giovanni di Paolo di Grazia (c. 1445: National Gallery of Art, Washington, D.C.) (fig. 9) the Fall is paralleled with the Incarnation. Similarly in paintings of the *Nativity,* such as that by Petrus Christus (c. 1445: National Gallery of Art, Washington, D.C.), Adam and Eve are to be seen, in this case, carved into the architectural arch that enframes the charming scene of Mary, Joseph, and the angels in solemn prayer before the tiny, naked, newborn Savior.

Certainly, the most mythic and commanding images of Eve are those of Michelangelo's Sistine Chapel ceiling where she is represented four times: first, we see her as she preexists within the mind of God prior to her creation—a beautiful, alert, and curious Eve who peers around her Creator toward the languid figure of Adam.[9] Then we see her as she arises from the side of the sleeping Adam, her ripe, curvaceous body moving upward, her hands and arms in the attitude of prayer (fig. 10). Michelangelo presents us with an Eve to whom the psalmist's words apply, "From the day of your birth in the beauty of holiness, have I begotten you, like dew from the womb of the morning."[10] Then, in a single panel (fig. 11) we see her reclining with knees drawn up in the classical erotic position, her head adjacent to Adam's genitals, though she looks toward the serpent. She is seen again at the right as she cringes, entering the bleak plains of this world, yet she looks furtively back at her lost Paradise.

For the purposes of this essay, two points are of particular interest in the development of Michelangelo's Eves. First, the full-blown eroticism of these Eves is unique in the work of Michelangelo, for in all of his extant drawings, there is none of a female nude. His drawings for female figures are of young men with breasts appended. The female figures who appear in other scenes on the ceiling clearly reveal their origin from male models. Second, we feel in these Eve paintings, indeed all the events depicted on

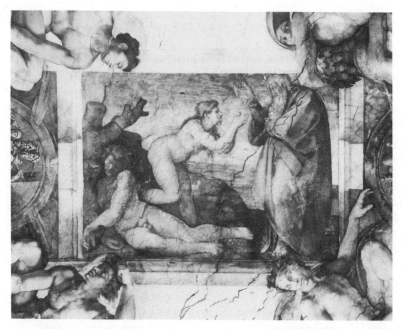

10. *Creation of Eve* detail from Michelangelo, *Sistine Chapel Ceiling*, 1508–1512. Fresco; 132 × 44 feet overall. Sistine Chapel, Vatican City. Courtesy of Office of Director, Monumenti Musei e Gallerie Pontifici, Città del Vaticano.

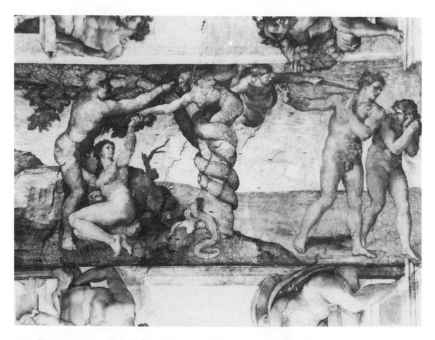

11. *Temptation and Fall* detail from Michelangelo, *Sistine Chapel Ceiling* 1508–1512. Sistine Chapel, Vatican City. Courtesy of Office of Director, Monumenti Musei e Gallerie Pontifici, Città del Vaticano.

the ceiling, the expanded and exalted imaging that transforms storytelling into myth.

To substantiate that claim, consider Hugo van der Goes's *Adam and Eve* (before 1475: Kunsthistoriches Museum, Vienna) (fig. 12). The pair stand before us, self-consciously naked. Hugo van der Goes has depicted portrait faces rather than generalized types, giving us the feeling that we have blundered into their privacy as we embarrassedly view Eve's tiny breasts, convex belly, heavy thighs, and ugly feet. This is not the mythic mother of us all, but the wife of the local parson or undertaker. The small painting is part of a small home or travel altarpiece, for the other panel of the diptych shows the *Deposition of Christ*. Thus, the scene of the Fall is paralleled with one of the Redemption like Jan van Eyck's altarpiece where the role of Eve is balanced by that of the Virgin Mary.

The most salacious Eve is that in Hans Baldung Grien's *Eve, The Serpent and Death* (1512: National Gallery of Canada, Ottawa) (fig. 13).[11] Eve steps forward toward us, the pearly flesh of her body highlighted and silhouetted against a very dark background. She seems to offer her body, with its scissor-like legs which emphasize the pubic zone, to us, yet the turn of her head and her sidelong glance are clearly directed toward her grisly companion, the figure of Death. He arrests her forward movement by his tight grip on her forearm, bringing our eyes to the strange knot of interlocking forms—his macabre hand, Eve's fingers that caress the tail of the Serpent, and the Serpent's head that bites the wrist of Death. We note that the Serpent has Death pinioned to the tree and that Death holds aloft one apple while Eve, with a coy gesture, hides her apple behind her back.

Death appears to be in the process of decomposition, partially skeletal and partially flayed, yet he is activated by a terrible explosive vitality. His violent energy and the tension within the Serpent's coiled body contrast dramatically with the inviting receptivity of Eve's sensuous body.

What are we to make of this strange painting? Is Death in fact Adam who, having eaten of the forbidden fruit, is metamorphosized, as the Lord God had warned, "But of the tree of the knowledge of good and evil you shall not eat, for in the day that you eat of it you shall die"?[12] Robert Koch, in his monograph on the painting describes Death as,

one of the most authoritative in all German art . . . The ghoulish reality of Baldung's creation resides in the combination of the fascinating repulsiveness of rotting flesh with an unmistakable vitality . . . Most effective is the face of Death, sinister in the contrast of dark and light flesh as though he were in masquerade . . . There exists a pictorial double-meaning in the composition, surely intended by Baldung: the personification of Death may also be seen as

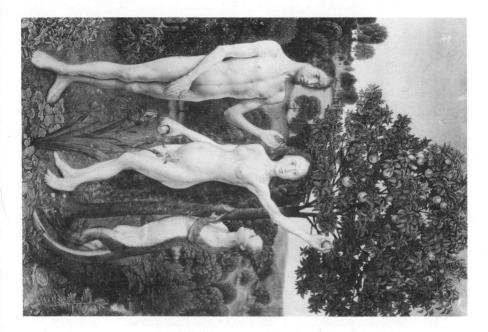

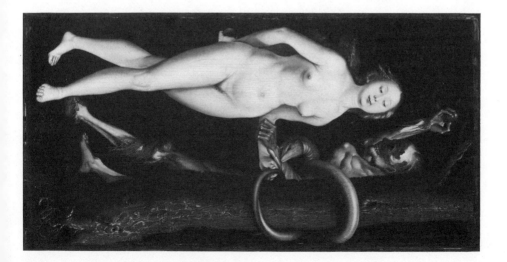

12. LEFT: Hugo van der Goes, *Adam and Eve*, before 1475. Kunsthistorisches Museum, Vienna. (5822A).

13. RIGHT: Hans Baldung Grien, *Eve, The Serpent and Death*, 1512. Oil on lindenwood; 64.0 × 32.5 cm. National Gallery of Canada, Ottawa. (#17011).

a representation of Adam himself as a corpse, the fate to which his body was destined at the Fall.[13]

Michelangelo's and Baldung's Eves were created at about the same time, and both emphasize the sexual aspects of the Fall and explore the complex psychic aspects of male-female relationships. Baldung in addition brings Death visibly into the drama.[14]

Rembrandt's extraordinary etching *Adam and Eve* (1638: National Gallery of Art, Washington, D.C.) (fig. 14) depicts a middle-aged couple who quarrel over the apple, and it is clear that this is not their first quarrel. Adam seems to grab for the apple, yet his upper torso draws away while his hips curve forward, the genitals visible and clearly relaxed. Eve holds the apple tenaciously and scowls at her mate. In the background, suggesting the next turn of events, an elephant trumpets, his trunk raised in midair, his mouth open. At our right an enormous tree supports the largest and most fearful of all the serpents to inhabit the scene. Batlike wings and a great clawed foot and scaly tail are appended to its body and its fierce head holding another apple leans forward. The serpent intervenes like a nasty mother-in-law, lecturing the two who are locked in a struggle of wills.

Rembrandt, a seventeenth-century Protestant, was deeply imbued with biblical tales from childhood and reconceived them in paint and etching throughout his life. He reinterpreted biblical events by locating them in his own time and place, thereby, envisioning them afresh. His depictions of biblical themes are often existential rather than mythic.

Peter Paul Rubens, Rembrandt's contemporary from nearby Flanders, was a devout Roman Catholic who painted many major commissions for cathedrals and churches in Flanders, and convents and chapels in Spain. When he depicted *Adam and Eve* (n.d.: Mauritshius Royal Picture Gallery, The Hague) (fig. 15) it was with the broader sweep of mythological envisioning that he saw the Garden and the first woman and man. Adam turns to Eve with a harmonious trusting gesture. Her golden body shines toward him as she reaches gracefully up toward the tree with one arm and with the other proffers him the fruit. The garden here has an opulence and abundance that is biblical—"the Lord God made to grow every tree that is pleasant to the sight and good for food"[15]—but to which none of the other artists we have considered previously have done justice. However, Rubens, was not the painter of the garden and the animals. The latter, incidentally, are already "fallen" and attack each other. Although the overall conception was Rubens, his friend Jan Brueghel collaborated on this painting as well as on many others.

After the radiant and wholesome vision of Rubens, Edvard Munch's

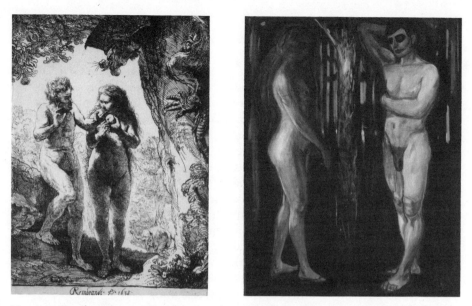

14. LEFT: Rembrandt van Rijn, *Adam and Eve*, 1638. Etching. Rosenwald
Collection, National Gallery of Art, Washington, D.C. (B-9464 [1943.3.7102]).

16. RIGHT: Edvard Munch, *Metabolism*, 1899. Munch-Museet, Oslo. (OKK M 419).

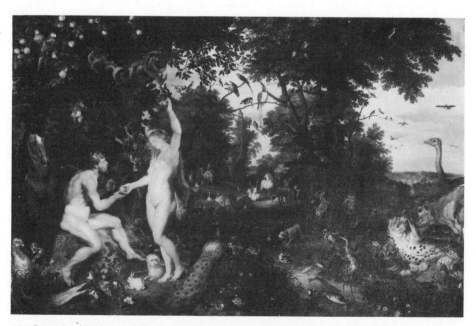

15. Peter Paul Rubens, *Adam and Eve*, n.d. Mauritshius Royal Picture Gallery,
The Hague.

late nineteenth-century Eve seems claustrophobic and fraught with a sultry destructive sexuality. Eve stands in a reverse of her usual position as she steps toward Adam with her left hand resting on her own pubic zone and her right hand moving toward Adam's genitals. Her hair cascades about her gleaming, light-touched body. Her face, however, is in shadow, with eyes either downcast or focused on Adam's genitals. Adam moves toward her, one arm languorously raised, the other passing narcissistically around his own body. Eve's hair, Adam's large mouth and passive genitals are all brilliant red. No serpent is present but the beautifully painted tree has a strange vitality and a place in the drama before us. Below we see its roots entwined with a human skull, a memento mori, at our left, and with a bestial skull at our right. The tree also points to a panel above where we see a cityscape outlined against a dark sky. Is the city, a communal entity, the product of the sexual encounter, or is it the destructive arena in which the sexual encounter takes place? Perhaps, it is both.

Perusing the painting, we recognize that though it is based on Genesis, it is a Symbolist painting that is really about something else—in this case, the power of male and female sexual drives, with their destructive and death-related potential. Munch called the painting *Metabolism* (1899: Munch-Museet, Oslo) (fig. 16) thus making the point that sexual desire is at the very center of the life-giving biological process that produces energy.

What can we conclude from our journey from early Christian crypts and coffins to Munch's painting? The earliest representations known in the third and fourth centuries center upon the Fall, and do so with the simplicity and directness of an ideogram: a nude male and female figure, a tree, and a serpent are the dramatis personae. To identify the event, we must know the account in Genesis. By the Middle Ages, the emphasis shifts to the various episodes of the story of Adam and Eve, told in narrative style chronologically and often arranged serially as in our comic strips. In these "once upon a time" pictured stories, we visually experience the biblical texts, but psychological and theological content is not pressed upon us. There is also a group of medieval works in which Eve is shown as Mother Earth and Adam as the source of the waters. However, in later medieval art, Eve is seen as the counterpart of the Virgin Mary, and the Fall becomes the keystone that antiphonally is related to redemption. Adam and Eve then are seen within the context of the Incarnation, in scenes such as that of the Annunciation or Nativity, and the Redemption, and in the scenes of the Crucifixion or Deposition.

A work of art that projects the Eve-Mary relationship within a fully articulated theological statement is the great *Ghent Altarpiece* by Hubert and Jan van Eyck. The inscription on Eve's panel says "Eve by succumb-

ing betrayed us." She is juxtaposed to Mary the New Eve and the Mother of Christ. Jan van Eyck's altarpiece stands between the medieval world and the nascent Renaissance.

The period of the High Renaissance is the time of Michelangelo. Somewhat less than one hundred years after the fallen Eve of the van Eycks, we have Michelangelo's four Eves of the Sistine Chapel ceiling. Michelangelo created an Eve with sensuously living flesh and a psyche. This Eve knows the tug of passion and the anguish of regret. Yet, passion and regret are here archetypal for in the realm of myth Eve and Adam are larger-than-life—psychically and physically—for they are representatives of the human race rather than particular individuals.

Contrariwise, the northern painter, Hugo van der Goes, represented particular individuals as Adam and Eve in his quite unmythic visualizing of the theme. While Rembrandt, another northern artist, again envisioned the first man and woman as particular persons, antagonists in a long contest of wills. With Munch, Adam and Eve were seen as subject to drives and inhibitions, patients inviting Freudian and Jungian psychoanalysis.

We can read into the foregoing summary a few milestones in the history of human consciousness, of how male-female relationships, and desire and guilt have been envisioned in earlier ages. In conclusion, it must be noted that Eve cannot be studied in isolation. She is always to be seen in her relationships, first with the Lord God, Adam and the serpent, in accord with the Genesis account. Secondly, her role is enlarged as she becomes the analogue to Mary the Mother of Christ, and thus as an image of the church. In the medieval period, she was recognized as the Mother of All Living—the Earth itself from which we come and to which we return.

We noted that the church and clerics generally viewed Eve as the evil seducer and sinner. This issues, of course, from an all-male body of opinion. The artists whose works are discussed in this essay were also all males. Rather than their reflecting a unanimously negative view of Eve's role in the first human drama, they show, as we have seen, a wide spectrum of interpretations.

1987

2

The Magdalen:
Reflections on the Image
of Saint and Sinner
in Christian Art

Who was Mary Magdalen? Two contemporary theologians provide contrasting interpretations. The first dubs her "sinner" and "bride" and wrote:

> The theme of the repentant harlot in love with Christ and become his bride was given a new dimension on account of a page of the Gospel and a happy historical error. The Gospel text in question is the moving pericope of Saint Luke, chapter 7, verses 36–50. We read there how Jesus, a guest of the Pharisee Simon, is visited by a woman who is a notorious sinner in the town. She weeps and pours out perfume on the feet of the Lord. The Pharisee reproaches Jesus for allowing her to do this. But the Master defends her, forgives her, and praises her. She is not named, but Latin tradition, as a result of a confusion in texts and names, identifies her with Mary of Magdala, out of whom Jesus cast seven demons [Luke 8:2], and Mary, the sister of Martha and Lazarus [John 11:4–43). In this way, the sinner converted in the house of

"The Magdalen: Reflections on the Image of Saint and Sinner in Christian Art" was first presented to the Symposium on Women, Religion, and Social Change, Hartford Theological Seminary, Hartford, Connecticut, in 1983. The essay, as it appears in this collection, is a revision of the symposium papers which were published as *Women, Religion, and Social Change* eds. Yvonne Yazbeck Haddad and Ellison Banks Findley (Albany: State University Press of New York, 1985), pp. 115–145. It is reprinted with permission.

Simon became Mary Magdalen, and all that is said about the other two Marys is attributed to her. This is indeed a happy mistake![1]

A second modern theologian considers the conflation of these texts "as the greatest historical falsification of the West." She wrote:

> The portrait of the Magdalene was constructed by men, and served to kindle male fantasies. . . . Anyone who loves the biblical Mary Magdalene and compares her with the "Christian" Mary Magdalene, must get very angry. . . . At the expense of women a provocative imaginary picture—scintillating, moving and dangerous—had been created by the patriarchal church.[2]

Elisabeth Moltmann-Wendel rejected the traditional identification and insisted on resurrecting the true Mary of Magdala who suffered from a serious mental illness, became the leader and spokesperson of the women about Jesus, encountered the risen Jesus, was the first apostle, and was the first woman preacher—this latter, according to legend, not Scripture.

A more positive interpretation from the feminist perspective is given by Marina Warner who wrote, "Together the Virgin and the Magdalene form a diptych of Christian patriarchy's idea of women." The church venerates two ideals of the feminine—consecrated chastity in the Virgin Mary and regenerate sexuality in the Magdalen. Mary the Mother of Jesus, as pictured in the Gospels, was transmuted by the church into an ideal of sinless perfection and purity whereas the harlot saint reflects "one of the most attractive features of Catholic Christianity—the doctrine that no one, except Satan, is beyond the reach of grace."[3]

The identity of Mary Magdalen is, indeed, obscure in Scripture. Luke recounts that an unnamed woman entered the house of the pharisee Simon, and while Jesus dined, she knelt, washing his feet with her tears and drying them with her hair. When the Pharisee objected that Jesus allowed a sinner to touch him, Jesus calls attention to her ablutions and anointing with oil, saying, "her sins, which are many, are forgiven, for she loved much."[4] Mark's account of the events that followed the crucifixion refers to Mary Magdalen who with two other Marys brought spices and went early to the tomb to anoint the body of Jesus.[5] Mark also says that the risen Christ appeared first to Mary Magdalen "out of whom he had cast seven devils."[6]

These scriptural passages provided the incomplete but suggestive data from which the image of Mary Magdalen emerged. Though none of the accounts state or imply that the casting out of the devils or the allegation "sinner" by the Pharisee Simon referred specifically to the Magdalen's

having been a prostitute, it is as penitent whore that she is exalted in Christian theology and art.

Whether the changes in the Magdalen's imagery can be linked with changes in the economic, domestic, and political realms, or whether they relate to the changing status of women, are questions to be answered by those with extensive historical knowledge in those fields. This study presents data, with speculations derived from the field of art history, a field closely allied with theology and church history during the periods discussed.

The main attribute of the Magdalen is the "alabaster jar of very expensive ointment" (Matt. 26:7). When represented as a devotional figure or as a patron saint, the Magdalen is often richly and elegantly attired. According to the *Golden Legend*[7] that recorded the lives of the saints, the Magdalen was of wealthy and noble lineage, and thus artists often show her in the most chic attire worn by the ladies of their own day.

The Magdalen as Symbol of Resurrection

The earliest known representation of the Magdalen was in an ancient Christian baptistery in the remote frontier town of Dura-Europos in Syria. There, in 1931–1932, three buildings were excavated—an early Christian baptistery, a synagogue, and a Mithraic temple—all immensely important because of their early date and because all were decorated with works of art with religious imagery. As the earliest datable Christian art, these paintings in the Christian baptistery from about 230, though crude, are of great significance. They represent the Good Shepherd, Adam and Eve, Christ healing the paralytic, Christ and Peter walking on the water, and most important for our purposes, the Marys at the tomb (fig. 17).[8] The first of these, the Magdalen and another Mary, are substantially all that remain out of a group of five women in the original; they are depicted with each holding a torch in her right hand and a bowl of ointment in her left; the corner of the tomb is visible just ahead of them. We can discern little information beyond noting the possibly elegant dresses and long veils of these two remaining Marys and their postures which, though close to the early Christian gesture of prayer, look oddly informal. Yet this fragment is strangely moving. It should be noted that the other subjects—Christ healing and his miracles—are rendered with awkward and sketchy contours presented as mere outlines of small figures. But the painter of the Marys fresco aspired to something more than representing signs and symbols. The Magdalen and the other Mary have a kind of presence in their larger scale, in the volume suggested by the painted dress

and veils, and in their ceremonial gestures as they hold the torches and ointment boxes.

In this earliest extant dated representation of Mary Magdalen, she is symbolic of the Resurrection in the elliptical visual language of early Christian art. Mary Magdalen was the first to see the risen Jesus, and having been directed by him to tell the brethren, there is scriptural basis for one facet of her role, that is, as apostle to the apostles, as Augustine was to describe her.[9]

The Magdalen as an Image
of the Subjugation of Sin to Christ

Another work of art depicting the Magdalen from a very early period, and one which also has been greatly damaged by the ravages of time, is the famous seventh-century Ruthwell Cross. This free-standing carved cross has on it a number of reliefs and inscriptions. The two largest of these are on the front and back respectively, and are of Christ standing on the beasts and Mary Magdalen wiping the feet of Jesus with her hair. Even in its damaged state, which makes the reading of these two reliefs difficult, the formal relationship of the two is clear. In one instance Christ stands over the beasts symbolizing the subjugation of the demonic; in the other, Mary Magdalen crouches at the feet of Christ wiping his feet with her hair, symbolic of the submission of the sinner to Christ. Meyer Schapiro has pointed out that in time Mary Magdalen became the model of female asceticism and penitence and remarks that the legend about her retirement to the desert for thirty years was known in England as early as the seventh century. He noted the common English institution of the double monastery, often under the rule of an abbess, and that "the importance of female ascetics in England perhaps inspired the elaboration of the legend of the Magdalen as an imposing prototype."[10]

During the medieval period, cults of saints flourished. Jean Leclercq wrote that in the eleventh century there was a sort of Magdalen ferment, what he called a

"Magdalen boom" in spiritual writings particularly in hagiography but also . . . in formulas for private prayer. The legends and liturgical texts originated and spread from a few important abbeys, especially Vézélay, Cluny, Fleury. The movement spread from France to Italy and even to Rome . . . with the result that the feast of Mary Magdalen (July 22) was given increasing prominence on liturgical calendars.[11]

Victor Saxer tabulated the cults of Mary Magdalen and recorded only 33 locations in the eighth to the tenth centuries, but 80 by the eleventh century; 116 between 1100 and 1146 (the time of the second Crusade), 125 by 1199, 196 in the period of 1279–1399, and a gradual dropping off thereafter.[12]

In the thirteenth century, Jacobus de Voragine (1230–1298) wrote a digest of the vast compilation of legendary lives of the saints. His digest, written in Latin, was called the *Legenda Aurea (Golden Legend)* that became a medieval best-seller, circulated and copied repeatedly. The legend of Mary Magdalen was recorded under her feast day, July 22. Here we read,

> Mary Magdalen was born of parents who were of noble station, and came of royal lineage. . . . Together with her brother Lazarus and her sister Martha, she was possessor of the fortified town of Magdala; near Genezareth, of Bethany and of a large section of Jerusalem itself.[13]

The account goes on to tell the life of the saint interweaving scriptural incidents with greatly elaborated accounts of her miracles and of her thirty-year penitence in a desert cave. The *Golden Legend* also refers to Mary Magdalen as the apostle to the apostles.

There is a curious discrepancy between the literary and liturgical evidence of the medieval Magdalenian ferment and the evidence from the visual arts. There are relatively few extant works of art depicting the saint from the medieval era. Even at Vézélay, in the church that carries her name and where an alleged relic of the saint is venerated, there are only minor representations of her. Even taking into account that the romanesque and gothic churches were decorated by carvings having vast programs that favored schemes over single episodes or figures, it seems strange that we have no single memorable Magdalen from the medieval "Magdalen boom." She was represented in scenes of the raising of Lazarus, the crucifixion, the *Noli Me Tangere*, and often in the pieta scenes, but no single image has captured the imaginations of believers and scholars, lifting that image into general familiarity.

The Magdalen as an Image of Human Grief over Human Loss

By the mid-fifteenth century, however, when the cults began to decline in numbers, we have a memorable image of the Magdalen in the famous Villeneuve-lès-Avignon, *Pieta*, or *Lamentation over the Dead Christ* (c.

17. *Women at the Tomb*, c. 230. Mural from the Christian Baptistery, Dura-Europos. Photograph courtesy of the Dura-Europos Collection, Yale University Art Gallery.

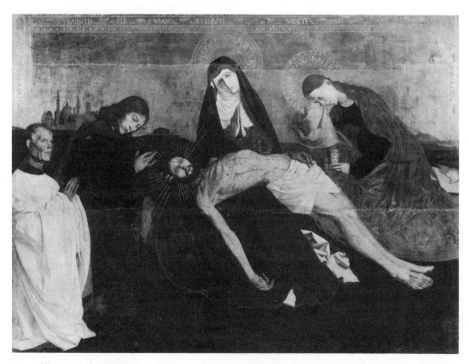

18. Villeneuve-lès-Avignon, *Pieta*, c. 1460. Oil on wood panel; 63-3/4 × 85-7/8 inches. Louvre, Paris. Courtesy of Réunion des Musées Nationaux, Paris. (RF 1559).

1460: Louvre, Paris) (fig. 18). Here we see the red-cloaked sorrowing Magdalen kneeling while the body of Christ lies across the knees of Mary the Mother. The mood of this work communicates a sense of a cataclysmic event of universal importance. Each detail bespeaks the epic tragedy—the emptied Mary the Mother, white and silent, garbed as a nun; St. John with bowed head and brooding face; the Donor, his face a solemn mask, though he is not truly present at the event; and finally, the Magdalen whose sloping body hangs over the Christ. With one hand she wipes her own tears with a convoluted fold of drapery, while with the other she holds her attribute, an ointment jar, which is charmingly decorated.

The sense of a grief almost beyond human bearing, yet a grief suffered with the knowledge that the tragedy has ultimate significance, is the mood of much of the art in the period toward the end of the fifteenth and early decades of the sixteenth century. The Magdalen became one of the principal vehicles for this passion.

Donatello's extraordinary sculpture of the *Magdalene* (c. 1455: Museo dell'Opera Duomo, Florence) (fig. 19) brings before our eyes and our consciousness a vision of a once beautiful woman whose flesh has been so subdued to the spirit that little of it remains on the gaunt frame. Suffering and deprivation are written upon the face, which we at first find as hard to look upon as watching one who is dying. Yet as we enter into her being, her selflessness melts our defenses. She is wholly absorbed in another realm. Her stance shows a touching uncertainty, almost a hesitation as she steps forward. What the Magdalen lacks in physical force is more than balanced by the spiritual power of her ravaged face and tender hands. She might have been a woman of Dachau or Buchenwald and there we could have found her twentieth-century antetype, but having said that, we are again arrested by the profundity of her essential being. The Magdalen embodies infinitely more than a courageous and noble endurance of suffering. With incredible sensitivity the artist shaped her hands to express both pleading and acceptance, the central Christian experience of faith and grace.[14]

Donatello's sculpture, *Magdalene*, has always been known as the "Penitent Magdalene," but it suggests another episode in the life of the saint as elaborated in legends. The *Golden Legend* relates how Mary, Martha, Lazarus, and two other Marys were put in a rudderless boat that was washed up on the shores of Provence in southern France. The Magdalen preached in that area and then for thirty years lived in a cave in Saint Baume in grim austerity as a hermit. Legend relates that at the canonical hours angels visited her and bore her heavenwards in esctasy; "Whyth aungelys handys she uplyfted was" as Osbern Bokenham wrote in his *Legends of Hooly Wummen*.[15] Bokenham (1393–1447) was an Augustinian friar, Doctor of Di-

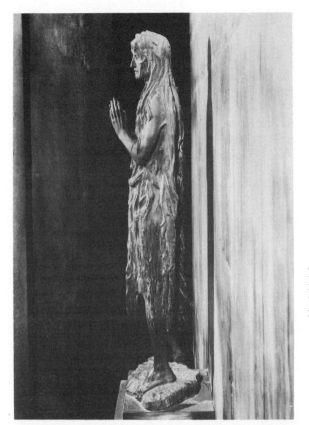

19. Donatello, *Magdalene*, c. 1455. Museo dell'Opera Duomo, Florence. Photograph courtesy of Alinari/Art Resource, New York. (1883).

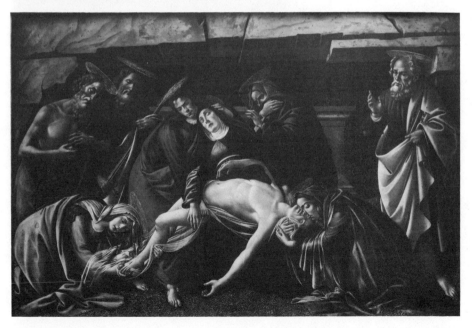

20. Sandro Botticelli, *Pieta*, c. 1495. Oil on canvas; 140×207 cm. Alte Pinakothek, Munich. (1075).

vinity, and patron of Literature in East Anglia in the early fifteenth century. It is this vision of the Magdalen who levitates in the heavens surrounded by angels, that the German sculptor Tilman Riemenschneider represented in *St. Mary Magdalen in Ecstasy* (1490: Bayerisches Nationalmuseum, Munich). Like Donatello's *Magdalene*, she is clothed only in her own hair. The Magdalen's flesh and face are not gaunt and wasted but have a lustrous full rotundity. She embodies the German and northern type of femininity—a very small bony frame with sloping shoulders, small high breasts and a pronounced protruding abdomen. Plump rounded arms and legs taper, and both feet and hands are tiny, narrow and delicate. By contrast, Donatello's *Magdalene* has a large skeletal frame, large and beautiful hands and feet. She is a classical Venus whose self-denial has ravaged flesh and muscle, leaving only the gaunt frame.

Donatello's *Magdalene* was prophetic of the religious fervor that was to sweep Florence at the end of the century. Stirred by the preaching of the fiery priest and reformer, Girolamo Savonarola, the sophisticated and luxury-loving people of Florence repented of their excesses and extravagances. For a time they submitted to the leadership of the Dominican monk in civil as well as in moral and religious matters. Savonarola's sermons that thundered from the pulpit of the Cathedral of Florence were heard by two of Florence's most gifted artists, Botticelli and Michelangelo. Both artists were influenced in their own way by Savonarola's cry for repentance and amendment of life.

The Magdalen as an Image of the Erring Church

Sandro Botticelli was fifty-two in 1497 when Savonarola was the virtual dictator of Florence. He had already painted decorations for the town hall of Florence and frescoes for the villa of Lorenzo the Magnificent and for the Sistine Chapel in Rome. In his younger years, Botticelli had depicted the classical myths, such as the *Birth of Venus* (1482: Uffizi, Florence), with lyric grace, poetry, and a sense of nostaglia. His early religious subjects (such as the lovely Madonnas holding a plump Christ Child) emanate a different spirit from his later works, which show a dramatic intensity reflecting a breathtaking religious fervor.

In Botticelli's *Pieta* (c. 1495: Alte Pinakothek, Munich) (fig. 20) the time of this world is collapsed, as the mourners about the body of Christ include not only the three Marys, and John the beloved disciple, into whose hands Mary the Mother had been committed, but also St. Jerome

who lived many years later and who is seen to the left holding a stone to his bared chest, and St. Paul whose conversion came after the event and who is depicted holding a sword. In addition, St. Peter stands to the right, and also a mysterious figure, perhaps the traitorous Judas, holding the nails in hand and shrinking from the sight of them.

The figure which most interests us, however, is that of the Magdalen who kneels and with a swooping, ballet-like grace clasps the head of the dead Christ against her own cheeks. Botticelli's Christ is a beardless, youthful Adonis whose beautiful body describes a graceful arc. The winding cloth beneath his body and the veil of the Magdalen create rhythmic arpeggios in the minor mode. The rhythm of these accelerates at the point where in unutterable grief the Magdalen's embrace encompasses the head of Christ.

Two other works by Botticelli from the time of the political and religious upheaval in Florence are *Mystic Crucifixion* (c. 1500: Fogg Art Museum, Harvard University, Cambridge) (fig. 21) and the series of predella panels with illustrations of the life of the Magdalen (c. 1470–1475: The Philadelphia Museum of Art, Philadelphia) (fig. 22).[16] The first is a visionary nightmarish scene; it shows the dead Christ on a cross on a hill outside the city of Florence. In the skies at the left, the forces of evil are in combat with the heavenly hosts. Below at the right of the cross, St. Michael raises a sword above the serpent (the devil) which he holds in his left hand. The only living human being in this painting is the Magdalen who clings desperately to the foot of the cross, her red cloak and hair rippling about her recumbent figure. But she is present not as a historic personage, but—and this may surprise twentieth-century lay persons—as an image of the church. The harlot who turns from her sins in penitence and who through the love of Christ is forgiven, is an image of the church whose excesses and errors will be forgiven when rooted in the love of Christ.

Botticelli's *Mystic Crucifixion* reflects the intensity of emotion that dominated Florence during the brief period at the end of the fifteenth century when the fanatical Savonarola headed the Florentine government. In his fiery sermons, Savonarola attacked the worldly and luxurious living of the Florentines and organized the burning of books and works of art, the "vanities," in the city square as public acts of cleansing. Vasari reported that Botticelli was one of Savonarola's supporters and *Piagnoni*, or weepers (for many wept at Savonarola's sermons).[17] Botticelli depicted the Magdalen as a weeper, clinging to the foot of the cross. The church which Savonarola had preached against with such fervor is symbolized by the repentant and forgiven whore in Botticelli's painting. Savonarola's reforms were moral, political, and economic, not theological, as was the

21. Sandro Botticelli, *Mystic Crucifixion*, c. 1500.
Tempera and oil on canvas;
73.5 × 50.8 cm. Friends of the Fogg Fund, Fogg Art
Museum, Harvard University, Cambridge,
Massachusetts. (1924.27).

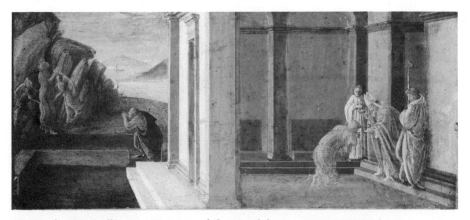

22. Sandro Botticelli, *Last Moments of the Magdalene*, c. 1470–1475. Oil on
wood; 7-1/4 × 16-3/4 in. The John G. Johnson Collection of Philadelphia,
The Philadelphia Museum of Art. (J # 47).

case with Luther's teachings of two decades later. Yet his rule in Florence was evidence of the impulses toward reform already present before the time of Luther. Luther himself referred to Savonarola as a saint.

The beautiful little predella panel by Botticelli of the last hours of the Magdalen does not display the same mood as does his crucifixion scene with its vision fueled by the deep spiritual anxieties experienced by the artist. The predella panel's second scene shows the Magdalen receiving her last communion (fig. 22); in the distance she is again shown and is about to be lifted into the heavens by two angels. The little painting resonates with a kind of crystalline, spiritual content. The body of the Magdalen seems to have lost all physicality. Her flame-like hair flows about her as she kneels in a luminous empty room before the bishop who bends over her with the sacrament. In the landscape behind, her elevation is witnessed by a priest. Though the two events represented are both legendary, Botticelli imbued them with a visionary character touched with ecstasy. Whereas the *Mystic Crucifixion* expresses "the mood of chiliasm of the end of the world [which] pervaded the time about the year 1500,"[18] the little painting of the Magdalen's last hours affirms the transcending power of faith. Both paintings depict supernatural occurrences, and the vehicle for their expression is the figure of the Magdalen, who in the one is the Church Incarnate, in the other is the soul of the individual sinner who in penitence and faith turns to God.

The Magdalen of the famous Crucifixion panel of Mathias Grünewald's the *Isenheim Altarpiece* (1515: Musée d'Unterlinden, Colmar) (fig. 23) comes from a slightly later time, but her figure and those of the others in this magnificent altarpiece are characterized also by a heightened intensity of emotion. The enormous figure of Christ looms up before us, his body stretched upon a roughhewn cross, the tension of his torso and his weight causing the great crossbeam to bend. His fingers claw stiffly at the empty air, and his knees buckle and the anklebones are riven from their sockets as the weight of the great body is pressed down upon them. At our right John the Baptist stands stiffly before us, holding the Scriptures in one hand, and pointing to the crucified with the other. At the left of the cross, John the beloved disciple supports in his arms Mary the Mother who has been committed to his care. The tiny impassioned figure at the foot of the cross is the Magdalen. Her body is pressed backward in an anguished arc. Her interlaced fingers are locked tensely together. The painful upward thrust of her head exposes the quivering cheeks and pitiable chin in outline against the bleak landscape. Her cascading hair seems to vibrate with the grief that racks the small body. True to an ancient tradition, Mathias Grünewald showed the Magdalen as experiencing sorrow in openly physical terms, whereas Mary the Mother grieves more inwardly.

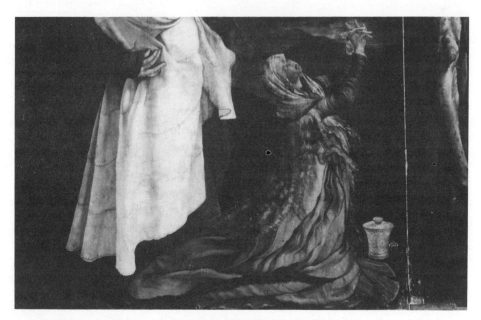

23. *Magdalene* detail from Mathias Grünewald, *Isenheim Altarpiece*, 1515. Oil on wood panel; c. 12' 3" × 17' 9" overall with wings. Courtesy of Musée d'Unterlinden, Colmar. Photograph by Otto Zimmermann.

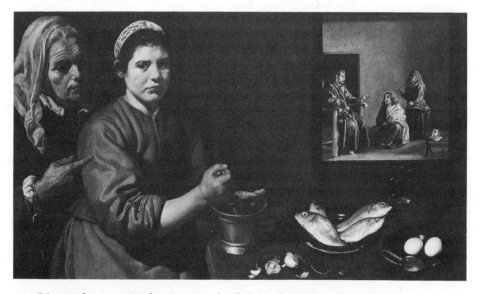

24. Diego Velázquez, *Kitchen Scene with Christ in the House of Martha and Mary*, c. 1617–1620. Oil on canvas; 23-5/8 × 40-3/4 in. Courtesy The National Gallery, London. (No. 1375).

Extremes of emotional expression are characteristics of the works of art with the Magdalen from the period before and after the year 1500. Parenthetically, and paradoxically, it should be noted that during the same period we have the creation of many of the great classical works of the High Renaissance—Leonardo da Vinci's *Last Supper* (1483: Santa Maria della Grazie, Milan), Michelangelo's *Pieta* (c. 1498–1499: Basilica of St. Peter, Vatican City) (fig. 75), and Raphael's early Roman Madonnas. The emotional restraint and classical balance of these masterpieces are characteristic of the dominating mood of the High Renaissance. Yet in the art of Donatello and Botticelli, and northern artists such as Riemenschneider and Lucas Cranach, Albrecht Dürer, Hans Baldung Grien, and Grünewald, ecstasy, fantasy, mysticism, and a highly charged emotionalism hold sway.

The unrest that would erupt into the Protestant Reformation was already in evidence in sporadic outbreaks such as in Savonarola's Florentine republic. Furthermore great anxiety preceded the turning of the year 1500. Predictions and signs abounded and apprehension that the end of the world was about to occur prevailed. Artistic expression, always sensitive to the tremors within society, mirrored these anxieties. Is it any wonder that the Magdalen, the repentant sinner, forgiven by Jesus Christ himself, would be the saint whose suffering and exaltation was repeatedly represented? By the late sixteenth and early seventeenth century the repentant Peter is also often represented in art. Why was it that a woman saint, rather than the male saint, was used as the prime symbolic image for this period? Though the answer lies outside the realm of art history, in the period around 1500, the imagery of women still reflected the medieval symbolism in which woman is either the image of virgin purity, as exemplified by the Virgin Mary, or the evil seductress who leads men to their ruin. The Magdalen is the *reformed* seductress, a wonderfully human image of repentance and amendment of life. The painters, as well as most of the patrons were, of course, men.

The Magdalen as an Image of Contemplative Life

With the seventeenth century a new image of the Magdalen appears. She is represented as being deep in thought, in contemplation, and she becomes the symbol of the contemplative life. Her role as contemplative

stems from the story of Martha and Mary, beginning at Luke 10:38, when Mary "who sat at the Lord's feet and listened to his teaching" is contrasted with Martha who "was distracted with much serving." A fourteenth-century commentator, called Pseudo-Bonventura, wrote "You must know that the saints say that these two sisters represent the two lives, the active and contemplative . . . the deed and the intellect."[19]

The Repentant Magdalen (c. 1640: National Gallery of Art, Washington, D.C.) (fig. 35), represented by the French painter, Georges du Mesnil de La Tour, is contemplative, "searching for solitude of mind and attending only to God."[20] She is seated at a table in a dark chamber illuminated only by a candle that is hidden from us but whose flame is seen at the periphery of the skull on which the Magdalen rests a large and graceful hand. Her other hand supports her chin as she gazes concentratedly not at the skull, but at its reflection in the mirror before her. The skull reflected in the mirror has a sharp-focus realism. It is the most detailed image in the whole painting. It compels our attention as well as the Magdalen's, and we note that the skull is in profile just as the Magdalen is—that it represents an eerie Xray in reverse of the lovely, living saint. The light touches her nostrils and the corner of her mouth, and plays across her wrist and the soft folds of her white sleeve. It is an image of silence, of a soul withdrawn into the depths of meditation. What image could contrast more vividly with the agony of the witness of the crucifixion in Grünewald's painting or the ecstatic elevation of the saint in Riemenschneider's carving?

Another interpretation of the contemplative versus the active life, and a curious one, is in Diego Velázquez's *Kitchen Scene with Christ in the House of Martha and Mary* (c. 1617–1620: The National Gallery, London) (fig. 24). In the foreground, we see an elderly woman chiding a young woman who looks resentfully at us as she continues her task of mashing garlic in a mortar. Four fish, two eggs, and other objects on the table are painted with a surrealist attention to detail. But the real event occurs in the distance in a room that we see through an opening in the wall. There Christ is seated, his hand raised as he addresses Martha who stands expostulating, and Mary who is seated at her Lord's feet. Martha appears elderly and veiled and may be the same person we see at the left in the foreground. Experts do not identify the ruddy-cheeked servant girl at her side as Mary. The juxtaposition of the vivid kitchen scene, and the biblical event, which is so small and so distant, gives the painting an arresting and puzzling character. Some of the unresolved questions of interpretation about this work are undoubtedly due to the fact that this is a very early picture by Velázquez, and that the elements, borrowed from or influenced by other artists, are imperfectly integrated into the whole

conception.[21] Still, for my purposes, the painting's interpretation of the theme of the active and contemplative life is to be noted.

The Magdalen as an Image of Penance

The seventeenth century might be called the Magdalen's century. The popularity of the theme at this time is noted by the fact that the Magdalen even inspired an ode written by Cardinal Maffeo Barberini, which was published in Paris in 1618.[22] Though other events of her life, both biblical and apocryphal, were repeatedly represented, the most frequent subject was the penitent Magdalen. The Spanish artist El Greco painted many versions of this subject in the last years of the sixteenth century and the early years of the seventeenth century. In his painting, *The Penitent Magdalene* (c. 1580–1585: The Nelson-Atkins Museum of Art, Kansas City, Missouri) (fig. 25). El Greco (Doménikos Theotokópoulos) represented the Magdalen before a rocky cavelike form that cuts down diagonally behind her figure, allowing us to see a patch of turbulent sky and clouds illumined by an unnatural light. Perhaps kneeling in prayer, the Magdalen looks upward, her great eyes highlighted and shining with tears. Just behind her at our right, we see a small glass vessel, which is the ointment jar and her attribute, and a skull. Like the skull in Georges du Mesnil de la Tour's painting, it is a symbol associated with penitence and the renunciation of all earthly possessions. It is a memento mori and a reminder of the transience of all earthly things. At the time of the Council of Trent, Roman Catholicism reaffirmed all seven sacraments, penance being one of these. Thus, we find in the art of El Greco many pictures of both the penitent Peter weeping over his denial, and of the Magdalen who weeps over her sins.

The feminist theologian, Elisabeth Moltmann-Wendel, criticized these representations of the Magdalen as sinner as being sexist and asked, "What is left of the great male sinner? . . . What would our tradition look like if it had made Peter a converted pimp?"[23] She is apparently not aware of the tradition in art in regard to Peter's denial and his repentence, both repeatedly represented. El Greco at different times did five paintings of *St. Peter in Tears*, many of them with the same posture and general format of his *Penitent Magdalene* paintings. For Protestants of the time, Peter was the apostle who denied Christ whereas for Roman Catholics, and El Greco, St. Peter was the first pope and the tears shed after his repentance became a symbol of the sacrament of confession.

Far in the background to the right in El Greco's *St. Peter in Tears* (c.

25. El Greco (Doménikos Theotokópoulos),
The Penitent Magdalene, 1580–1585. Oil on
canvas; 40 × 32-1/2 in. The Nelson-Atkins
Museum of Art, Kansas City, Missouri.
(Nelson Fund). (39-55).

26. Pablo Picasso, *Studies for Crucifixion*, 1929. Pencil.
Musée Picasso, Paris. Photograph courtesy
Réunion des Musées Nationaux, Paris. (MP
1875.39).

1580–1585: Bowes Museum, Barnard Castle, County Durham, England)
is a scene linking him to the Magdalen:

> An angel sits on the empty sepulcher of Christ, while Mary Magdalen,
> carrying a jar of spices she brought to anoint the body of the Messiah,
> hurries away to tell Peter of Christ's resurrection. . . . the empty sepulcher
> suggests the idea of the Resurrection as the foundation for faith and hope.[24]

It is of no small interest that Martin Luther also linked Mary Magdalen
and Peter, not as penitents, but as sinners who received grace: "St. Peter,
St. Paul, St. Mary Magdalen are examples" wrote Luther, "to strengthen
our trust in God and our faith, by reason of the great grace bestowed on
them without their worthiness, for the comforting of all men." In another
of his writings he again emphasized her faith and grace rather than her
penitence: Jesus "also absolves Mary Magdalen because of her faith, for
His words are, 'Go in peace; your faith has saved you.' "[25]

Guercino's beautiful painting of the *Penitent Magdalene* (1622:
Pinacoteca, Vatican Museum, Vatican City) could be seen on the other
end of a seventeenth century scale that runs from the silence and annihila-
tion of the self in Georges du Mesnil de La Tour's paintings through many
shades of emotional content, to Guercino's comely grieving Magdalen.
She gazes tearfully upon the instruments of the passion shown to her by
the two angels at the tomb of Jesus. This is the moment before she turns
around to find Jesus standing near her; the blue sky and the lightening
horizon suggests the coming of the dawn and of her savior. The Mag-
dalen's plum-colored robe falls in large sculptural folds about her kneeling
figure; her white gown has slipped away from the shoulder, the arm, and
the breast; her disordered hair falls caressingly across her flesh; her head
tilts to one side and she clasps lovely hands as she gazes upon a great nail
held up to her by one of the angels.

Guercino has skillfully controlled the source of light so that it gleams
upon her arm and breast, her eyelids and nostrils, upon the underside of
the angels' entirely believable wings, and finally upon the crown of thorns
laid upon the abandoned winding sheet of Christ. The emotional impact
of the Magdalen's beauty and her grief are heightened by the rich sen-
suality of her flesh. Given these observable characteristics, it is of interest
to note that this painting has been described in Vatican literature as one
whose "subject is given a somewhat moralistic, typically post-Tridentine
interpretation," and paraphrasing Passeri's 1772 description, states that
Mary Magdalen

> kneels on the hard ground and laments her faults while one of the angels
> assisting in her penitence presents her with the nails with which Christ was

crucified: the other points to heaven to indicate the true hope for her salvation.[26]

Other episodes in the life of the Magdalen are also frequently depicted during the seventeenth century, such as the themes of the *Noli Me Tangere* and the ecstasy of Saint Mary Magdalen. *The Ecstasy of Saint Mary Magdalene* (n.d. Hispanic Society of America, New York) by the Spanish baroque painter Ribera, rather than expressing the supernatural other-worldliness of the saint, portrayed a lovely, sad young woman surrounded by plump playful putti who accommpany her melodramatic "translation." Her soulful gaze upward appeals to sentiment and elicits our easy identification with her, but has little of the transcending power of Riemenschneider's sculpture of the same subject.

Several of the penitent Magdalens of this study as well as other examples from the early seventeenth century are contemporaneous with a poem by an English writer, Thomas Robinson, "The Life and Death of Mary Magdalen."[27] This poem which dates from 1620 was written in English. Highly allegorical and in two parts, Robinson's poem first emphasizes her "death to sinne," and in the second part, her "life in righteousness." The existence of this sentimental and allegorical poem is noted because it coincides with an overwhelming number of works of art devoted to the saint in the seventeenth century. Also its English provenance is of interest, for though the English Protestant clerics who formed the Anglican *Book of Common Prayer* on the basis of Roman Catholic liturgies severely limited the Common of the Saints, Mary Magdalen was included. However, she was not included in the American *Book of Common Prayer* that was ratified in 1789. It is to be remarked with approval and puzzlement that after almost two hundred years in limbo, Mary Magdalen made a comeback, for in the recent Episcopal prayer-book, she has regained her ancient appointed feast day, July 22.

The ubiquity of the Magdalen in seventeenth-century art in Roman Catholic Europe can be related, certainly in part, to the effects of the Council of Trent and its reaffirmation of dogmas and teachings of the church. Roman Catholicism exalted the cult of the saints, and thus the saints of the seventeenth century are depicted in states of transport and aspiration and embody a "painful effort to escape from human nature and to become absorbed in God."[28] Roman Catholicism reaffirmed all seven sacraments (the reformers eventually retained only baptism and the Eucharist), chief among them penance. As Émile Mâle remarked,

For this reason the image of Mary Magdalen recurs frequently in the seventeenth century. . . . Beauty consuming itself like incense burned before God

in solitude far from the eyes of men became the most stirring image of penance conceivable.[29]

The Magdalen as an Image of Grief of Mythic Depth and Intensity

We have discussed in detail the two historic moments when the image of Mary Magdalen was vividly represented in painting and sculpture: first, right before and after the year 1500, and second, during the seventeenth century. What remains to be considered is the contemporary image of this figure.

In the twentieth century, the prodigious Pablo Picasso created perhaps the most memorable image of the Magdalen. She appears in a series of drawings of the crucifixion done by the artist in 1927 and 1929, all of which are related to a small but very important painting of the subject completed early in 1930. The crucifixion appears unexpectedly within the work of the artist, whose large output up to that time had been concerned with persons, places, and things taken from the visual data that he saw about him. It should be noted that the drawings are all small, spontaneous studies, showing the artist thinking through what he wants to do and how he wants to do it—experimenting, erasing, trying it another way. The drawings are private utterances, and in viewing them we are, as it were, watching the workings of his mind: even the culminating painting has something of this private character. It is to be noted that Picasso kept the painting in his own possession, along with a group of other works dubbed "Picasso's Picassos,"[30] all of which had special significance to the artist himself.

The first known, that is, published drawing, is dated 1927; it bears the evidence of numerous erasures and revisions of form. The iconography, that is, the reading of the images, begins with Christ. His small head encircled by a crown of thorns and set in an egg-shaped halo is in the center of the upper part of the composition. His bulbous arms stretch the length and breadth of a wide crossbeam, the hand at our right being palm up, with a large ovoid nail at its center. Several figures merge into each other at the left side of the corpus, and at the right, a horseman with a two-pronged lance is about to plunge it into the side of Christ, while holding a shield in the other hand.

The most astonishing figure in this drawing is, however, the female who bends backwards at the foot of the cross, achieving an extraordinary posture. Her head falls back, the hair falls down toward her curved buttocks and her massive ankles and feet. Her inflated arms reach upward

imploringly, and the acrobatic curve of the body causes the breasts to be seen in profile against the foot of the cross. This is the Magdalen.

Picasso's Magdalen is related to the representation of this Mary in Grünewald's *Isenheim Altarpiece,* in which may be seen the small, but passionately arched body of the Magdalen kneeling at the foot of the cross, her head pressed back, her interlaced fingers raised toward the body of the crucified. Her body is tilted backward in a "sprung" position. Picasso has taken his figure, rotated it so that her back is to us, and drawn her head down even further than did Grünewald.

Two years later, Picasso returned to the crucifixion subject, and this same figure, in a series of extraordinary drawings. On the sheet dated May 25, 1929, we see a series of studies, also of this bent-sprung female figure. Again the arms reach upward and the head falls backward. Tubular legs and feet curve in unarticulated contours across the sheet. The breasts remain recognizable, but increasingly their contours serve a design function rather than a descriptive function. The four extra studies of the face rearrange the human features in willful, playful ways. Another page dated the next day has two studies of this figure and shows a futher departure from the natural bodily proportions and relationships. The impulse to design is uppermost, creating a complex of lines bearing only some suggestive clues which relate, often in an abrasive way, to our experience of our own bodies.

Whereas the page from May 25 shows the artist's hand, the servant of a mind groping for a visual image to express an idea, the page from May 26 (fig. 26) shows the image clearly possessed by that mind and now elaborated consciously as a design. A more exaggerated contortion of the figure is depicted, bringing the nose to the pubic/anal zone. The lines are more purposeful. The elaboration of details like the carefully drawn fingernails and toenails, the reiterated curves which are read as hair or eyelashes, as blades of grass or as contours of the rib cage, are all rendered with a masterful sense for pattern. A tight, small self-complete study at the lower left shows Picasso working with elements that vestigally relate to the human physiognomy and the breasts in particular, but these forms are displaced and designed so freely that they read first as vivid black and white designs, and only secondarily as nose, hair, mouth, eyes.

What are we to make of these willful, violent distortions of the human body, of the Magdalen's body and face, particularly when we view Picasso's works in the context of the great works of religious art of the past? Is the 1927 drawing of the Magdalen the primal woman overcome by sorrow? "Beside herself with grief" is a popular epithet, here literally true. Despite the brevity of the linear delineation, it is not an ideogram or a diagram. It is a visual image of woman emitting the primal scream. It is

the *woman* who screams—the elemental woman whose sexuality is affirmed even in anguish.

Is it a "religious" work of art? For most viewers, this question, which may not have arisen before, will come forcibly to mind. What was his intention? Picasso himself spoke of the mystery of the creation of works of art:

> How can you expect an onlooker to live a picture of mine as I lived it? A picture comes to me from miles away: who is to say how far away I sensed it, saw it, painted it, and yet the next day I can't see what I've done myself. How can anyone enter into my dreams, my instincts, my desires, my thoughts, which have taken a long time to mature and to come out into the daylight, and above all grasp from them what I have been about—perhaps against my own will?[31]

Picasso's dreams, instincts, desires, and thoughts have been those of the age in which we live. His oeuvre both expresses and has shaped our own seeing and being.

The fact that Picasso studied the famous *Isenheim Altarpiece*, transforming and retransforming its images, is to be noted. Grünewald's painting of the crucifixion speaks the language of ultimate meaning for the early sixteenth century; Picasso's works, for the twentieth century between the two world wars.

Conclusions

We have seen that at two periods of momentous change in Western history, images of the Magdalen multiplied and were the bearers of meanings related to these changes. First, in the period around the year 1500, when there was much unrest in the church and outside of it, and chiliastic anxieties about the imminent end of the world abounded, the Magdalen was represented either as immersed in this world, as an archetype of suffering, or as escaping this world, in a mystical or ecstatic transport.

In the seventeenth century, the Magdalen had a multiplicity of roles. In the art for Counter-Reformation churches, she was prominent in the pantheon of saints whose lives were put before the faithful. She was depicted in scenes of the crucifixion, deposition, lamentation, the raising of Lazarus, the feast in the house of Simon, the *Noli Me Tangere*—all of her biblical appearances. But most frequently she was the penitent sinner whose travail of spirit was intended to strengthen worshipers in their

belief and spur them to emulation. A scroll held by a Magdalen of an earlier period had a Latin inscription which translates,

There is no need to despair, even
For you who have lingered in sin;
Ready yourselves anew for God
Because of my example.[32]

We turn to our original query, who is Mary Magdalen? In religious art, her image and the meaning borne by that image, have changed with each era. She symbolized the Resurrection (Dura-Europos), the subjugation of sin and the demonic (the Ruthwell Cross), human grief over human loss (Grünewald), the erring church (Botticelli), mystical transport (Riemenschneider), the contemplative life (Georges du Mesnil de La Tour), the sacrament of penance (Donatello, El Greco, Guercino), and finally with Picasso, a grief of mythic depth and intensity.

There is no biblical figure other than the Magdalen who has borne a comparable breadth of humanity in all its many facets. Henry Adams thought that the Virgin was the greatest force the Western world had ever felt and that it was her power that built the great cathedrals.[33] Her power was great but her humanity was narrowed by the Roman Catholic church, and she was largely ignored by Protestantism. By contrast, the Magdalen was all that was female and all that was human. She was the apostle to the apostles, and perhaps is still available to both women and men today.[34]

1983

François Lemoyne, *Head of Omphale in Profile*, 1724. Red, black, and white chalk on paper; 9¹/₁₆ × 6½ inches. University Art Museum, Berkeley. Gift of Mr. and Mrs. John Dillenberger in memory of her son, Christopher Karlin.

94. Lucas Cranach the Elder, *The Crucifixion with the Converted Centurion*,
1536. Oil on wood; 0.508 × 0.349 (20 × 13¾ in.). Samuel H. Kress Collection,
National Gallery of Art, Washington, D.C. (1961.9.69 [1621]).

117. Pablo Picasso, *Crucifixion*, 1930. Oil on wood; 20 × 26 in. Musée Picasso,
Paris. Photograph courtesy of Réunion des Musées Nationaux, Paris. (MP
#122).

27. Detail from Jan van Eyck, *The Marriage of Giovanni (?) Arnolfini and Giovanna Cenami(?),* 1434. Oil on wood; 32¼ × 23½ in. Courtesy The National Gallery, London. (No. 186).

106. William Blake, *Angel Michael Binding Satan*, 18/19th century. Watercolor, black ink, and graphite on off-white paper; 359 × 325 mm. Gift of W. A. White, Fogg Art Museum, Harvard University, Cambridge, Massachusetts. (1915.8).

103. Lucas Cranach the Elder, *The Nymph of the Spring*, after 1537. Oil on wood; 0.485 × 0.729 (19 × 28⅝ in.). Gift of Clarence Y. Palitz, National Gallery of Art, Washington, D.C. (1957.12.1 [1497]).

36. Diego Velázquez, *The Toilet of Venus* ("*The Rokeby Venus*"), 1657–1658. Oil on canvas; 48¼ × 69¾ in. Courtesy The National Gallery, London. (No. 2057).

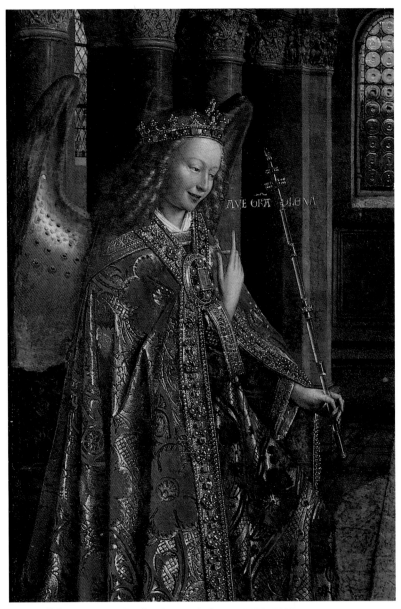

1. Detail from Jan van Eyck, *Annunciation*, c. 1434–1436.
Oil on wood transferred to canvas; 0.927 × 0.367
(36½ × 14⁷⁄₁₆ in.). Andrew W. Mellon Collection, National
Gallery of Art, Washington, D.C. (1937.1.39[39]).

3

The Mirror in Art

Charles Baudelaire invented the title, "The Mirror of Art," for his essays in art criticism, published posthumously in 1867. "I love mysterious titles," he wrote to his publisher, Poulet-Malassis.[1] It is an evocative title, appropriate to his own conviction that art criticism should be the reflection of the work of art in the mind of the critic. With a change of preposition, I have adopted Baudelaire's title and method. My subject matter is the mirror *in* art.

Art had long been viewed as a mirror, a reflection of life and morals, nature and history. Indeed, Émile Mâle, the esteemed French medievalist, when he wrote his great volumes on the art of the French cathedrals, described the sculptures of Chartres and the churches of the Ile de France as illustrative of the Mirror of Nature, the Mirror of Knowledge, the Mirror of Morals, and the Mirror of History.[2] In doing so he adopted the fourfold categories of Vincent of Beauvais, whose vast scheme encompassed all the activities, aspirations, and spirituality of the medieval world.

My scope is narrower, for my subject is the mirror as represented in art. Though mirrors existed in the medieval period and for thousands of years before, they do not appear in art in any significant way until the fifteenth century. Therefore, this study begins with Jan van Eyck's *The Marriage of Giovanni (?) Arnolfini and Giovanna Cenami(?)* (1434: The National Gallery, London) (fig. 27).

This extraordinary double portrait of Giovanni and Giovanna Arnolfini shows the couple standing in a cozy, comfortably furnished bedroom, suffused with soft light which envelopes the two still figures, and

"The Mirror in Art" was first presented to the Town and Country Club, Hartford Connecticut, in 1979.

51

28. *The Dog* detail from *The Marriage of Giovanni (?) Arnolfini and Giovanna Cenami(?).* Detail of fig. 27.

29. *The Mirror* detail from *The Marriage of Giovanni (?) Arnolfini and Giovanna Cenami(?).* Detail of fig. 27.

27. Jan van Eyck, *The Marriage of Giovanni (?) Arnolfini and Giovanna Cenami(?),* 1434. Oil on wood; 32-1/4 × 23-1/2 in. Courtesy The National Gallery, London. (No. 186).

the griffon terrier at their feet; the clogs in the left foreground, the fruit on the windowsill and the bench beneath; the bed with its plump pillow and mattress and its enclosing draperies, now gathered together and tied at one corner; the ornate brass candelabra with its single burning candle, the translucent tassled beads; and finally, the mirror hanging upon the wall at the back of the room, which has a simple statement in elaborate calligraphy written on the wall above: "Jan van Eyck was here."

The multiplicity of details that have been noted seem, as we study them, to suggest meanings transcending their mere presence. We get a mysterious sense of their quintessential character: the dogginess of the dog (fig. 28) the rigidity and woodenness of the clogs, the gleaming metalicness of the brass chandelier, the fragrance of the rotund fruit, the cozy invitation of the red, warm bed.

Each and every detail suggests meanings beyond their mere physicality.[3] We note the still solemnity of the two figures and the emphasis the artist has given to the space between them, which is the central axis of the painting. If we were to draw a line from the chain of the chandelier to the lower edge of the painting, it would pass through, not only the chandelier, the inscription, and the mirror, but also the two crossed hands and the face of the little terrior below.

What does it all mean? The clue lies in the two delicately joined hands and in Giovanni's right hand which gestures in solemn affirmation.[4] We, like the artist Jan van Eyck, are witnesses of the marriage vows of Giovanni and Giovanna Arnolfini. According to canon law, marriage vows were concluded by the joining of hands and, on the part of the groom, the raising of the forearm. The fact that the bridal couple stands before us alone in their bedroom is surprising to us, but is, in fact, a part of fifteenth-century practice. Before the Council of Trent, the sacrament of marriage was the only sacrament that was not dispensed by a priest, but was bestowed by the recipients themselves.

As Erwin Panofsky explained, Giovanni Arnolfini and his bride were married in Bruges far from his Italian home. Apparently, he commissioned Jan van Eyck to record this very private marriage "in the hallowed seclusion of their bridal chamber," making it both a "double portrait and a marriage certificate."[5]

With the knowledge that the sacrament of marriage is the true subject of the painting, the room and its contents can be seen in a new light. Each detail has a raison d'être that relates to the life of faith and the sacrament of marriage. The fruit on the windowsill recalls the state of innocence before Eve received the forbidden fruit after yielding to the innuendo and tauntings of the serpent. The wooden clogs, akimbo on the floor, and another daintier pair in the background, are symbolic references to the Lord's

admonition to Moses, telling him not to come near but to "put off your shoes from your feet, for the place on which you are standing is holy ground."[6] The dog, represented often on the tombs of ladies, was a familiar symbol of marital fidelity.

The fact that the event takes place in the nuptial chamber hallows every detail of this room. For us who live in a secular and desacralized world, it is hard to understand that this cozy red marraige bed, which visibly emphasizes warmth, passion and comfort, is hallowed by sacramental associations and symbolic significance. Panofsky noted that "the matrimonial bed was so sacred that a married couple in bed could be shown visited and blessed by the Holy Trinity."[7] The single candle burning in the chandelier is clearly not for light, since the scene takes place in full daylight: it is, instead, an emblem of the all-seeing Christ, who is symbolically present at an oath-taking scene, in particular here at the matrimony.

Now for the bridal pair, Giovanni and Giovanna, who stand before us, a bit diagonal to us, facing slightly inward toward each other. Giovanna's slender little hand rests, ever so lightly, in that of Giovanni. His pale, aquiline, long-nosed and rather expressionless face is turned toward us and his eyes, rather than seeking his charming companion, seem unfocused, as if lost in thought. As for Giovanna, she is dreamily preoccupied as well, but less solemnly so; we anticipate the stirring of a smile about the small mouth and a change of color on her round young cheeks. We cannot help but reflect upon the personalities of these two, while yet remembering Baudelaire's dictum, "a portrait is a model complicated by the artist."[8] Clearly, the couple are well-to-do, as their capacious, fur-edged garments and her fashionable crimped headdress attest.

We, as spectators, have another view of them seen from behind in the convex mirror (fig. 29) that hangs between them on the rear wall of the room. There we see, in reverse, and in miniature, the couple, the room, the windows, and the bed. But the mirror records not only these reflections, but two other persons who lie outside of our line of vision. They are Jan van Eyck, the painter himself, and a companion, presumably a second witness to the vows; both are about to enter the room.

The mirror, like the inscription, "Jan van Eyck was here," becomes a part of the document of the matrimony, but one which presents the entire scene in miniature, that is, in microcosm, and extends our own viewing to include two persons—the artist and a companion—who are not part of the picture-space proper but who, like ourselves, are at the threshold of the room.

Jan van Eyck, unlike the artists of earlier periods, possessed the extraordinary technical skill required for the painting of such consummate

verity of detail. He is credited with the invention of oil painting, a medium that dries so slowly that it possesses a flexibility that the media of the illuminated manuscript and tempera and fresco painting lack. He is said to have used a brush with but one hair to achieve the detailed illusion of reality. But it is not the technique for representing reality that is as important for the history of art and culture as is the way the artist sees reality.

If we look at a medieval manuscript painted about two hundred years before the Arnolfini wedding portrait, we are at once aware of an utterly different way of seeing the world. True, the subject matter is overtly religious, rather than symbolically so, as in the case of the van Eyck panel. We easily identify the subject, the *Last Supper* from the *Berthold Missal* (c. 1225: The Pierpont Morgan Library, New York) (fig. 30), the Christ with his cruciform halo, one hand on the head of the sleeping St. John, and the other giving the cup to Judas, who receives it with open mouth. Clearly, the apostles are gathered about a round table which we are intended to interpret as being in "the upper room," since we see the roof, moldings, and courses of a building along the sides of the oval area in which the event takes place.

Our recognition of the persons and the event depends upon a kind of shorthand reading of the data presented. The dishes with the fish and several crescents representing bread tell us that this is a supper, not a business meeting of the vestry or selectmen. Our familiarity with the New Testament identifies the dramatis personae. Though the unknown manuscript artist was also representing persons in a room, he was not interested in the kind of reality that absorbed Jan van Eyck. These are not portrait heads and no attempt is made to represent space in a coherent and convincing manner: we look down upon the table, yet each of the apostles is represented as if directly in front of us. Medieval seeing has this character of a separateness of individual parts, the integration of these being in an overall design, or an overall conception that welds the individual parts together into a compelling whole.

Jan van Eyck's integration of the whole painting comes from a seeing of reality in which the relationships of persons and setting accord more closely with our own visual experience. The couple is "realistically" rendered and related convincingly in size and in spatial setting to the objects about them. I belabor the point because it is only when the artist sees the world about him as Jan van Eyck did, rather than diagraming people, places and things, as the medieval miniaturist did, that the mirror becomes an important object and an image in art. Indeed, Jan van Eyck's Arnolfini portrait can be viewed as the first, and in many ways, the quintessential use of the mirror in art.

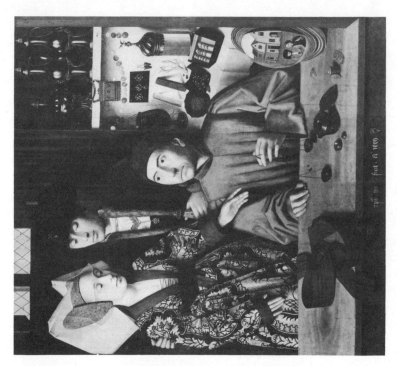

31. Petrus Christus, *St. Eligius*, 1449. Oil on wood; 39 × 33-7/16 in.

30. *Last Supper* from the *Bertbold Missal*, c. 1225. The Pierpont Morgan Library, New York. (MS 710, 39 v.).

Jan van Eyck's follower, Petrus Christus, painted a fascinating and somewhat enigmatic picture of a goldsmith in his ship, visited by a young couple who apparently are purchasing a ring, for the balance held by the goldsmith has a weight in one receptacle and a gold ring in the other. This painting entitled *St. Eligius* (1449: The Metropolitan Museum of Art, New York) (fig. 31) is signed and dated by the artist with the inscription, "Master Petrus Christus made me in the year 1449," followed by the heart-shaped monogram which is the artist's device. It is a curious inscription and if translated correctly, suggests that the painting, once completed by the artist, has a consciousness of its own.

The painting has been known by the title *St. Eligius*, a saint who was the bishop of Noyon and patron saint of goldsmiths. Legend reports that the bishop placed his episcopal ring on the finger of a pious nun, affiancing her to Christ, and that as St. Godeberta she was later canonized. The legend does not fit what we see here, and thus the Lehman Collection curators opine that the halo to St. Eligius may have been added later, the painting's true subject being a genre theme, simply a noble couple purchasing a ring. I am not inclined to agree that it is a genre painting. A genre painting represents what we now call a "slice of life," or an everyday episode in the life of everyday people. These are not portrait heads. Look again at Giovanni Arnolfini's long pale face and heavy-lidded small eyes, and Giovanna's pointed nose, round cheeks and slightly pursed mouth. They are individuals, but these three faces, though differing in proportions, have a somewhat mannikin-like blandness and lack the impress of psychic individuality. They could well be saints!

However, to study these three faces is to deny our eyes the pleasure of roaming about the goldsmith's shop, delighting in the exquisitely rendered two silver cruets on the upper shelf next to a gadrooned ciborium, and a string of beads hanging on nails below. On the lower shelf, a rock-crystal cup has a jeweled finial and on top, the "pelican in its piety," a symbol of Christ. Thirteen rings are in a display box and unmounted rubies and other stones are in a black folder; at our left is an open circular pouch with seed pearls and red coral; and slabs of porphyry and rock crystal lean against the wall, and we note their varying shadows as well as their substance, both so faithfully represented. On the counter before us are goldsmith's weights and three groups of coins identified as ducats for Philip the Good of Burgundy, "angels" struck by Henry VI of England and guilders minted in Mainz. The detailed description of the jewels and artifacts makes the little painting an exceedingly important document of the fifteenth-century goldsmith's art. It is the mirror which brings the painting within our purview.

Again it is a mirror that is convex in shape, thus possessing the power

of miniaturizing the reality that it reflects. Thus, though the face of the mirror is approximatley the size of the head of the goldsmith, we can see two persons reflected in it—a squire and his companion, the latter holding a falcon and apparently commenting in "an aside" to the squire. Behind them we see a city street and a row of four or more houses across the street. We begin to get our bearings and realize that we, like the squire and his falcon-bearing companion, are standing in front of an open shop on the street across from that row of houses. The steady realism of the scene is so consistently purveyed and the mirror so accurate and so gleaming, that one is almost surprised not to find one's own reflection visible in the mirror.

Petrus Christus has used his convex mirror as Jan van Eyck did also, to puncture the picture plane, that is, to represent things that are not in the picture-space, but are instead in *our* space. The result is an extension of reality in the Arnolfini and St. Eligius paintings. These two intimate yet solemn scenes reflect a world of more than five hundred years ago, yet somehow eerily incorporate us into their presence.

How differently the mirror operates in Giovanni Bellini's *Toilet of Venus* (1515: Kunsthistoriches Museum, Vienna) (fig. 32) which is painted almost seventy years after Petrus Christus's *St. Eligius*. The opulent young nude holds a hand mirror, and behind her on the wall another round mirror is visible, but its darkened surface, rather than extending our spatial awareness, reflects only the woman's jeweled headdress and hair. The artist did not want a reflected image of persons, places, and things to compete with the image of lovely feminine nudity. Though he shows her seated within a room with an open window behind her, giving us a view of a serene landscape, the room is barren of detail. The darkened wall becomes a mere backdrop, its function to silhouette the curving contours of arms, abdomen, and thigh. Venus is partially draped by a light, pink-apricot veil, which lies on the balustrade at the left and covers her upper arm, then crosses behind her back and falls in a fold across the pubic zone and upper thigh. Like the Aphrodites of the classical world, her veiling is not intended to conceal her nudity, but instead to set it off, by its rhythms, color, and texture, the glorious flesh it adorns.

The mirror is, of course, an attribute of Venus and is used here exclusively to reflect her beauty. In this particular painting we sense a dimension beyond the mythic in this image of ripe, young golden flesh. Philip Hendy speculates that the aging artist here memorializes a youthful second wife—that her "delicious dewy paganism" testifies to a "new joyful flowering of the senses" on the part of the old artist, who was experiencing "a wonderful second spring which comes to old men of vigour."9

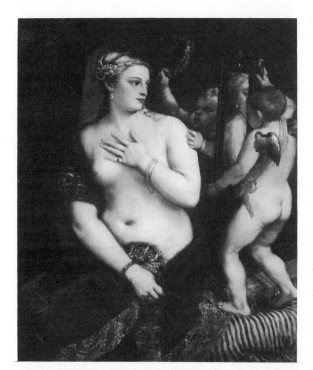

33. Titian, *Venus with a Mirror*, c. 1555. Oil on linen canvas; 1.245 × 1.055 (49 × 41-1/2 in.). Andrew W. Mellon Collection, National Gallery of Art, Washington, D.C. (1937.1.34 [34]).

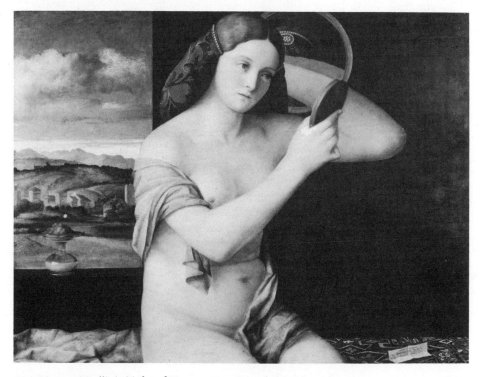

32. Giovanni Bellini, *Toilet of Venus*, 1515. Kunsthistoriches Museum, Vienna. (GG 97).

Titian, who had been a pupil of Giovanni Bellini, painted his own version of *Venus with a Mirror* (c. 1555: National Gallery of Art, Washington, D.C.) (fig. 33) about forty years after Bellini and when Titian himself was in his eighties. Age in no way diminished his appreciation of radiant and voluptuous flesh, for Titian has placed his *Venus* before us, surrounding her with dark, rich fabrics that set off her gleaming body. A chubby cupid holds a mirror toward which she glances. Another cupid is about to put a wreath upon her elegantly coiffed and jeweled head.

Titian was undoubtedly familiar with the classical so-called *Venus Pudica*, or modest Venus. The *Medici Venus* was an ancient copy of the statue and was the source of many later interpretations, including Antonio Canova's *Venus* (1803: Corcoran Gallery of Art, Washington, D.C.). The position of the hands and turn of the head of the two Venuses by Titian and Canova are similar. Both are related to the subject matter of the classical *Venus Pudica*, who, when intruded upon while bathing, is startled and endeavors to cover her breasts and pubic zone. Titian adopted the pose, but not the content of the *Venus Pudica:* a sublime and queenly self-assurance pervades this most beautiful goddess whose earthy sensuality knows no coy concealment.

The function of the mirror here, as in the Bellini, is as an attribute of the goddess. Titian has muted and darkened the reflection of Venus in the mirror so that it may in no way detract our attention from the vital, voluptuous, living, breathing Goddess of Love herself. However, if we study the serene and lovely features of the Venus and then return to the partial reflection of her, glimpsed in the mirror, we suddenly become aware of a disparity between the two. Deep shadows lie about the eye, the flesh seems less firm, and the contours have lost their resilient lines. Titian, who had painted many Venuses and many beautiful women, may here be suggesting that time puts its imprint upon all things.

Another painting by Titian, *Woman with a Mirror* (1512–1515: Alte Pinakothek, Munich) (fig. 34) quite clearly is intended to emphasize the transitory character of all pleasures of this world.[10] A charming young woman holds an oval mirror in a six-sided frame before us. Her ample garments fall away, revealing one rounded shoulder, and she looks intently and questioningly at us. In this case, the mirror communicates the message inasmuch as it reflects an old woman exiting the room, and shows an array of rings, necklaces, jewels, and a money bag in the foreground. These are the "treasures on earth, where moth and rust consume" which we are enjoined by Jesus in the Sermon on the Mount, not to "lay up" for ourselves.[11] This type of painting in which worldly pleasures are symbolized and shown to be transitory is called *Vanitas* and is a frequent subject in a sixteenth-century art. The message of *Vanitas* is

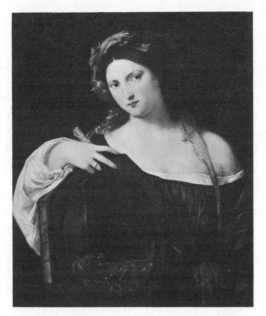

34. Titian, *Woman with a Mirror*, 1512–1515. Oil
on wood; 97.5 × 81 cm. Alte Pinakothek, Munich.
(483).

35. Georges du Mesnil de La Tour, *The Repentant
Magdalen*, c. 1640. Oil on canvas; 1.130 × 0.927
(44-1/2 × 36-1/2 in.). Alisa Mellon Bruce Fund,
National Gallery of Art, Washington, D.C.
(1974.52.1 [2672]).

"you can't take it with you," and by implication, "mend your ways and prepare for death."

The meaning of the *Vanitas* paintings of the sixteenth century merges with that of *Memento Mori* paintings of the seventeenth century. Georges du Mesnil de La Tour's *The Repentant Magdalen* (c. 1640: National Gallery of Art, Washington, D.C.) (fig. 35) is a masterpiece of this category. In studying the painting, we must first accustom ourselves to the darkness of the room we are in. It is lit only by a single candle, hidden from our eyes. The yellow light illumines the profile of a woman who sits, her chin resting in one hand, her eyes fixed before her, on the image in the mirror. On the table, a large book supports a skull also seen in profile, and the woman's left hand, with fingers extended, lightly touches the skull. How beautifully this hand is painted, the warm light of the candle giving a slight glow to the inner contours of the fingers! Also exquisite are the modulations of light and dark on the sleeve of the Magdalene and about her eye and nostrils.

The true focus of the painting is the dialogue between life and death— between the face of the Magdalen and the skull reflected in the mirror— her wide-open eyes and dilated nostrils contrast strikingly with the empty eye socket of the skull, her firm cheeks with the gaping cavity of the skull, her half-open mouth with the upper jawbone and remaining teeth of the skull. In a curious and somewhat "surrealist" reversal, the most alive part of the painting seems to be the skull, whose gleaming bony protuberances and cavities seem to communicate a grotesque grin.

It is a beautiful painting. Consider how much the artist has allowed to sink into darkness in order to achieve the quiet drama of this painting. If you half-close your eyes, thus muting the recognizability of the various objects, you will see that less than a quarter of the painting is seeable; the rest sinks into gloomy darkness. Recalling the earlier paintings by Jan van Eyck and Petrus Christus, with their crowded interiors filled with a variety of fascinating details, we might speculate about how they would paint a *Repentent Magdalen*. It is certain that it would be in full daylight and that a multiplicity of carefully described objects would be included. In contrast, Georges du Mesnil de La Tour allowed darkness and shadows to encompass all but the few details that speak his meditation on life and death, faith and repentance.

About two decades later, the great Spanish artist, Diego Velázquez, painted his beautiful *The Toilet of Venus* ("The Rokeby Venus") (1657–1658: The National Gallery, London) (fig. 36) with a Cupid who holds the mirror before the recumbent nude. Venus lies gracefully, easefully, before us, the curves of her thigh, buttocks, and back emphasized in their warm fleshiness by the cool and dark green silk mantle beneath her. Her

37. Jean-Auguste-Dominique Ingres,
Comtesse d'Haussonville, 1845.
Copyright The Frick Collection, New
York. (27.1.81).

38. Pablo Picasso, *Girl before a Mirror,*
1932, March 14. Oil on canvas;
64 × 51-1/4″. Collection, The Museum of
Modern Art, New York. Gift of Mrs.
Simon Guggenheim.

36. Diego Velázquez, *The Toilet of Venus* ("The Rokeby Venus"), 1657–1658.
Oil on canvas; 48-1/4 × 69-3/4 in. Courtesy The National Gallery, London.
(No. 2057).

proportions, with her square shoulders, narrow waist, and slender an-
kles, are appealingly "modern" in contrast to Titian's opulent goddesses.
Here Velázquez used the mirror, not to extend our knowledge of what is
going on outside the picture area, as Jan van Eyck and Petrus Christus
did, but rather like Titian and Georges du Mesnil de La Tour, he gave us
additional information about what is in the picture area; here, the shad-
owy smiling face of the Venus reflects contentment with herself and her
sensuous world of green silk and red velvet, as she awaits her lover.

From the nineteenth century is Jean-Auguste-Dominique Ingres's cool
portrait of *Comtesse d'Haussonville* (1845: The Frick Collection, New
York) (fig. 37). Our first impression is of the extraordinary virtuosity of
the painter, who succeeded in bringing this woman and her environment
before us with such breathtaking realism. As with the Arnolfini portrait,
here, too, the tactility of silk, flesh, wood, porcelain, and metal invite our
fingertips to touch their varying textures. Though the Comtesse stands so
quietly before us in a corner of an elegant, still room, and there is no
source for an errant breeze or movement of air, her dress suggests the
whisper of silk. The interesting color harmonies of cool tones in much of
this painting—the blue-gray of her gown, the green tending toward olive
of the wall, and the dark gray-blue-green of the mirror, the dark mantel
against which she leans—give a flashing brilliance to the red velvet bows
in her hair, and to her mustard-colored cashmere shawl, lying on the
chair, an acrid brightness of tone.

She is clearly a woman of wealth and position, and she coolly returns
our gaze, revealing very little of her own inner life. Hers is an enigmatic
face. She awaits our comment or query, without curiosity, attentive to us,
but somehow remote. Her round arm and boneless hand are relaxed, as
one finger touches the rounded chin in a gesture that usually connotes
thoughtfulness.

The Comtesse must have had unusually symmetrical features, and the
artist has exaggerated the symmetry rather than seizing upon the irreg-
ularities, which are unique to this individual. Her reflection in the mirror
behind gives us more external evidence—the intricate and elegant coif-
fure, adorned by cascading velvet bows, are certainly the handiwork of a
skillful servant and beautician, and not that of the leisured lady before us.

We do indeed know a good deal more about the Comtesse than she
betrays of herself in this portrait: her family was active politically and
intellectually, her father being a trusted official of Louis Phillipe and her
mother the daughter of the renowned Madame de Staël. She was twenty-
seven when the portrait was completed, and according to a letter of the
artist, the portrait met with immediate success. The Comtesse was an

author in her own right, publishing among other things, a biography of Lord Byron. She is supposed to have had some talent for drawing and to have been active in amateur theatricals. She was, thus, more the intellectual and "activist" than the artist had suggested.

It is not only the Comtesse and the architectural setting of her salon which suggest wealth and social position, but the still life on the chest behind her: the jardinieres, the bouquet and the Sevres vase, the black opera glasses and calling cards, one with its corner pressed back; all bespeak wealth, leisure, good taste and high society. These are the attributes of gentility and are as surely symbolic of pride of rank and place as the Arnolfini chamber was of the sacrament of marriage. The artifacts surrounding the Comtesse connote entirely secular meanings, and by contrast the van Eyck artifacts have, even for those who may not know their symbolic meanings, a sense of spirituality.

Studying a detail of the Arnolfini portrait we notice the central role of the mirror (fig. 29) that miniaturizes the entire scene and the two witnesses, as over against the merely reflective role of the mirror in the portrait of the Comtesse. In the cusped frame of van Eyck's mirror there are ten tiny round paintings set into the frame, all of the life and Passion of Jesus Christ. These paintings, like the single burning candle symbolizing the all-seeing, all-present Christ, evoke the Eternal at this solemn ceremony and again affirm a spirituality imaged in all things within this painting.

Five hundred years separate the Arnolfini portrait from the Ingres portrait, and less than a hundred years separate Pablo Picasso's *Girl before a Mirror* (1932: The Museum of Modern Art, New York) (fig. 38) from Ingres's *Comtesse.* Yet the difference in style and content between the Picasso and the Ingres is more jolting than in any previous comparison. The modernist revolution that began in the first decade of our century, with the cubist paintings of Picasso and Georges Braque, changed the artist's seeing and therefore our own perceptions of the world about us. Picasso was not interested in representing a room and a corner of reality. We see only the two principal images, a young girl at the left, who stands before a large mirror with her image reflected in it. Behind both is a wall, covered with a brilliant and diversely colored diamond pattern. But the compelling images are the girl and her reflection.

She wears a striped bathing suit, and her own awareness of her sexuality is shown in the emphasis on her rounded breasts and bulging abdomen, which encloses the circular womb. She has a classically beautiful young face, seen in profile, but also in full face, since the adjacent yellow oval has another eye and continues the line of her mouth. "By contrast the face in

the mirror seems older, with its unfathomable stare, parted lips, and hawklike nose: it is at once more anxious, aggressive and inscrutable."[12] Note the gesture of the young girl who reaches toward the mirror, perhaps in fear and in anticipation, embracing her enigmatic reflected image.

The painting was done in 1932 and records in the profile the features of the youthful Marie-Thérèse Walter, with whom Picasso had recently begun a liaison. Also of importance was the climate of the times during the post-World War I period when Sigmund Freud's understanding of the structure of human consciousness and Carl Jung's theories about individuation and the so-called "shadow" side of our nature were much in the air.

Nonetheless in this painting, Picasso has given us a modern recreation of a traditional type which we saw in Titian's paintings: a woman gazing into her mirror sees the transitory character of her own beauty. The kind of looking glass that Picasso has represented is called in French, *psyche,* from the Greek word for the soul. It thus relates to a popular belief that a mirror has magic properties and can reflect the inner self, rather than the outward likeness, of the person who peers into it.

The magical properties of the mirror in art have been the subject of this essay. We have witnessed its mirroring of a hallowed environment in Jan van Eyck's Arnolfini Wedding Portrait, its extension of reality in Petrus Christus's *St. Eligius,* its mirroring of fleshy loveliness in the art of Titian, Bellini, and Velázquez, its operation as moral admonishment in Georges du Mesnil de La Tour's *Penitent Magdalen,* its function in delineating position and privilege in Ingres's portrait of the Comtesse, and finally, its recording of the disturbing psychological split of Picasso's *Girl before a Mirror.* The mirror *in* art thus functions as a somewhat more compressed, allusive, and intensified image within the wider category of the mirror *of* art.

<div align="right">1979</div>

4

Images of Women
in American Art

We begin the study of women in American art with a remarkable portrait of *Ann Pollard* (1721: Massachussetts Historical Society, Boston) (fig. 39). She looks out toward us with an unflinching, yet unfocused, gaze, as if she were physically assertively present to us, but psychically absent. She is dressed in a cap that encases her head and a gown with a sharply pointed collar which forms a V-shape that is repeated again and again—in the sharp nose, the deep hollows about the nose and mouth, in the folds of her garment, and in the fingers of her hand, which holds the book. These triangular shapes and the many diagonal and straight lines give a lively geometry to the painting and dramatize the circular forms which are, by contrast, so few—the helmet-like curves of her cap, and those two round, dark, remote eyes which do not meet ours.

We see only the upper half of her body; we view this through an oval aperture. At the lower left of the picture-plane (the location in space which is that of the picture itself, with all that is represented depicted as behind that plane) we find the inscription giving the name and age of the sitter. Ann Pollard was one-hundred years of age when an unknown limner painted her in 1721. James Thomas Flexner, one of the first historians to study early American paintings, wrote that she was a former tavern keeper, who, because of her great age and her claim to being the last survivor of the original settlers of Boston, was regarded as a curiosity and a symbol by her fellow townspeople. She had 130 descendants in the Boston of her day and is supposed to have recounted "in the squeaking

"Images of Women in American Art" was first presented to the Saturday Morning Club, Hartford, Connecticut, in 1982.

voice of extreme age" how she, as a romping girl of ten, had leapt from the boat which brought an exploring party to Boston Neck, from which Theodore Winthrop led them on to the territory now known as Boston.[1]

This ancient early Bostonian is presented to us by the unknown artist with a forthrightness that must have matched the sitter's own. Everything is eliminated but the face and upper figure. There is no suggestion of a landscape background or domestic setting, and none of the red velvet draperies that were a conventional accompaniment to portraits of those of wealth and position. There are no "attributes," such as those found in later portraits, that is, musical instruments, pets, fine furniture, and fine fabrics. We see only the austere, dour face enframed by stiff fabrics. It is a visage of great dignity that seems to await the beckoning nod of Death, rather than acknowledging the ephemeral encounter with us, the transitory viewers.

Mrs. James Bowdoin, II (1748: Bowdoin College Museum of Art, Brunswick, Maine) (fig. 40), a portrait painted only twenty-seven years later, presents quite another picture. An opulently dressed and blooming young woman of seventeen, she is seen seated in a satin gown, surrounded by trees and a distant landscape. We know that she was the daughter of a wealthy Boston merchant, that this is probably a wedding portrait, and that it was done by the popular artist Robert Feke. It is probable that the artist based the posture of the figure, its drapery, and the pastoral setting upon a mezzotint after an English portrait, as was the custom among the painters of Feke's time. Nonetheless, his choice of prototype must have been consistent with Elizabeth Bowdoin's abundance of form, for her husband wrote a poem extolling her charms which includes the lines:

> *Her tempting breasts in whiteness far outgo*
> *The op'ning lilly, and the new faln snow:*
> *Her tempting breasts the eyes of all command,*
> *And gently rising court the am'rous hand.*[2]

The full round face and the round forms of the breasts that press against the gleaming satin are but the most obvious use of the circular, a spherical form which is the basis for the composition of this painting, as the triangle was the basis for Ann Pollard's portrait. Elizabeth Bowdoin's "jetty locks," to quote her husband's poem, fall in circular ringlets. The roses at her breast and in the basket on her lap reiterate the circular movement. The great billowing lines of her skirt arch in half-circles; the billowing clouds in the background echo the shape. Symbolically the circle is an emblem of completeness and harmony. It communicates a sense of gentle

39. LEFT: Pollard Limner, *Ann Pollard*, 1721. Massachusetts Historical Society, Boston.

40. RIGHT: Robert Feke, *Mrs. James Bowdoin, II*, 1748. Oil on canvas; 50-1/8 × 40-1/8 in. Bowdoin College Museum of Art, Brunswick, Maine. (1826.7).

41. LEFT: John Singleton Copley, *Mrs. John Winthrop*, 1773. Oil on canvas; 35-1/2 × 28-3/4 in. Morris K. Jessup Fund, New York. (31.109).

42. RIGHT: Rufus Hathaway, *Molly Whales Leonard*, 1790. Oil on canvas; 34-1/4 × 32 in. Gift of Edgar William and Bernice Chrylser Garbisch, New York. (63.201.1).

rotation and of undulating movement, all pleasurable sensations for us, the viewers.

What does the portrait tell us of Elizabeth Bowdoin, the seventeen-year-old bride of a Harvard graduate who was an important leader in pre-Revolutionary Boston? Certainly, she is a young woman of breeding and of wealth, accustomed to fine clothes and good manners. The full oval face with the hint of a double chin, and a strong nose, does not suggest a shy or reticent personality. The eyes look at us somewhat appraisingly. Is there the merest suggestion of a smile about the eyes? If so, the repose of the mouth seems to deny it. She neither courts our attention nor retreats from our gaze.

Robert Feke, the painter of Elizabeth Bowdoin, was born around 1705, probably in Oyster Bay, Long Island. He was of the first generation of painters born in the colonies, and, though many of the details of his life remain open to conjecture, it is certain that he painted in Newport, Philadelphia, and Boston.[3] The portrait of Elizabeth was done in his late thirties, when he had gained considerable skill at his craft.

By contrast, the portrait of *Sarah Ursula Rose* (c. 1756: The Metropolitan Museum of Art, New York) by Benjamin West seems less technically proficient. Sarah looks sidelong at us, her long, oval face turned slightly to the left. It is hard to read her expression, and, as we question her eyes and lips, we suspect that the lack of any sense of personality may be less Sarah's fault than that of the artist's. Benjamin West was about eighteen when he did this portrait. Not only had he had little training at that time, worse still, he had seen very few works of art of any merit. He had used much the same formula that Feke used, the figure set against trees and a bit of sky, the position approximately the same, though the right arm rests upon a chest, rather than raised to be breast. As we study this portrait, we become aware of the stiffness of the figure and note that we have no sense of a living, breathing body beneath Sarah's garments. For example, the way that the head joins the neck, and the neck merges with the shoulders is not anatomically correct. Similarly, the hand and arm seem not only boneless, but also not organically related to the rest of the figure. These details are noted to contrast this portrait with another done by West only eight years later.

By the time he painted *Mary Hopkinson* (1764: National Museum of American Art, Smithsonian Institute, Washington, D.C.), Benjamin West had studied classical sculpture and the great paintings of the Renaissance in Rome and northern Italy.[4] Something of his remarkable ability to absorb knowledge and learn technical skills can be seen in the contrast between the colonial portrait of Sarah and the later portrait of Mary. West,

who was then residing in England, was twenty-six years of age when he painted Mary Hopkinson's portrait. She sits easily before us, elegantly attired, bedecked with pearls, and holding a mandolin. She does not look at us and, instead, seems lost in pleasant thought—perhaps recalling a melody she has just played, or the one she anticipates the pleasure of playing.

West has set Mary against a dark hanging with only a bit of sky visible at the upper right. The effect of the painting is that of an intimate interior with soft lighting from our left, which illumines her white flesh, her hand on the keyboard, her shoulder, and the folds of her heavy silk gown. There is a sense of ease and believability about her body, which, though not given in detail, still makes her physically present to us. Psychically, Mary betrays less than we would like: she certainly inhabits a world where leisure, wealth, and music reign. Her clearly delineated oval face has arching brows, dark eyes, a long nose, and lips curved in a slight smile. Yet, what kind of woman is she? She is delineated for us, but little is revealed of her personality or passions.

The painters, Benjamin West and John Singleton Copley, born in 1738, were almost exact contemporaries. Both artists left the Colonies, studied in Italy, and then went to England where they became permanent residents and were recognized members of the English artistic community. Both became members of the Royal Academy of the Fine Arts, and West was made president of this august body and remained so for twenty years.

Copley painted *Mrs. John Winthrop*, née Hannah Fayerweather (1773: The Metropolitan Museum of Art, New York) (fig. 41) when she was forty-six years of age. John Winthrop was a great-great-grandson of the first governor of Massachusetts, was Hollis Professor of Mathematics and Natural Philosophy at Harvard University, and America's first prominent astronomer. Hannah Winthrop shared her husband's intellectual interest and in her later years spoke of "being lonely for Cambridge and the delights of intellectual companionship."[5]

Here we have an accomplished portrait of a mature woman who meets us confidently, and who is as interested in sizing us up as we are in discerning her person and personality. Age and experience have inscribed lines about her mouth and between her brows. With unflinching fidelity, Copley has delineated the contours of the cheeks and chin, which show the undulations caused by the aging of the flesh. Mrs. Winthrop's double chin is discretely highlighted, and, below, her pearls gleam; laces and a lovely, striped bow bedeck her matronly ample bosom. A beribboned cap outlines the full ovoid shape of her head: this full oval, which flattens out at our right, is the basic shape reiterated throughout the painting, giving a

pervasive rhythm and unity to the whole; the contour is seen in her hairline, and in reverse in the edge of the cap above; in her lacy sleeve and in reverse in the edge of the table. The placement of Mrs. Winthrop's head in the upper right quadrant of the canvas makes for a more interesting composition than our previous portraits. Not only is the subject mature, the artist is older and more skilled.

Copley consciously composed the painting, giving it a sense of completeness that derives from the superb balancing of the image and the background. Allow your eye to follow the outline of Mrs. Winthrop, her chair and table, as it is silhouetted against the plain dark background. How satisfying is the way her figure is at once set off from the background and locked into it by a sensitive balance of solid forms against a void.

The limner Rufus Hathaway's portrait of *Molly Whales Leonard* (1790: The Metropolitan Museum Art, New York) (fig. 42) makes an interesting contrast with Copley's Mrs. Winthrop. Molly Leonard is also seated and dressed in her best attire. Her position, the turn of her head, and her placement with regard to the background, are similar to Mrs. Winthrop's. Yet, we are immediately impressed by the differences between the two portraits rather than the similarities. Molly's dark, close-set eyes, sharp nose, and set mouth reveal little of her personality, and suggest no communication with us. To concentrate on her facial features is an effort, for it is the details surrounding Molly Leonard that clamor for our attention. Our eyes are drawn from one detail to another, inquisitively, restlessly, wonderingly. About her are her pets: a black cat, a tame bird on the chair back, and a parrot in a hoop. Making full use of all the background space, the artist has even added two butterflies in the upper left corner. Molly's outspread fan is decorated with flowers and blossoms adorn her fichu: atop her headdress two great curving ostrich plumes add a somewhat bizarre touch to her costume. Who is Molly Leonard? A novelist might construct a personality and a plot on the basis of the evidence, but, on studying Molly's face, one is struck by how little it suggests her character and inner life.

Looking again at Copley's Mrs. Winthrop, we note that the details, such as the fruit she holds, and the lace and furbelows of her elegant gowns, are rendered with a marvelous fidelity of texture and form, yet they are only a setting and do not unduly attract our attention from that wonderfully alive and attentive face that challenges us with its amiable sociability. Molly's face, on the other hand, remains enigmatic while her pets, her gown, and her ostrich feathers merrily assert their importance.

The contrasts between these two portraits are contrasts between what is

awkwardly called "fine" art, and, equally awkwardly, "naïve" art. Copley was, of course, a professional artist, having studied as best he could in this country, the discipline taught in the European academies: anatomy, perspective, draftmanship, color. Rufus Hathaway was a self-taught itinerant painter who practiced medicine in Duxbury for twenty-seven years and who, in the 1790s, did a series of remarkable portraits of his friends and family, to which belongs this portrait of Molly.[6]

By comparing the hands of the Copley and the Hathaway portraits, we see a typical difference between the professional artists's rendering of the hand as a bony and muscular structure capable of movement and the naïve artist's rendering of the hand with a minimal and anatomically incorrect outline. Copley has rendered light and shadow so that we feel the three-dimensional roundness of Mrs. Winthrop's face and body, and we assume a single source of light from the upper left that lends a unity to the whole image. Hathaway, on the other hand, did not think in terms of a light source, and there are very few shadows. Both Molly's face and body have only a minimal suggestion of volume. We sense them as silhouettes rather than as three-dimensional forms in space.

Both portraits are memorable, but in wholly different ways. If we press further to an evaluation of these two kinds of art, it should be noted that the great portraits, which are not only aesthetically satisfying but which are also penetrating in their representation, make the sitter a bearer of our common humanity—such portraits are "fine" art and are painted by professional artists. One thinks at once of Titian, Rembrandt, Velázquez, and Goya. The charm of "naïve" art is evident in Hathaway's portrait of Molly and her pets. We sense little of her inner life, but what a good time we have enjoying her pets, her finery, and her dignified, if enigmatic, presence.

Moving from eighteenth-century portraits to the nineteenth-century depictions of American women by Washington Allston, we encounter his painting of a woman seated on a "flowery bank" in the presence of a tranquil lake behind which are mountainous slopes: this is clearly not a portrait. Even if we were to isolate the head of the *Spanish Girl in Reverie* (1831: The Metropolitan Museum of Art, New York) (fig. 43) it would be evident that the artist was not portraying one particular individual: her features are generalized and idealized, lacking the idiosyncrasies and irregularities of a single human face. Rather than mirroring the features of a young New England woman, Allston has represented a young heroine of a poetic episode of his own composing.

Allston, an accomplished painter, also wrote poetry for his own pleasure, and one of the poems called "The Spanish Maid,"[7] gives a libretto

for this painting. It tells of the maiden whose lover had plighted his troth to her on a flowery bank, then left for the wars, and now returns to find her at the very place he had left her. His vision of her is ours as well.

> *And now he nears the mountain-hollow;*
> *The flowery bank and little lake*
> *Now on his startled vision break,—*
> *And Inez is there . . .*[8]

Washington Allston was the first American "romantic" painter. He was interested in subject matter drawn from literature and myth and from his own imagination, rather than from the persons, places, and things of New England and of his home in Cambridgeport, Massachusetts. Though the poem provides a story for the painting, the painting communicates a meaning, what Erwin Panofsky called "intrinsic meaning."[9] That is, what is betrayed, rather than proclaimed—what is so a part of the visual data that we sense or feel it, rather than having it communicated through the intellect. The intrinsic meaning of this painting has to do with young womanhood—the beauty, vulnerability, and dreaminess of one who trembles yearningly at the very edge of what we now call "real life." This dreaminess, or reverie, is the true subject, of a number of nineteenth-century paintings of women.

The Muse—Susan Walker Morse (1835–1837: The Metropolitan Museum of Art, New York) (fig. 44) is both a portrait and a romantic evocation of young womanhood. Painted by Samuel F. B. Morse of his sixteen-year-old daughter, the picture captures the sense of the evanescent innocence of maidenhood. Morse was a student of both Allston and West, and had won some honors in England. However upon returning to this country, he discovered that he could not survive financially as an artist. Embittered by many disappointments, he turned to his experiments with electricity and to his invention of the telegraph. The portrait of Susan was done while Morse was working on the telegraph and was in an impoverished state. The grand architectural setting, the opulent cushions and couch, as well as the elegant silk gown worn by Susan, are all thought to be imaginary creations of Morse who was desperately poor at the time. It is known that the portrait was in fact painted in his cluttered rooms at New York University in Washington Square.

It is a large painting, and one of Morse's last, as he soon devoted himself wholly to his invention. It is also perhaps his finest painting. It is "essentially a summing up of all that a young maiden of 1835 should be— unworldly and good, fashionably pale, a perfect expression of sheltered female virtue."[10] This description is reminiscent of the title of a contem-

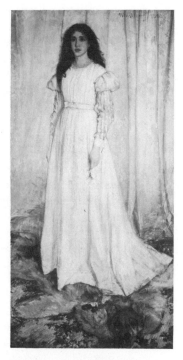

43. LEFT: Washington Allston, *Spanish Girl in Reverie*, 1831. Oil on canvas; 30 × 25 in. All rights reserved, The Metropolitan Museum of Art, Gift of Lyman C. Bloomingdale, New York. (01.7.2)

45. ABOVE: James McNeill Whistler, *The White Girl (Symphony in White #1)*, 1862. Oil on canvas; 2.147 × 1.080 (84-1/2 × 42-1/2 in.). Harris Whittemore Collection, National Gallery of Art, Washington, D.C. (1943.6.2 [750]).

44. LEFT: S. F. B. Morse, *The Muse—Susan Walker Morse*, 1835–1837. Oil on canvas; 30 × 25-1/8 in. All rights reserved, The Metropolitan Museum of Art, Bequest of Herbert L. Pratt, New York. (45.62.1).

porary publication on literature written for women called *Chaste, Silent, and Obedient*. Though the book is a publication written for women in sixteenth- and seventeenth-century England, these ideals were propounded in the eighteenth and nineteenth centuries in the Colonies and new nation as well. There is, however, an additional dimension to Morse's portrait of Susan: even if we did not know the name of the sitter, we would know, simply on the evidence of our eyes, that she was beloved by the artist. By some mysterious alchemy, the artist betrays his own affections. The image of Susan has an indefinable and touching appeal achieved in a way that quite escapes description but which certainly derives from the artist-father's love for this charming, young innocent.

A wholly different mood is evoked by James Abbott McNeill Whistler's *The White Girl (Symphony in White #1)* (1862: National Gallery of Art, Washington, D.C.) (fig. 45). Whistler's favorite model, Jo Hiffernan, stands before us upon a bear rug in a carpeted area with walls draped with patterned white damask.[11] It is an arresting picture. The white-on-white of Jo Hiffernan's dress and background bring a special emphasis to her auburn hair, large, dark eyes, and full red lips. She looks toward us, but her intense gaze is focused inwardly.

Her posture suggests incipient movement, but it seems a trancelike movement, for her thoughts seem to be elsewhere. There is an odd disjunction between the white gown and long flowing hair, which are the attributes of a maiden, and the worldly face and voluptuous mouth. Indeed, the painting caused a scandal when it was first exhibited in Paris. One French critic "explained the work as the uneasy reverie of a woman on the morning after her bridal night."[12]

The contrast between Morse's *Susan* and Whistler's *White Girl* is that between innocence and worldliness. This contrast is the constant theme of the novels of Henry James, such as *The Wings of the Dove*. Morse's portrait could be used to evoke James's American heroines whose fate is determined by their innocence as they encounter the sophisticated worldliness of European women such as Jo Hiffernan, whom Whistler so memorably portrayed.

The word "reverie" is one which is used in nineteenth-century literature and art in regard to young women. Women in thoughtful or dreaming inaction are encountered throughout Henry James's novels, and in paintings such as John Singer Sargent's *Repose* (1911: National Gallery of Art, Washington, D.C.) (fig. 46). Not only does the relaxed position of the dark-haired girl reclining on the couch suggest repose, but also the reiterated, restful horizontals of the picture frame, the tabletop, the couch, reinforce the feeling. Also, the muted colors of silver-gray and beige have an aura of quietude. Sargent's brilliant brushwork is evident in

the brio with which he delineated textures and patterns in the fabrics of the sitter's gown and shawl. The young woman was Sargent's niece, Rose Marie Ormond, whom he painted many times. While we would never recognize her were we to meet her at a ball, we are fully aware that this is not a protrait of a particular young woman, but is instead an evocation of languid and luxuriant femininity.

The subject of the *Portrait of Miss Amelia Van Buren* (c. 1889–1891: The Phillips Collection, Washington, D.C.) (fig. 47), whose facial features are so faithfully delineated that we would recognize her were we to meet her, was painted by Thomas Eakins. Though she rests her head on her hand in a position of repose, all else belies such an interpretation—the expression of Miss Van Buren's face, first of all. It seems a sad and somewhat troubled countenance. The corners of the mouth are drawn in, and a slight frown creases the area between the brows. Miss Van Buren looks to our left toward the source of light, but her gaze remains unfocused and inward.

Eakins has delineated her features with astonishing fidelity, but more important, perhaps, is his ability to catch the depths of Amelia Van Buren in a private moment when she reveals her troubled humanity. Eakins's greatest portraits, like those of Rembrandt, have the mysterious ability to carry us beyond the particularities of one individual into the realm of the profoundly human.

Some nine years later, Eakins painted a remarkable portrait of Mary Adeline Williams, titled with her nickname, *Portrait of Addie* (c. 1900: The Philadelphia Museum of Art, Philadelphia) (fig. 48). Addie was an old friend of the Eakinses who had moved to Chicago, but had been asked, after Eakins's father's death, to return to Philadelphia and live within the Eakins household. Another portrait of *Addie* (c. 1899: The Art Institute of Chicago, Chicago) by Eakins exists, painted only a year earlier, and yet the difference between the two portraits is striking. In the Chicago portrait, she appears prim, composed, and severe, whereas the Philadelphia portrait of a year later shows a woman of tenderness and passion who knows full well the tragic dimensions of life. The marvelous eyes seem at the point of tears and the full mouth is tremulous. It is a face that has known deep joy, but which recalls to us Virgil's phrase, "In all things, tears."[13]

Eakins's biographer speculates that Addie, who had known great loneliness, found affection in the Eakins household. He also reports that one of the relatives said that "Uncle Tom made love to Addie Williams."[14] Whether or not the relationship was consummated, certainly the portrait documents Eakins's love for this woman. Like Rembrandt's portrait of his common law wife, the aging Hendrijke, the very brushstrokes proclaim a

47. LEFT: Thomas Eakins, *Portrait of Miss Amelia Van Buren*, c. 1889–1891. Oil on canvas; 114 × 81 cm. The Phillips Collection, Washington, D.C.

48. RIGHT: Thomas Eakins, *Portrait of Addie*, c. 1900. Oil on canvas; 24-1/8 × 18-1/4 in. The Philadelphia Museum of Art, Given by Mrs. Thomas Eakins and Miss Mary Adeline Williams. (29.184.10).

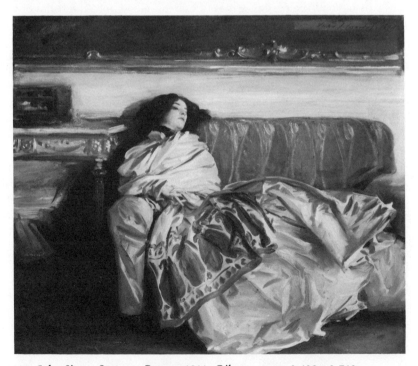

46. John Singer Sargent, *Repose,* 1911. Oil on canvas; 0.638 × 0.762 (25-1/2 × 30 in.). Gift of Curt H. Reisinger, National Gallery of Art, Washington, D.C. (1961.9.69 [1621]).

love of this particular human being and of her flesh that incarnates her precious human spirit.

Quite different is John Singer Sargent's handsome painting of *Mrs. Henry White* (1883: Corcoran Gallery of Art, Washington, D.C.). Sargent was a brilliant and successful portraitist whose subjects made up a kind of "Who's Who" of the Americans of wealth and privilege and position in the 1880s, 1890s, and the pre–World War I period. He painted a full-length portrait of twenty-six-year-old Mrs. White in Paris, just prior to her husband's appointment as Second Secretary of the Legation of the United States in England. The portrait went with the Whites to London, where it hung in the dining room of their mansion in Grosvenor Crescent, near the United States Embassy.[15]

Rather than focusing upon the face and eliminating all suggestion of setting, as was the case with Eakins's *Addie*, Sargent has placed Mrs. White in an opulent interior—very evidently a high-ceilinged room with elegant floor-to-ceiling draperies and a rococo chaise lounge. Margaret Rutherford White stands before us poised and unsmiling. Her wellbred countenance seems to question us, and, implicitly, to warn against familiarity or garrulousness.

She is very tall. In contrast to what is considered the classical norm, that is, seven and one-half heads equaling the height, Mrs. White is more nearly ten heads tall. Sargent has further emphasized her height by her almost frontal face, with hair piled high, and by the reiterated perpendicular lines of her gown and the draperies behind. The brilliance of Sargent's brushwork is evident in the play of light on the variety of silken textures.

All of these characteristics contribute to a sense, not so much of an individual, as of a type; Mrs. Henry White epitomizes the elegance, wealth, and savoir faire of the American elite of the end of the century. It is the society portrayed so skillfully by Henry James in his novels. Parenthetically, it should be added that Sargent and James both lived in London and were friends at this period, which, for both of them, were immensely creative years. Though both the writer and the artist were a part of London society and the artistic and literary circles of the city, both regarded themselves as Americans whose creative energies flowed from their native land, though they flowered in England.

The only painting by a woman artist selected for consideration in this study of the image of women in American portraiture is Mary Cassatt's *Woman Reading* (1880: Norton Simon Collection, Los Angeles). It is a charming painting, breathing light, air, privacy, and serenity. We look down upon this white-clad young woman, perhaps Lydia Cassatt, the artist's older sister, who is cozily seated in an armchair before a glass door

open to a balcony. We are less aware of the features of the woman's face than we are of the mood of the whole—a sense of comfort and ease, and a radiance of light within this domestic interior.

Is there any evidence in this painting, that it is the work of a woman rather than a man? Is there a feminine perspective here that would not be found in the portraits of John Singer Sargent or those of Thomas Eakins? Neither Sargent nor Eakins depicted the entire settings for their portraits of women with a sense of pervasive domesticity, of intimacy and serenity, as did Mary Cassatt. These qualities might be those claimed by a woman artist. However, Claude Monet's portraits of his own wife have the same lightness of touch and atmosphere as Cassatt's paintings. Thus, I don't believe that Mary Cassatt's "image of woman" is different from that of other male artists who were her contemporaries.

The first twentieth-century painting of a woman in this study is Arthur B. Davies' *Madonna of the Sun* (1910: Hirshhorn Museum and Sculpture Garden, Smithsonian Institution, Washington, D.C.) (fig. 49). Davies was an interesting artist, for he stands at the beginning of the modern era, and he became a prime mover in the introduction of the European avant-garde into this country; yet, his own style is rooted in late nineteenth-century naturalism. This dreamy young nude is seen against a backdrop of trees silhouetted by a glowing, sun-filled sky. The painting was intended by Davies to show the harmony between nature and this nude young woman who is unembarrassed and at home in her own flesh and the world of nature. The term, "madonna," is used not ironically, but to suggest the sacredness of the body and its place in hallowed nature.

The choice of a nude for our introduction to the twentieth century is not capricious. In nineteenth-century paintings, women are seen often in silent reveries or reading quietly, or playing solitaire or sewing. They are never shown nude unless in the context of a subject matter, like Adam and Eve, or in their professional role, as a nude model in the paintings of Eakins or Elihu Vedder. In the twentieth century, an isolated female figure is most often a nude figure, though, portraiture continues in a variety of opposing styles.

Davies' *Valley's Brim* (before 1910: Hirshhorn Museum and Sculpture Garden, Smithsonian Institution, Washington, D.C.) embodies an ideal of the unfettered and ecstatic woman in an harmonious nature. In such a conception sin and the Fall have no part: it is a paradisaical vision of harmony. Davies knew the American dancer Isadora Duncan, who was one of the first women to abandon the restriction of corsets and of elaborate, heavy gowns, which concealed the movement of the body.[16]

An almost opposite viewpoint is implied by *Christina's World* by Andrew Wyeth (1948: The Museum of Modern Art, New York) (fig. 50),

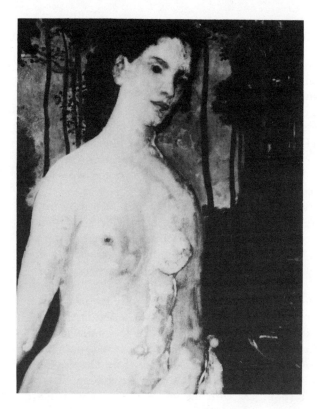

49. Arthur B. Davies, *Madonna of the Sun*, 1910. Hirshhorn Museum and Sculpture Garden, Smithsonian Institution. Washington, D.C. Gift of Joseph H. Hirshhorn, 1966. (66.1100).

50. Andrew Wyeth, *Christina's World*, 1948. Tempera on gesso panel; 32-1/4 × 47-3/4″. Collection, The Museum of Modern Art, New York. Purchase.

which also presents a woman and a segment of nature. Christina was a neighbor of the artist's in Maine. She had been severely crippled by polio, and the artist wanted in the picture "to do justice to her extraordinary conquest of a life which most people would consider hopeless."[17] He saw her out picking berries and witnessed her stopping a few moments "to gaze back across the field toward her house."[18] It is the intensity of her yearning posture that first impresses us—then we note the distorted arm and posture. Alone in a vast, bleak field of dry grass, the woman's solitude is movingly accentuated.

Arthur B. Davies' ideal nude, with her ballet-like movement upward, presents a wholly different image of woman from that of Christina, with her distorted body and awkward posture. A barren and indifferent nature extends endlessly about Christina in Wyeth's painting, whereas nature as depicted by Davies is a congenial and verdant setting for the transports of an Eve before the Fall.

Edward Hopper's *Hotel Room* (1931: Collection of Mr. and Mrs. Lawrence Fleischman, New York) shows us a woman seated on a bed, clad in a chemise, her shoulders and head bent as she looks down at a sheet of paper held across her knees. About her in the barren room are bags and a garment thrown upon an overstuffed green chair. Despite the bright light and yellow wall, the whole has a somewhat chilling effect. The impersonality of the room jars with the undressed privacy of this woman. Her face is in shadow, and we tend to feel that her psyche, too, must be shadowed, hidden, inhibited. Is she pondering a letter which conveyed sad news, perhaps of desertion? The empty room, her brooding posture, and the packed bags and waiting garment, hat, and shoes, seem to suggest such a meaning.

Another twentieth-century painting of an American woman pictured as an inhabitant of a particular environment is Richard Diebenkorn's *Woman on Porch* (1958: Washington Gallery of Modern Art). Again, we find a woman seated, alone, and, in this case, on a sun-drenched porch with an intense blue sky above. Studying this woman, we are at once aware that the artist has provided very little data regarding her physiognomy and her psyche. What we know of her is conveyed only by "body language": a slight turn to her head, which could suggest that she is lost in thought, the relaxation of the arm and hand that suggests that she is at home here, at one with both the domestic setting and the large, blank, blue California sky above. It is also clear that the artist's interest in this woman is less as person than as a shape in his created space, a shape that is locked into the horizontal forms and the strong diagonal thrust from the foreground into the background. Looking back at Hopper's painting, it is clear that Hopper, too, was dealing with a strong diagonal thrust (the bed) from the

foreground into depth, and that the emphatic verticals of the wall, window, and furniture all provide an abstract pattern of interesting shapes that beguile our interest, and, in fact, have greater importance than the anonymous woman on the bed. Both artists are viewing these women less as bearers of human meanings than as shapes, which along with other shapes, are the abstract building blocks of their painting. American artists for the most part did not go so far in abstracting the forms of the natural world as did Georges Braque and Pablo Picasso, but something of the same impulse lies behind these two paintings by Hopper and Diebenkorn.

Cubism's fracturing of the human visage was practiced in another form by some of the so-called "Pop" artists of the 1960s. James Rosenquist's *Marilyn Monroe, I* (1962: The Museum of Modern Art, New York) (fig. 51) shows details of the face of the famous movie star juxtaposed capriciously with some of the letters of her name, both in large print, and in the superimposed smokey tracery of skywriting. The way the paint is applied and the choice of colors reminds us of a billboard, as does the large size of the picture—it is more than seven feet high by six feet wide. The artist had attended art schools but he had earned his living for several years as a billboard artist. Here he used the billboard technique for a painting of the ill-fated film star who had recently died. Her dramatic rise to fame and her personal tragedy were equally a matter of public report, and the billboard was therefore appropriate to her image. More than any other woman of her time, the glamor and tragedy of her life, films, marriages, and death captured the imagination of painters and writers.

Gazing at Willem de Kooning's *Woman, I* (1950–1952: The Museum of Modern Art, New York) (fig. 52), the viewer may feel that the distortions of Rosenquist's *Marilyn Monroe, I*, and even those of cubism, seem benign by contrast. This ferocious image with enormous empty eyes and toothpaste-ad teeth, grimaces idiotically. She is the first of a famous series of studies of women by the artist. Despite the wildly random character of the brushstrokes, the artist was not working in a purely spontaneous fashion: he made many careful preparatory studies and took two years on the canvas itself. De Kooning himself spoke of the long tradition of the woman, "the idol, the Venus, the nude" and also said that the woman's body strongly reminded him of a landscape, "with arms like lanes and a body of hills and fields."[19] For our investigation, the title is instructive, for the painting is not a portrait, nor a figure study, but rather an evocation of femaleness by a male who clearly feels all the mythic power of the earth mother and is ambivalent in its presence, expressing both hate and love.

Tom Wesselman's *Great American Nude, 2* (1961: The Museum of

52. Willem de Kooning, *Woman, I*, 1950–1952. Oil on canvas; 6′3-7/8″ × 58″. Collection, The Museum of Modern Art, New York. Purchase.

51. James Rosenquist, *Marilyn Monroe, I*, 1962. Oil and spray enamel on canvas; 7′9″ × 6′1/4″. Collection, The Museum of Modern Art, New York. The Sidney and Harriet Janis Collection.

Modern Art, New York) (fig. 53) shows us another conception—one in which the body is seen simply as a silhouette—pink beyond all human pinkness, provocative in position, brilliant in color and yet totally uninvolving—"cool" is the word the sixties critics used. All that is expressed in Francisco Goya's marvelous painting, *The Naked Maja* (1800: Prado, Madrid) (fig. 54) here becomes posterlike, blatant, inconsequential, and amusing in the twentieth-century artist's painting. The great theme of Venus is just a pink pattern among other patterns for the twentieth-century Pop artist.

Phillip Pearlstein's *Nude in a Rocking Chair* (1977–78: Brooklyn Museum of Art, Brooklyn) presents a somewhat analogous contrast to a study of a nude by the nineteenth-century American artist Elihu Vedder, who surrounded his *Little Venetian Model* (1878: Columbus Gallery of Fine Arts, Columbus, Ohio) with the real or imagined contents of his studio. We get a sense of the warmth and comfort of this corner of the room with a picture of a curious ship on the wall and a carved figurehead against which the model leans. The light from an unseen source bathes the model's figure, affectionately moving over the round thighs and pear-shaped abdomen. By contrast, the light in Pearlstein's barren room seems cool and crisp, touching the flaccid lines of the nude's body impersonally. Seen as a composition, Pearlstein's painting is a tour de force, the sharp diagonal of the floor being cut across by the rocker, the nude's leg, the fascinating shadows on the wall. The most striking element, however, is the loss of the head of this figure. Cut off by the picture frame, in a seemingly arbitrary decapitation, we are told by the artist that his interest—and ours—is in the body, not in the human face or psyche. The body is seen more nearly as Wesselman did, that is, primarily as a pattern or design, not as the fleshly bearer of womanly qualities as in Vedder's *Little Venetian Model.*

When the human face is depicted by twentieth-century avant garde artists, it undergoes strange transformations. Chuck Close's painting *Leslie* (1972: Collection of Edmund Pillsbury Foundation, Fort Worth) might appear to be a tinted photograph. Indeed, it is based on a photograph, but the photo is enlarged tremendously and then painstakingly reproduced in watercolor on paper. The picture is about six feet in height, making Leslie's head almost as tall as the average male. This immense enlargement is startling. The face is seen almost exactly frontally, and the intent look of the eyes and stillness of the other features challenge us to the point of effrontery. What can we discern of who Leslie is? With so much specific detail, we are still left without any sense of personality or passions.

Behind her dark glasses, Alex Katz's young woman in *Study for Ada*

53. Tom Wesselman, *Great American Nude, 2.* 1961. Gesso, charcoal, enamel, oil, and collage on plywood; 59-5/8 × 47-1/2″. Collection, The Museum of Modern Art, New York. Larry Aldrich Foundation Fund.

54. Francisco Goya, *The Naked Maja,* 1800. Oil on canvas; 95 × 160 cm. Prado, Madrid. Photograph courtesy Marburg/Art Resource, New York. (54869).

(n.d.: Colby College, Maine) stares steadily at us but she, too, conceals her personality, her life, her being. Ada is seated in a lawnchair and the green grass about her is punctuated by a lily: bright sunshine bathes her mannish features and the zone about her. Only the expert balancing of colors and shapes asserts this as a work of art as distinguished from the chic ads for sunglasses found in *Vogue* or *Harper's Bazaar.*

Alfred Leslie's *Coming to Term* (1968–1970: Sydney and F. Lewis Collection) is a painting of his wife, far advanced in pregnancy. The artist began his career painting large, abstract works with turbulent lines and shapes, heavy paint, and surging color, rather akin to de Kooning's *Woman, I.* In the 1960s, however, he began to paint meticulously realistic portraits of himself, his friends, and his wife, with a conscious wish to "emphasize the individuality and the unique qualities of each person" and to return to an art like that of the past which has "a persuasive moral, even didactic, tone."[20] The dramatic lighting and detailed description of what is a very private moment of reverie for this young mother-to-be bring the painting dangerously close to melodrama. Yet if one accepts and is not embarrassed by the exposure of the burgeoning body and breasts, the inward focus and the sense of waiting expressed in her face and in the relaxed body give this painting a larger reference. She seems to irradiate and reflect a warm light: the generative principle is particularized in this quiet figure.

A marked contrast is found in comparing Leslie's portrait of his wife (1970) with Thomas Eakins's portrait of his wife, *Portrait of a Lady with a Setter Dog (Mrs. Eakins)* (1885: The Metropolitan Museum of Art, New York) (fig. 55). Eakins invites us into an intimate corner of their Philadelphia home to meet Susan MacDowell Eakins whom he had but recently married. She looks up steadily and unsmilingly at us while Eakins's setter dog, Harry, eyes us but does not raise his head. Mrs. Eakins's slender figure is clothed in a blue-green, close-fitting gown. The only brilliant color in the muted "brown decade" interior is the red hosiery visible on her slippered foot as it rests on an Oriental rug. Mrs. Eakins's guarded glance and worn face suggest a person of intelligence and reticence; she reveals little of her innermost thoughts to us. Eakins's portrait of his wife and Leslie's of his, show us two women who inhabit entirely different worlds: the environment of Victorian America as contrasted with the immediacy, the specificity, the relentless insistence on the realities of the moment that characterize the world of the realist avant garde of the twentieth century.

You remember the remarkable Ann Pollard, whose portrait was the first considered in this essay. Her austere presence contrasts stunningly with Duane Hanson's *Woman with White Hair* (1976: O. K. Harris

Works of Art, New York) (fig. 56). The sculptor has achieved a tour de force in replicating with exactitude a particular human being. To the polyester resin and fiberglass sculpture of the body and face, the sculptor has added the blowsy print dress, sweater, tennis shoes, purse, and folding chair. He has modeled and colored the skin with an exactitude that resembles aging flesh. The resulting sculpture looks so lifelike that even when placed in museums such sculptures are often taken to be persons, rather than being seen as art. Yet for all the specificity of the features and garb of Hanson's *Woman with White Hair,* she suggests to us less a particular person than a type, the aged women who, with pathos, populate our nursing homes of today. By contrast, Ann Pollard, is a doughty presence to be reckoned with, a memorable image from the past.

This is the end, but not quite the end, for inevitably, one reflects on the nature of women in the American social structure. In conclusion, several observations are derived from the paintings we have considered. First, in nineteenth-century American art, women were often depicted in reverie, in romantic dreams, in a withdrawn, or quiet moment. Sometimes, as in the portraits of young women by Copley and the portrait of his daughter by Morse, they are shown as vulnerable, innocent, and receptive. The other side of this is that they seldom seem to be decisive or "in command" or actively shaping their own lives—an exception being Copley's *Mrs. John Winthrop* or Sargent's *Mrs. Henry White.* Generally, life seems to happen to them, and they react, rather than vigorously shaping their own lives.

From the evidence, one concludes that nineteenth-century American women did not know their own bodies, but with the twentieth century, the body is unveiled by Davies, and is seen with pathos by Hopper, with anger and desire by de Kooning, with a cool realism of texture and form by Leslie, and as a mere element of design by the Pop artists.

In an age that explores gerontology, has workshops in aging, and golden years communities, we have Duane Hanson's depiction of old age that chills the viewer. Without dignity and without purpose, the *Woman with White Hair* awaits her end. Ann Pollard did so as well, but, transformed by art, she become archetypal, a symbol of the enduringness of humanity.

1982

2

The Human Image
in Sacred
and Secular Art

5

The Appearance and Disappearance of God in Western Art

Not only is the Bible repeatedly said to be God's book: God appears in it "in person." Some of these latter moments have been interpreted by artists across the centuries, but the choices may surprise twentieth-century Christians. Which events, or which moments would you choose were you an artist, or a donor?

My choices are those events that carry a world of visual suggestion—a contented Creator strolling in the garden in the cool of the day, or the Lord showing his backside to Moses, or God wiping away the tears of the faithful in the new Jerusalem. However, these events are seldom represented. Though God appears in a vast number of paintings, only occasionally is he represented anthropomorphically before the twelfth century. Furthermore, the translation of some biblical texts referring to God, which seem unpictorial, into visual imagery, is always interesting, and in some instances, is ingenious, indeed.

In this study I am dealing with the intersection of two vastly complex areas of inquiry—the history of biblical interpretation and the history of art. Endeavoring to interpret the formative influence of each in regard to specific works of art can be extremely difficult. Let me give you an

"The Appearance and Disappearance of God in Western Art" is revised from its earlier publication in *Bible Review* 1.2 (1985): 26–36. It is reprinted here in revised form with permission. The text was originally presented to a session of the Art, Literature, and Religion Section of the 1984 Annual Meeting of the American Academy of Religion.

example. It had long been thought that the Second Commandment was the sources of a prohibition in regard to religious art, and particularly in regard to the image of God. Then, in our own century, as interest in early Christian art and archeology developed, the so-called *Dogmatic Sarcophagus:* (4th c.: The Vatican Museums, Vatican City) attracted scholarly attention: the group of figures in the upper left corner was identified as an early representation of the Trinity. Here we see the creation of Eve: the Creator is seated upon a draped throne and he extends his right hand in the gesture of blessing. Two other figures with similar features, hair and beard stand nearby. The one behind the throne watches earnestly as he places one hand on the throne. The other looks intently at the Creator and has a hand upon the head of a doll-like Eve who stands before her Creator while Adam lies upon the ground nearby. It is argued that the enthroned figure is God, the blessing figure Christ, and the figure behind the throne, the Holy Spirit. It is thought to be a fourth-century work; but the presence of a representation of the Trinity at this early date is problematic. The iconography was thought to be unique, but some years ago another sarcophagus with a similar scene was discovered at Arles. While it bolstered the case for the interpretation, both seem foreign to the known repertoire of subjects oft-repeated in works of early Christian art. Could we be seeing here a reflection of Augustine's writings on the Trinity? Augustine's (354–430) extensive discussion of the Trinity must have been known among the churchmen who would have had an influence on the sculptor's choices and the treatment of religious themes in monuments such as this sarcophagus.[1]

The existence of a second sarcophagus with the same iconography is additional evidence that the Second Commandment did not operate as a taboo in all fourth-century Roman Christian art. It is possible, however, to view these two sarcophagi as aberrations in the early Christian corpus, that is, puzzling and untypical, with a deteriorated classical vocabulary of form inappropriate to Christian subject matter. From this viewpoint God the Creator is seen as having the form of a classical philosopher because that was the imagery available to the artist in the fourth century. Thus we see how intermeshed, how dependent on each other are the artist's visual vocabulary and syntax—what art historians call style—and the biblical texts to be illustrated. These texts were read and interpreted by the fathers of the Church. Augustine in particular was influential in the visualization of the themes as well.

Still the two sarcophagi will remain "sports" within the canon of early Christian art until more evidence comes to light. During that period and in the following centuries until the fourteenth century, it is the hand of

God that was the ruling image for the Yahweh of the Old Testament and of God the Father of the New Testament.

Perhaps the earliest visual reference to God within the Judeo-Christian corpus is in the cycle of frescoes of the synagogue at Dura-Europos dating from about 244 to 245. Here among the many Old Testament scenes Ezekiel's vision (fig. 57) is depicted: "The hand of the LORD was upon me, and he brought me out by the Spirit of the LORD, and set me down in the midst of the valley; it was full of bones."[2] The third-century painter depicted Ezekiel in classical garments, the white chiton and himation; his right hand, with an orator's gesture, is outstretched toward those who represent the house of Israel. But Ezekiel's gaze is not toward them nor toward the great hand of the Lord above him nor, though his gaze is directed toward us, does he look at us. His eyes have the glazed and unfocused look of the visionary. He is the mouthpiece for the Lord whose mighty hand with splayed fingers is seen in the sky above.

The right hand of God, the *Dextra Dei*, precedes all other visual images referring to the Lord in the art of the Christian era. The Old Testament uses the verbal image repeatedly, as in the Song of Moses: "Thy right hand, O LORD, glorious in power, thy right hand, O LORD, shatters the enemy."[3] At Dura-Europos, the visual image of the divine hand appears in Jewish art.[4] Louis Réau called attention to the Hebrew word *"i a d"* which signifies hand and power, and thus the hand was expressive of God's power in human affairs.[5] It is to be noted that it is always God's right hand which is represented, the right always being the side of righteousness and of those delivered from evil.

During the medieval era, the hand of God and God in anthropomorphic form as an elderly man are seen in works of art. Also, and indeed frequently, God is represented in the form of the Second Person of the Trinity. In northern Europe in the late medieval period, we find an elaboration of the type of the elderly God, that is, the representation of God with the attributes of the pope, as in the exquisite manuscript leaf from the *Paris Book of Hours, Ms. 453* (1420: The Pierpont Morgan Library, New York) (fig. 58). The tiara, or triple crown, was adopted by the popes in the fourteenth century, and elaborate bejeweled garments such as the cope seen in this manuscript illumination were created for church ceremonies.[6] The identification of the eternal God with the earthly power of the pope was not a diminishing of the notion of deity, but rather a reflection of the ritual of the coronation of the pope, who is crowned Father, King, and Vicar of Christ. Here we see the enthroned God who hands the tablets of the Law to Moses with one hand while handing the communion chalice and host to a priest with the other. Thus

58. LEFT: *God the Father Enthroned* from *Paris Book of Hours, Ms. 453,*
1420. The Pierpoint Morgan Library, New York. (Ms. 453, f99).

60. RIGHT: *God Enthroned* detail from Mathias Grünewald, *Isenheim
Altarpiece.* 1515. Oil on wood panel; c. 12′ 3′ × 17′ 9″ overall with wings.
Courtesy of Musée d'Unterlinden. Photograph by Otto Zimmermann

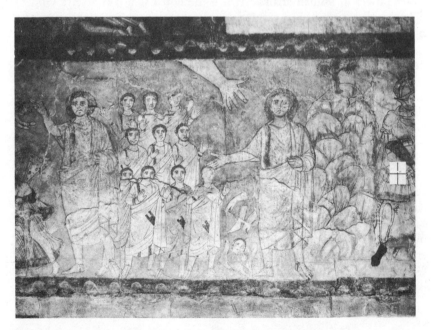

57. *Ezekiel's Vision of God's Hand,* c. 244–245. Mural from the
Jewish synagogue, Dura-Europos. Photograph courtesy of the
Dura-Europos Collection, Yale University Art Gallery.

the law, that is, the Old Testament, is here juxtaposed and fulfilled in the sacrifice of Christ reenacted in the Mass.

The physical type here represented—that is, a very old man, somber of visage and with white hair and beard—derives from the vision in the book of Daniel and is thus called the Ancient of Days. The passage reads, "Thrones were placed and one that was ancient of days took his seat; . . . the hair of his head [was] like pure wool."[7] But the apparel and gestures of this figure probably also relate to how God was enacted in the medieval Mystery plays.

Certainly the grandest vision of God is that of Michelangelo (fig. 59). With sublime self-assurance, he created the image of an all-powerful God, human in form but heroic in size, and endowed with power, strength, and a mobility that rivals the most cunningly designed space rockets. With a fiat-like gesture of a mighty hand he brings forth a plump and dewy Eve from the side of Adam. Floating across the heavens in company with cherubim, and the preexistent Eve and also the preexistent Christ child,[8] God stretches forth a hand and causes the energy of life to leap to the languid, outstretched hand of the recumbent Adam. With a great rush of movement, God thrusts forward and with a mighty gesture throws the sun into being; he then moves away from us, showing us his backside and the soles of his feet as with another gesture he casts the moon into the heavens. The first lines of Genesis speak of "the Spirit of God moving over the face of the waters"; thus Michelangelo's God looks down upon the darkness that "was upon the face of the deep," the deep shadows within his cloak a reflection of that darkness. His arms seem outstretched in a gesture of blessing. Beautiful and ecstatic in its sense of the oneness of God's physical being with the elements is Michelangelo's vision of God separating the light from the darkness. God pushes the darkness away with his right hand and cups his hand about the light, his twisting, turning, reaching body illumined by colors as brilliant as the nineteenth-century Impressionist's yellow, apricot, and cerise.

At the same time that Michelangelo was painting his Sistine Chapel frescoes with the image of the Creator as all-powerful virile, moving through the heavens and over the earth with a controlled dynamism, a northern artist whom we call Mathias Grünewald was creating another image of God in his *Isenheim Altarpiece* (1515: Musée d'Unterlinden, Colmar) (fig. 60).[9] Enthroned in the heavens, Grünewald's God holds the scepter, symbol of temporal power, and the cross surmounted-orb, a symbol of the cross's rulership over the world. He wears simple, voluminous garments and is surrounded by a mandorla of light. The billowing yellow clouds about him are inhabited by angels whose hands are raised in praise.

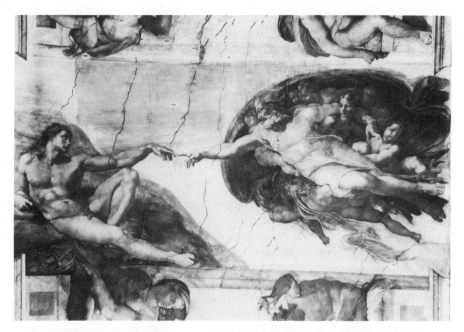

59. *Creation of Adam* detail from Michelangelo, *Sistine Chapel Ceiling*, 1508–1512. Fresco; 132 × 44 feet overall. Sistine Chapel, Vatican City. Photograph courtesy Office of Director, Monumenti Musei e Gallerie Pontifici, Città del Vaticano.

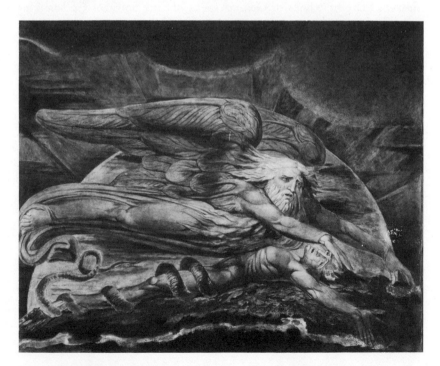

61. William Blake, *Elohim Creating Adam*, 1795. Colour, wash/paper; 432 × 537 cm.. Courtesy the Trustees of the Tate Gallery, London. (N-05055).

How spectral and insubstantial, how remote and spooky, this God seems when contrasted with Michelangelo's muscular activist who is so at home in his own firmament. Yet both images were painted about the same time and come within the category of the God the Father represented as an elderly man. Grünewald's God is a spectator of a scene in which the Virgin Mary smiles as she tenderly holds the infant Christ before her upon a torn cloth which alludes to the Crucifixion. She is seated in the enclosed garden and is the "rose without thorn" (shown at her right), and "the dwelling of the Lord" (the church in the background).[10]

Influenced by Michelangelo's image of God, yet having quite different content, is William Blake's *Elohim Creating Adam* (1795: Tate Gallery, London) (fig. 61).[11] Blake's extraordinary and memorable vision portrays a winged deity with brows intently contracted, mouth open, and troubled gaze focused inward, hovering over the prone and anguished figure of Adam. Adam throws up his arms in despair, as he experiences the pain of coming into being. About his body a serpent is entwined, for Blake an emblem of mortality and human enslavement to the material world.

Like Rembrandt, William Blake obsessively illustrated the Bible. His masterpiece, the illustrations for the *Book of Job*, forms an extraordinary corpus. In this group *The Lord Answered Job Out of the Whirlwind* shows a Michelangelesque God, who, with arms outspread, seems to bless his own creation—"the dwelling of light" and "the place of darkness," "the springs of the sea" and "the recesses of the deep."[12]

The Throne of God

God as an elderly man appears in a large group of works referred to as the Throne of Grace and originating, according to Émile Mâle, in the twelfth century as an "invention" of the Abbot Suger, but most often represented in the fourteenth and fifteenth centuries. A fifteenth-century French sculpture of the *Throne of Grace* (second half of fifteenth century: M. H. De Young Museum, San Francisco) is a typical example. God the father, wearing the papal tiara and a cope, is seated on a throne. His right hand is raised in the gesture of blessing and with his left he holds before him the cross with body of the dead Christ thereon; between the Father and the Son the dove of the Holy Spirit is seen. Such a sculpture could be correctly identified as *The Holy Trinity*, but its true subject is God's assurance that the crucified Christ is his Son and that he has offered and accepted the sacrificial death of Christ on behalf of humanity. The biblical source for this image comes from the Book of Hebrews: "Since then we have a great high priest who has passed through the heavens, Jesus, the

Son of God. . . . Let us then with confidence draw near to the throne of grace, that we may receive mercy and find grace to help in time of need."[13]

The Master of Flemalle (1375–1444) painted a majestic variation on the theme of the *Throne of Grace* (1430–1432: Stadlesches Kunstinstitut, Frankfurt). Iconographically it is similar except for the absence of the cross. God the Father upholds the lifeless body of his beloved Son, as he gazes unseeingly before him, with brows contracted. It is a stark painting. The artist used grisaille—that is, neutral grays only—so that the painting appears to be a sculpture. Beneath the figures in the base of the sculptural group are the words SANCTA TRINITAS UNUS DEUS. Erwin Panofsky identified this painting as the "Trinity of the Broken Body." Panofsky noted further that it was tender in sentiment but harsh in execution, with its double shadows and the Dove of the Holy Spirit oddly perched upon a shoulder muscle of Christ. Thus, a tension exists between reality and fantasy, between the softer emotions and "tough mindedness."[14]

The Logos, "by whom all things were made," to use the words in the Nicene Creed, was given human form by artists in the centuries between the time of late antiquity and the early Renaissance. What a challenge to the artist to illustrate one of the most central and profound texts of the New Testament: "In the beginning was the Word, and the Word was with God, and the Word was God. He was in the beginning with God; all things were made through him."[15] How could the artist suggest the thrust of this declaration visually? He did so by conflating the image of the Creator and the Redeemer, so that it is Christ the Son with his special attribute, the cruciform nimbus, who separates the light and the darkness, creates heavens and earth, creates Adam and Eve.

A beautiful page from a thirteenth-century manuscript, *Paris Ms. 638* (13th c.: The Pierpont Morgan Library, New York) (fig. 62) depicts the Lord God portrayed with brown hair and beard, and with the cruciform halo. His right hand is raised in the Western gesture of blessing and his left rests upon the globe of the world. It is the Fifth Day of Creation, and the sun and moon, created the day before, ride high in the skies, the "great whales" and "every winged fowl according to its kind" cavort in the newly made creation, and from above angels fly down, their hands extended—perhaps they are applauding the deity. On the Sixth Day, the Lord God creates Adam. God's gesture with pointed finger seems admonitory, and he grasps Adam's arm as one would a wayward child; indeed, Adam's figure is smaller in scale than his Creator. Then, again with the gesture of blessing, God draws Eve forth from Adam's side as Adam lies with his head propped up on a plant-covered hillock. In the same scene

62. LEFT: *God Enthroned* from *Paris Ms. 638*, 13th century. The Pierpont Morgan Library, New York. (Ms. 638, fl).

63. RIGHT: *God Enthroned* detail from Hubert and Jan van Eyck, *The Ghent Altarpiece.* Copyright A.C.L. Bruxelles.

64. Albert Pinkham Ryder, *Jonah,* c. 1890. Oil on canvas; 26-1/2 × 33-1/2 in. Gift of John Gellaty. National Museum of American Art, Smithsonian Institution, Washington, D.C. (1929.6.98).

God instructs the modest couple about the tree of the knowledge of good and evil. At the lower left, we see the Fall. Adam and Eve greedily bite into one fruit while dancing toward the tree grabbing another. Presiding over the event is a smiling French wench with a chic headdress, but whose body is a green dragon with graceful red wings. In all of these scenes, God wears classical dress and has the brown hair and beard of young manhood, and has the cruciform halo, the latter being an attribute of Christ, and here an attribute of the Logos.

Two centuries later, again from the north of Europe, we have the great triptych known as the *Ghent Altarpiece*, painted by Jan and Hubert van Eyck and completed in 1432. This vast cycle of paintings was intended to mirror the entire Christian universe. When the wings of the Altarpiece are open, we see a great vision, but one which is laid out before us in two levels: the lower zone shows a continuous landscape with figures on horseback at the left, and those on foot at the right, coming toward the central group who kneel before the fountain of life in the foreground, and the altar on which the lamb stands in the center of the panel. Above the lamb is the Dove of the Holy Spirit surrounded by an aureole of light.

The entire upper zone of the altarpiece is rendered in an entirely different scale—the figures gigantic, in contrast to the multitude of worshippers below. At either side, the large and realistically rendered fleshly figures of Adam and Eve are seen. In posture, flesh, and spirit, they are depicted as sinners after the Fall. Moving inward, we see the much-reproduced panels of the music-making angels, then the Virgin Mary and St. John the Baptist, who sit enthroned at either side of the central figure of the King of Kings (fig. 63), whose image expresses the three persons of the Trinity.[16]

The King of Kings imagery from the Book of Revelation was interpreted by Augustine to refer to all three persons of the Trinity, "In these words neither the Father is specially named, nor the Son, nor the Holy Ghost, but the blessed and only Potentate, the King of Kings and Lord of Lords, the Trinity itself."[17]

The King of Kings is represented as a mature, but young man. His eyes look out toward us but with an unfocused gaze which makes no contact with us as individuals. The absolute frontality of the face, with features which, unlike our own unsymmetrical faces, are entirely symmetrical, gives a hieratic and otherworldly cast to the face. The elaborate jeweled papal tiara is a reference to spiritual power, and the exquisite crown at his feet is a symbol of secular power.[18] The cloak of honor behind the King of Kings has embroidered motifs of the "Pelican-in-its-Piety," a symbol referring to Christ and his sacrifice. Thus, this figure is not only the first person of the Trinity, but the Second also, and by implication, the Third as well.

Images of God appear in the great baroque ceiling paintings, and the cycles of the seventeenth-century as well as in eighteenth-century altar and ceiling paintings by artists such as Giovanni Battista Tiepolo. But by the nineteenth century, the frequency and quality of such works of art diminished.

In the late nineteenth century, the American artist Albert Pinkham Ryder painted in *Jonah* (c. 1890: National Museum of American Art, Smithsonian Institution, Washington D.C.) (fig. 64) one of the last images of God in both American art and in Western art. Ryder's God has the special distinction of being the only left-handed God known to this investigator. Contrary to the received tradition, God gives the blessing with his extraordinarily large left hand. Unlike earlier representations, this God is involved in the drama before him. He looks urgently sidelong at the great fish whom he had appointed to swallow up Jonah. God's immersion in the drama before our eyes is portrayed in his expression and gestures, and in the design of the painting, which makes him the apex of a swirling ovoid form that encompasses both the fish-shaped ship with its terrified crew, and the great fish itself, who hurtles toward the drowning Jonah.

If the *Book of Jonah* is read with Ryder's painting in view, it is clear that the artist is not depicting the drama of Jonah's flight, nor his shipboard experience, nor the subsequent episode when Jonah is thrown into the sea, for when this was done "the sea ceased from its raging." Rather, Ryder depicted the totality of Jonah's experience of God when he prayed to the Lord from the belly of the fish, saying "Out of the belly of Sheol I cried . . . For Thou did caste me into the deep, into the heart of the seas, and the flood was round about me."[19] Here the Lord, answering his prophet Jonah, enters into the drama of flight, descends into Sheol, and is an active protagonist in salvation. The Lord is not an all-seeing, all-knowing overseer whose presence guarantees the right outcome. Ryder represented him as a force, as much psychic as physical, enlisted on the side of the prophet. Indeed, Ryder's internalized appropriation and rendering of God is a marked transformation of the tradition. Michelangelo's God works by fiat, and William Blake's early nineteenth-century visualizations, represent a God in whom good and evil are conjoined. Ryder unlike his predecessors, represented a God who is involved in the event and whose omnipotence is exercised in the throes of participation.

In the early twentieth century, God appears once again in a small group of pictures, painted not for a house of worship but for individual collectors. The largest number of such works are from the circle of the German Expressionists of the World War I period, and those subsequently influenced by them, i.e., Kathë Kollwitz, Ernst Barlach, Emil Nolde, and Paul Klee. But these works are few in number, and informed by a personal and

individual piety, rather than reflecting the commonly held faith of a believing community.

If we ask the question, Does the image of God appear in twentieth-century art, the answer would have to be a qualified no. That is, God appears in only a small group of works such as those by the artists just named. But if the question is changed to ask, Is the human encounter with God the subject of painting in our century, the answer is decisively yes.

One of the great cycles of paintings in the twentieth century has as its subject the individual's encounter with God. Barnett Newman's fourteen paintings are named, and misnamed, the *Stations of the Cross* (1958–1966: Robert and Jane Meyerhoff Collection, National Gallery of Art, Washington, D.C.) (fig. 65). Their real subject is Jesus' agonized cry, reiterating the lines of the psalmist, "My God, my God, why has thou forsaken me?"[20]

Newman wrote a statement about the paintings in which he said that his *Stations of the Cross* were about "the unanswerable question of human suffering."[21] In a conversation with Thomas Hess at the time of the first exhibition of the paintings, Newman further elaborated his theme:

> I was trying to call attention to that part of the Passion which I have always felt was ignored and which has affected me and that was the cry of Lema Sabachthani, which I don't think is a complaint, but which Jesus makes. And I always was struck by the paradox that he says to those who persecuted Him and crucified Him, "Forgive them for they know not what they do." But to God, and Jesus is projected as the Son of God, he says, "What's the idea?"[22]

Thus the true theme of the *Stations* is "Why, Why, did you forsake me. To What purpose? Why?"

Newman began the paintings in 1958 and completed the series of fourteen in 1966. They are large in size, more than six feet in height and with a width of five feet; thus, they are the height of a tall person and the width of the human arm span. Most of the series are limited to black paint on the wheat-colored raw canvas, but the *Ninth, Tenth,* and *Eleventh,* as well as the last *Station,* the *Fourteenth,* have white paint that seems incandescent after viewing the preceding black canvases. *Station I* introduces us to the series and their austere format. A wide black vertical traverses the entire left side of the canvas; our eyes move across the remaining expanse of canvas to the vertical strip of unpainted canvas (what Newman called a "zip") which is defined by softly brushed, feathery strokes of black paint. Slightly sloping, the artist's signature and date add a final touch of black in the lower right of the canvas. The spacing of the

verticals remains similar in all fourteen paintings, but the variations in tonality and design are such that the viewer often recognizes the spacing of the verticals only after continued study of the series.

It is important to view the paintings in their proper order. Lawrence Alloway noted how the pilgrim who follows the traditional Stations of the Cross moves sequentially.[23] So Newman's *Stations* are to be viewed as they create their own resonant space. Speaking of a synagogue which he had designed, Newman used words about it which also apply to the *Stations:*

> My purpose is to create a place, not an environment, to deny the contemplation of the objects of ritual for the sake of that ultimate courtesy where each person, man or woman, can experience the vision and feel the exaltation of "His trailing robes filling the Temple."[24]

As we move toward the twenty-first century, the disappearance of the image of God from art seems to be less of a problem than the appearance of God in earlier ages. The feminists of our own day are not the only ones who reject the God-the-Father imagery of Renaissance works of art. Other individuals of all ages, groups, and genders find the anthropomorphism of Jan van Eyck and Michelangelo irrelevant to contemporary religious concerns, if not actively repugnant to modern spirituality. Does this mean that the magnificent heritage of religious art is accessible to twentieth-century believers only in aesthetic terms?

Many are inclined to assent to this query. But all who have seen the original works of art, standing in their presence thoughtfully and expectantly, know that what they have felt was not "merely aesthetic." They have been deeply and strangely moved as the totality of the work of art asserted its power and meaning. For them, the imagery, the symbolism, and the anthropomorphism are so embedded within and at once with the symphonic totality of design and color, a sense of depth and breadth, and a grandeur of vision, that they can only respond in awe and praise.

The history of twentieth-century art has not prepared us for visions such as those created by Jan van Eyck and Michelangelo for their contemporaries. In 1907 cubism was invented by Pablo Picasso and Georges Braque, and though, as a style, it remained stubbornly grounded in the real world, it so shattered and rearranged that reality, that it prepared the way for the subsequent development of nonobjective, or nonrepresentational art.

In the late 1940s and 1950s a liturgical reform movement within Roman Catholicism developed. Artists, architects, a few enlightened clerics, and dedicated laypersons worked together to take the lessons of modernism

65. Barnett Newman, *Stations of the Cross* (Installation Photograph), 1958–1966. Magna on canvas; approximately 1.978 × 1.537 (77-7/8 × 60-1/2 in.) each painting. Robert and Jane Meyerhoff Collection, National Gallery of Art, Washington, D.C. (1986.65.1-14).

66. Mark Rothko, *Interior View of the Rothko Chapel*, 1970. Houston, Texas. Photograph courtesy The Rothko Chapel.

and to appropriate them for the church. They dedicated themselves to good design and craftsmanship and to the commissioning of present-day artists, and hoped to obliterate the banal and sentimental art for churches available through religious supply houses. The movement flourished for a while but finally expired because of the intransigence of the clerics and the church. It must be admitted that from the viewpoint of artistic quality, the works of art that came out of the movement too often expressed the same banal piety as the plaster statues (now in hand hewn wood or stone), with simplified and stylized lines intended to be modern, but in fact, "modernistic" and often vapid.

By the 1950s New York was the center of Abstract Expressionist art, and among its leaders were Jackson Pollock, Barnett Newman, and Mark Rothko. All three artists did "religious" works. Rothko painted fourteen large canvases for an ecumenical chapel which he himself designed (fig. 66).[25] Jackson Pollock worked on paintings and window designs for a chapel that was never built,[26] and Newman painted the *Stations of the Cross* and other abstract works with biblical titles.[27] However these works of art have had more impact in the world of art than in the world of religion, a fact that lends credence to Thomas Messer's dictum "Today the art museum is the Temple."[28]

Religious imagery and symbolism is *not* dead. Two developments within the past two decades indicate the continued interest in religious imagery and symbolism. On the religious front, there is the efflorescence of an interest in the iconography of the sacred figures of other religions, especially Buddha and Shiva. Secondly, art historical scholarship has in recent years delved deeply into Christian iconography, theology, and liturgy. This is quite a different approach from the stylistic analysis of art that was the dominant mode of interpretation at the beginning of our century. Art historians are reading the theological, the liturgical, and the church historical documents of every period of the Christian tradition.[29] Thus, Jan van Eyck's *Ghent Altarpiece* is understood as embodying the thought of its place and time—and here the word "embody" is the appropriate term.

We live in a waiting time—an awaiting of the birth of new symbols and new imagery. But this should not be a passive waiting. It should be, a time of experimentation, openness, and a passionate and expectant awaiting. We must keep alive the religious art and imagery of the past, to try to understand it in its own terms and to make it a part of the present, for all new imagery grows out of the fabric of past history. We must embrace the old and look to that which shall be born out of the great art of the past.

1984

6

Northern and Southern
Sensibilities in Art on the Eve
of the Reformation

This essay is an exercise in a detailed viewing of two very familiar masterworks, two cycles of painting, both created within a seven-year period shortly after the year 1500. My purpose is to contrast the style and the content of a major work of the Italian Renaissance with a major work of the Northern Renaissance, to show how each reflects its own particular and peculiar religious sensibility, its historic cultural context, and even its geographical and climatic environment.

Thus, though we shall be observing stylistic details as data, the implications of the data for the broader questions of the interpretation of content will be the focus of our observations. Therefore the works of art shall be seen as reflecting two differing, and opposed, understandings of the image of humanity, of nature, and of the supernatural, though both works are contained within the broad cultural designation of the Renaissance.

There is a further dimension to this study. In my several decades of viewing and teaching art, I have come to agree with Wilhelm Worringer's analysis of the art and temperament of what he terms classical humanity, as differing radically from that of northern humanity.[1] Further, I have observed that most of us are, latently or consciously, either Northern or

"Northern and Southern Sensibilities in Art on the Eve of the Reformation" was the Inaugural Annual Lecture sponsored by the Jane and John Dillenberger Endowment for the Visual Arts, Graduate Theological Union, Berkeley, in 1981. A revised version of this text was presented to a special symposium on the Isenheim Altarpiece at the Winter 1988 Meeting of the Society for Art, Religion, and Contemporary Culture in New York.

Classical in taste and in temperament. I should like, therefore, to propose to demonstrate the style and content of these two kinds of art through an examination of Michelangelo's classical art—the frescoes of the *Sistine Chapel Ceiling* (fig. 67) and Mathias Grünewald's "northern" art—the panels of the *Isenheim Altarpiece* (fig. 68). As the contrasts and comparisons unfold, the reader may discover to what extent he or she is Northern or Classical in taste and temperament.

The first focus of my analysis will be Michelangelo's ceiling frescoes for the Sistine Chapel, painted between 1509–1511 for Pope Julius II. Occupying the Chair of Peter from 1503 to 1513, Julius II was described by a contemporary as a giant "in body and soul," who conceived of everything about him "on a magnificent scale" in his attempt to imitate the splendor of Imperial Rome. It was Julius II who commissioned Michelangelo in 1508 to decorate the ceiling of the Sistine Chapel. The chapel walls had been previously covered with frescoes that paralleled Old and New Testament themes, showing the history of humanity *sub lege* and *sub gratia.*

It remained for Michelangelo, in a succession of scenes, to give the history of humanity *ante legem;* the great creative acts recorded in Genesis are depicted beginning at the altar wall, with the *Separation of the Light and Darkness, Creation of the Sun and Moon, God's Division of Heaven from the Waters, God's Spirit Moving over the Face of the Waters,* the *Creation of Adam,* (fig. 60), the *Creation of Eve* (fig. 10), the *Temptation and Fall* (fig. 11), the *Building of the Ark,* the *Flood,* and finally, the *Drunkenness and Indecent Exposure of Noah.* These scenes summarize the creation of the world and humanity, the first sin and Fall, and its echo in the second fall, that is, in Noah's disgrace. These events are depicted as a succession of scenes, viewed by us through an architectural framework, a framework peopled by the twisting, turning bodies of a population of enigmatic, energetic nudes (who were "the athletes of God"), and by the enormous brooding figures of the Old Testament Prophets and the Sibyls. Both the Prophets and the Sibyls were thought to foretell, in their cryptic pronouncements, the coming of Christ.

We do not know if the subject matter for the ceiling was Michelangelo's own invention or the result of consultation with authorities, in person or in print.[2] However, the grandeur of the theme and heroic scale of this immense fresco, which covers 5,560 square feet and is peopled by 300 human figures, makes a visit to the Chapel an awesome experience.

By contrast, when we visit Grünewald's *Isenheim Altarpiece,* we enter the small, still-medieval town of Colmar, near the Rhine River, and the late gothic chapel serving as a museum, where the altarpiece now stands. The altarpiece is a polyptych, composed of many panels, which are today

67. Michelangelo, *Sistine Chapel Ceiling* (overview), 1508–1512. Fresco; 132 × 44 feet overall. Photograph courtesy of Alinari/Art Resource, New York. (945).

68. Mathias Grünewald, *Isenheim Altarpiece* (overview), 1515. Oil on wood panel; c. 12'3" × 17'9" overall with wings. Courtesy of the Musée d'Unterlinden. Photography by Otto Zimmerman.

separated so that all panels can be seen simultaneously. Originally the central exterior composition with the *Crucifixion* (fig. 87) opened back to reveal four scenes the *Annunciation* (fig. 69), the *Angel Concert*, the *Nativity* scene (fig. 70), and the *Resurrection* (fig. 71). In turn, the central panels could be opened to reveal two painted scenes from the life of St. Anthony and finally, a central sculptural group of figures carved by Niklas Hagnower (1505). The predella painting which depicts the *Entombment* (fig. 72) also opened to reveal sculptures of the twelve apostles carved by Desiderius Beichel. Thus, rather than being confronted by the totality of an overarching theme, as is the case in Michelangelo's *Sistine Chapel Ceiling*, we have a succession of scenes that are not coherent in terms of chronology (events before and after the Crucifixion are not shown in order of their occurrence) nor in terms of any traditional iconographic program.[3]

Returning to the *Sistine Chapel Ceiling*, of all the three hundred figures, Michelangelo's Adam (fig. 73) is the most familiar. Yet this Adam always strikes one afresh with the contradiction between the attitude of languor of this beautiful body and its potential for energy and action. The body is an organism, a physical whole, and we are made to sense the internal workings, the slow drawing of the first breath, the rhythm of the first heartbeat, the power in those broad shoulders, muscular torso, and limbs.

Grünewald's work is overwhelmingly dominated by the figure of the anguished, crucified Christ (fig. 74). Michelangelo's work, as Walter Pater noted, has as its motive the creation of life, and life which always comes as recovery or resurrection, as in this Adam. Michelangelo's Adam has a sense of unity and harmonious thrusts and counterthrusts; Grünewald's Christ is taut and distorted. The head of Christ falls forward at an unnatural angle. One arm seems to be out of its socket, the other acutely strained. The great chest is expanded, the upper abdomen sharply contracted. Scarlet blood flows from the wound in the side of Christ, as well as from the many wounds from the scourge. These multiple wounds and acute physical distortions communicate, with immediacy, the horror of the sufferings and death of the Christ. Our eyes travel from the enormous, living, aggressive crown of thorns to the bloody face and half-open mouth, the individual muscles of the great chest, the ribs pressed against the skin. It is by the multiplicity of detail that Grünewald involves and implicates us in this painful death. The details so occupy our attention that only later do we realize that the body lacks any sense of unity and structure. It is like a relief map of a torso, delineating texture, detail, hollows and protuberances, but lacking a sense of internal organic unity.

It can be argued that a crucified body must indeed lack organic unity,

69. *Annunciation* detail from Grünewald, *Isenheim Altarpiece*. Courtesy of the Musée d'Unterlinden. Photography by Otto Zimmermann.

70. *Nativity* detail from Grünewald, *Isenheim Altarpiece*. Courtesy of the Musée d'Unterlinden. Photography by Otto Zimmermann.

71. *Resurrection* detail from Grünewald, *Isenheim Altarpiece*. Courtesy of the Musée d'Unterlinden. Photography by Otto Zimmermann.

72. *Entombment* detail from Grünewald, *Isenheim Altarpiece*. Courtesy of the Musée d'Unterlinden. Photography by Otto Zimmermann.

but Michelangelo's few drawings of the *Crucifixion* and his *Pieta* sculptures, in which one sees the body of the dead Christ in the arms of Mary, minimize the evidence of the wounds, as in his first *Pieta* (c. 1498–1499: Basilica of St. Peter, Vatican City) (fig. 75). In this sculpture the spear wound in the side is a mere slit, which does not detract our attention from the beautiful proportions and gleaming flesh of the relaxed young body—in contrast to the tortured body of Christ in Grünewald's *Lamentation* from the predella of the *Isenheim Altarpiece*.

Behind Michelangelo's conception of the human body lies the classical tradition and sculptures, such as the magnificent torso of *Ilissus* from the west pediment of the Parthenon (c. 440–432 B.C.: British Museum, London) (fig. 76). Michelangelo could not have seen this particular sculpture from the so-called "Elgin Marbles," which so astonishingly resembles his Adam in pose and proportions. But Rome abounded in sculptures from antiquity. Michelangelo, like his own depiction of God the Father, breathed new life into the forms of the pagan sculptor, creating an Adam who strikes us as different *in spirit* from its classical counterpart—a difference described by Sir Kenneth Clark as that "between being and becoming."[4] The classical sculpture, Clark wrote, "in its timeless world, obeys an inner law of harmony; [but] the Adam gazes out to some superior power that will give him no rest."[5]

If we compare the head of Michelangelo's Adam (fig. 77) with the head of St. Sebastian (fig. 78) from the *Isenheim Altarpiece*, we note differences in conception on the part of the two artists as to the image of an ideal being. The idealized, generalized features of Michelangelo's close-shaven first man contrasts with the particularity of the features of St. Sebastian. Though none of us have eyes as symmetrically placed as Michelangelo's ideal faces have, few people have eyes as asymmetrical as St. Sebastian's or as different in focus. The two sides of his face differ in planes and proportions, the mouth is full and somewhat loose-lipped, the eyebrows each arch differently; the stubble of several days' growth of beard covers the upper lip and jaws. Thus, the artist has emphasized all the details of one particular, finite human being, in all their specificity. St. Sebastian also shows the early northern incapacity to see the body as an organic whole. The upper arm and forearm of Sebastian are united, but without any understanding of the bony and muscular structure beneath; thus the arm looks rather like an unevenly stuffed sausage, and the relationship of the collar bone to the neck is one of adjacency rather than function.

Similarly, when we look at Michelangelo's God the Creator in the *Creation of Adam*, (fig. 59), in comparison to Grünewald's *St. Paul* (fig. 79) from the *Isenheim Altarpiece*, we see two elderly men. Michelangelo's generalized and idealized creator has mythic grandeur and power of form,

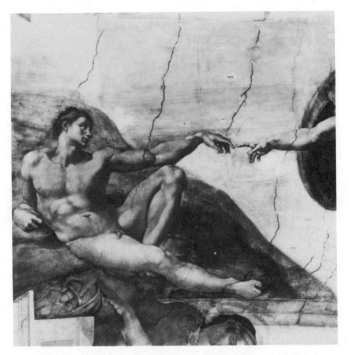

73. *Adam* detail from Michelangelo, *Sistine Chapel Ceiling*.
Photograph courtesy Office of Director, Monumenti Musei e
Gallerie Pontifici, Città del Vaticano.

76. *Ilissus* from Parthenon, West Pediment, c. 440–432 B.C. Marble.
Copyright the Trustees of the British Museum, London. (A).

74. *Crucified Christ* detail from Grünewald, *Isenheim Altarpiece*. Courtesy of the Musée d'Unterlinden. Photography by Otto Zimmermann.

75. Michelangelo, *Pieta*, c. 1498–1499. Marble; height 68-1/2 inches. Basilica of St. Peter, Vatican City. Photograph courtesy of Alinari/Art Resource, New York. (5948).

77. LEFT: *Adam* detail from Michelangelo, *Sistine Chapel Ceiling*. Photograph courtesy Office of Director, Monumenti Musei e Gallerie Pontifici, Città del Vaticano.

78. RIGHT: *St. Sebastian* detail from Grünewald, *Isenheim Altarpiece*. Courtesy of the Musée d'Unterlinden. Photography by Otto Zimmermann.

79. RIGHT: *St. Paul* detail from Grünewald, *Isenheim Altarpiece*. Courtesy of the Musée d'Unterlinden. Photography by Otto Zimmermann.

80. LEFT: Michelangelo, *Florence Pieta*, 1548–1555. Marble; height 92 inches. Museo dell'Opera del Duomo, Florence. Photograph courtesy of Alinari/Art Resource, New York. (1588).

and his immense body is freed from gravity and quite believably and majestically floats before us. Grünewald's St. Paul, whose face has the particularity of a portrait, has shrunken arms which have the pathos and the distortions of aging flesh. Michelangelo's God is indeed Godlike; Grünewald's St. Paul speaks of the finitude of human beings and the transitory character of the flesh. The head of St. Paul, like the head of St. Sebastian, is presented to us with all its irregularities, e.g., the wrinkled brow and enormous ear are emphasized. St. Paul has been identified as a self-portrait of Grünewald himself, through its resemblance to a known Grünewald drawing. The artist, however, was about fifty-four years of age when he completed the altarpiece, if our scant information is to be trusted. Very little is known of his life and even his name is a fiction. He was known as "Mathis the Painter" to his contemporaries; and it was this appellation that Paul Hindemith used when he wrote his musical tribute to the master.[6] We know that "Mathis" was court painter to the arch-bishop electors of Mainz; that in 1520 he met Dürer who made a gift to him of some drawings; that he died in 1528, the same year as Dürer; and that among his effects, at his death, were some Lutheran writings.

Michelangelo's own self-portrait, which is a part of the *Florence Pieta* (1548–1555: Museo dell'Opera del Duomo, Florence) (fig. 80), shows the idealization and regularization of the features typical of all his work. He came of an old Florentine family, but his features, as we know then from other portraits, were irregular and somewhat satyrlike. Further, a youthful fight with another artist left Michelangelo with a broken nose. In this beautiful autoportrait at the age of eighty, these irregularities were ignored and the essential man—noble, weary, and inward—looks down with unseeing eyes upon the body of Christ in his arms.

Michelangelo's Eve (fig. 81) and Grünewald's Magdalen (fig. 23) show the female form as created by these two artists. Eve is summoned forth from the side of Adam by her maker. She rises in the attitude of prayer, and her full, rounded figure is a sensuous whole. The Magdalen by Grünewald, by contrast, is fully clothed in concealing garments that beautifully underline the crescent curve of her little body. Her cheeks quiver, her mouth trembles, her fingers lock impetuously, and her hair vibrates as if with electricity, as she, in an ecstasy of agony, looks up at her crucified Lord. Her face is that of a particular individual, rather than being like the archetypal image of Michelangelo's Eve.

Michelangelo's *Doni Tondo*, or the Doni *Holy Family* (c. 1503: Uffizi Galleries, Florence) (fig. 82), painted about four years before he began work on the *Sistine Ceiling*, provides the best example for contrasting his female type with Grünewald's Madonna and Child from the *Isenheim Altarpiece* (fig. 83). Michelangelo's athletic Mary has all the sense of

81. LEFT: *Eve* detail from Michelangelo, *Sistine Chapel Ceiling.* Photograph courtesy Office of Director, Monumenti Musei e Gallerie Pontifici, Città del Vaticano.

82. RIGHT: Michelangelo, *Doni Tondo,* c. 1503. Oil on wood; diameter 47-1/4 inches. Uffizi Galleries, Florence. Photograph courtesy of Giraudon/Art Resource, New York. (PEC 4155).

83. LEFT: *Mother and Child* detail from Grünewald, *Isenheim Altarpiece.* Courtesy of the Musée d'Unterlinden. Photography by Otto Zimmermann.

84. RIGHT: *Mary and Angel Choir* detail from Grünewald, *Isenheim Altarpiece.* Courtesy of the Musée d'Unterlinden. Photography by Otto Zimmermann.

volume and clarity of contour and position which a sculptured figure possesses. Clearly, Michelangelo has taken pleasure in the draftsmanship of the Virgin's complex position: in particular, her left arm which curves toward us and then away from us, creates a foreshortening which the artist masterfully articulates. Michelangelo has created large unbroken forms and planes in the Virgin's blue mantle, and in the yellow robes about Joseph's legs. But as our eyes move upward toward the Christ Child, the rhythm quickens as the shapes become smaller and more complex. The arms and legs of the Christ Child, St. Joseph's hand which holds his torso, the hand of the Virgin with its skillfully modeled fingers adjacent to the genitals of the child, the Christ Child's features and curled locks—all elements present a concentration of carefully modeled small forms that accentuate the culmination of the pyramidal mass made by the three interlocking figures. In this tondo, we see as much of nature as Michelangelo ever depicted: a few plants and tufts of grass are in the foreground and a limpid suggestion of lake or river, hills and mountains, in the background. But these are of such minimal importance as to hardly claim our attention. Of much greater interest are the nude figures who disport themselves behind a stone balustrade. These nude figures are thought to symbolize the pagan world before the coming of Christ, and the young lad in the right middle ground holding a reed cross over one shoulder is the young St. John the Baptist, who here stands in the world of the old dispensation but looks up at the Holy Family and the coming of the new.[7]

Michelangelo's Mary the Mother has a sculptural face. The irregularities that characterize any particular human face have been eliminated in order to create an idealized, symmetrical countenance. This Mary is akin to one of the Sibyls of the *Sistine Chapel Ceiling*. Grünewald's Mary, on the other hand, has the high forehead and shallow eye sockets, irregular cheek line and slight double chin of a young German matron.

Michelangelo's Mary is heroic; Grünewald's, the tender mother absorbed in her child. Michelangelo's Christ Child is held aloft by the parents and seems a solemn infant athlete. Grünewald's babylike Christ Child looks happily up at his mother while playing with a rosary. We note the ragged swaddling clothes about the child and recognize the loincloth that will encircle the body of the crucified Christ. But this is a minor note in an otherwise paradisaic scene. Grünewald's mother and child are on an open terrace surrounded in the foreground by domestic details of the child's bed and chamber pot; a red rose "without a thorn," an attribute of Mary, and a wall with a closed gate, an allusion to Mary's virginity, are behind them. Beyond is a phantasmagoric scene, a distant path on which a shepherd looks up at two annunciating angels. Precipitous mountains

lead our eyes upward to the light that illumines the angels who ascend and descend about the throne of the Almighty. These are the "heavenly host praising God and saying, 'Glory to God in the highest, and on earth peace among men with whom he is pleased!' "[8]

This Christmas scene, which ranges from the homely, earthy detail of the chamber pot, to the heavens in which a spectral deity is glimpsed at the heart of a golden shower of light, gives us the full range of Grünewald's art. He emphasizes the finite, perishable, and transitory character of life.[9] Grünewald sees the natural world about us as teeming with growth, life, vitality, fantastic mountains, thick, black, fearful forests. In contrast, the natural world for Michelangelo is but a backdrop for the heroic deeds of humankind. Michelangelo's figures always dominate the minimal environment. His supreme and only interest is humanity and God, and humanity for him is archetypal, not particular and finite, as is the case of Grünewald.

For example, consider the strange, frondlike, boneless fingers of Grünewald's mother and child, and recall to your mind's eye the beautiful hands of Michelangelo's Mary, with the bony and muscular structure clearly articulated. Note further the red rose of Grünewald, which is so poetically painted that we seem to smell its fragrance.

The Christmas scene and the Angel Choir are depicted together and are the two subjects at the center of the altarpiece under the Crucifixion panel. In the background of the Christmas scene, Grünewald portrayed God the Father enthroned in heaven. In contrast to this enthroned ruler, Michelangelo's God as depicted in the *Creation of the Sun and Moon* is a mobile figure. Michelangelo has represented a mighty God as moving toward us, who with a powerful, fiatlike gesture creates the sun that spins toward us at the center of the scene. We see him a second time, when having thrust forward around the sun, he moves back into the cosmos and with another gesture creates the moon. What an extraordinary, imaginative creation of Michelangelo! These two massive, ponderous figures, yet so believably thrust through space, are freed from the claims of gravity. What marvelous daring to represent the Creator from the rear, so that we, like Moses, see his backside, and even the soles of his feet! The contrast with Grünewald's God, who is scarcely delineated at the center of an aureole of light, is striking.

Grünewald's presentation of the angel choir with Mary the Mother (fig. 84) crowned with flame is a fantasy of a most extraordinary exuberance. We see a pavilion, which though apparently of stone, breaks forth into bloom and blossom and has figures of prophets who, though depicted as carved, burst into life, gesticulating to one another in lively fashion. In the foreground a snub-nosed, plump-cheeked German lassie impersonates an

angel playing a cello. Behind, a host of fantastic seraphim and cherubim play instruments as they cluster about the Virgin of the Incarnation.

When the Christmas and Angel Choir panels are opened, they have on their backs two episodes from the life of St. Anthony, the patron saint of the Order of St. Anthony that maintained the large monastery for whom the altarpiece was made. The Antonite monastery was part of a hospital order devoted to the care of the sick, in particular to those who had diseases of the skin—leprosy, syphilis, and the terrible affliction called St. Anthony's Fire. Recent studies have identified the plants as herbs used in the fifteenth and early sixteenth centuries for their medicinal properties, in this case, for the patients of the Antonite hospital at Isenheim.[10]

St. Anthony is depicted in conversation with the elderly hermit, St. Paul. The setting is a wilderness with weird, dead trees covered with pendant moss, a strange palm tree, and broken boughs. Above a great raven flies downward, with the loaf of bread which, according to the *Golden Legend,* he daily brought to the hermit, St. Paul, to sustain him in his remote retreat.

Grünewald's St. Anthony is represented again in the companion panel in the throes of a horrific nighmarish scene, the *Temptation of St. Anthony* (fig. 85). Here the saint is assaulted by monstrous, fantastic demons. These devils are imaginary combinations of all kinds of human and bestial elements. The details of the various parts are accurately observed, but when these are combined in fantastic, extremely ingenious ways, they become repulsive, abnormal, pathological freaks. It is curious that, whereas Grünewald's mortals seldom are convincing as organisms, these monstrous, demonic creatures of his imagination do indeed have an extraordinary, believable, organic unity, despite the fact that they are a compound of loathsome, disparate parts. The agonized figure seated in the lower left corner of the panel is thought to be the demon of leprosy or syphilis or St. Anthony's fire. His distended abdomen and flesh covered with repulsive running sores suggest the victims of these diseases which the monks of Isenheim specialized in treating.

St. Anthony cries forth to God, his lament appearing on a parchment on the lower right. Translated, this Latin inscription reads, "Where were you good Jesus, where were you? Why were you not there to heal my wounds?" This lament is ascribed to St. Anthony by his biographer, Athanasius. God the Father *is* faintly visible, enthroned on high, holding a great scepter. He sends forth the Archangel Michael to do combat with the forces of evil. Michael is almost transparent as he assaults an insect-like devil who springs off the rooftop with his shield thrust forward.

The nightmarish surrealism of Grünewald's vision of the assault of the forces of evil contrasts dramatically with Michelangelo's analogous repre-

86. Michelangelo, *Last Judgment*, 1536–1541. Fresco; 48 × 44 feet overall. Sistine Chapel, Vatican City. Photograph courtesy Office of Director, Monumenti Musei e Gallerie Pontifici, Città del Vaticano.

85. *Temptation of St. Anthony* detail from Grünewald, *Isenheim Altarpiece*. Courtesy of the Musée d'Unterlinden. Photography by Otto Zimmermann.

sentation in the *Last Judgment* (1536–1541: Sistine Chapel, Vatican City) (fig. 86), painted by the master on the altar wall of the Sistine Chapel. The idea for this subject had come from Pope Clement VII, who was perhaps making reparation for the sack of Rome in 1527, for which he had been at least partially responsible.[11] Michelangelo began the painting in 1536 and completed it in 1541. It is said that Pope Paul III, who had goaded the artist into hastening the completion of the painting, fell on his knees, when he saw the *Last Judgment,* crying, "May the Lord forgive me my sins."

In its original state, with the figures appropriately nude, the vast fresco must have been even more compelling than as we see it today. But winds of reform were blowing. The Council of Trent, meeting from 1545 to 1564, made specific statements about immodesty in works of art. Pope Paul IV, after consulting Michelangelo himself, commissioned one of his pupils to veil the figures. Daniel da Volterra, who did the overpainting, thus became known to his contemporaries and to history as the "breeches-maker."

The great composition rotates about the figure of the Herculean Christ, who, with an upraised arm, draws the blessed into the heavens, and with the downward movement of his left hand casts the damned into Hell. A particular reason for discussing this painting is the demonic angels and the damned en route to Hell in the lower right zone. Since the demons are men whose humanity is only slightly modified by the addition of small, coiled horns and pointed toenails, it is difficult to identify them and disentangle them from the mortals whom they pull or thrust into Hell. The one clearly identifiable figure is the boatman, who derives not from biblical sources, but from Dante's *Inferno.*[12] But Charon is, as a person-ification of evil, far from Grünewald's grotesque, fearful conglomerates of human and bestial parts, which we saw in the *Temptation of St. Anthony.*

The massive figure at the right with ass's ears and a serpent entwined about his torso has a portrait-head. This is Biagio, the Master of Cere-monies for Pope Paul III, who saw the painting before the veiling of the nudes, and when asked his opinion, said the fresco was "more fit for a place of debauchery than for the Pope's chapel." The offended prelate's criticism reached Michelangelo's ears and the infuriated artist contrived his own revenge. He painted Biagio's features on the Dantesque Minos who presides over the farthest section of Hell at the lower right. The offended prelate complained to the pope, who wittily replied: "Had the painter sent you to Purgatory, I would have used my best efforts to get you released; but I exercise no influence in hell; *ubi nulla est re-demptio.*"[13]

Michelangelo's imagination works with the idealized human form. The

full range of human emotions and psychic states—love and hate, joy and terror, pride and shame, desire and lust, the sense of freedom and the sense of power—all are expressed by Michelangelo through the corporeal human body; indeed, more fully through the body than through facial expression. The Neoplatonic idea of the interpenetration of physical and spiritual being finds its most complete expression in the work of Michelangelo.[14]

Returning to the central panel of the *Isenheim Altarpiece* (fig. 87), we see what Otto Benesch called "a work of such tremendous and dismal grandeur of expression that nothing on earth seems equal to it."[15] The huge body of the Crucified hangs from a roughhewn crossbeam, his great head sunken between his shoulders, his rib cage taughtly expanded above the shrunken abdomen. The arms seem riven from their sockets. The ankles twist under the weight of the tortured body. The fingers are extended, clawlike, seeming to cry shrilly forth as they are silhouetted against the darkened sky.

Jesus is shown after "he bowed his head and gave up his spirit." John's Gospel relates how the Jews, in order to prevent the bodies from remaining on the cross on the sabbath,

> asked Pilate that their legs might be broken, and that they might be taken away. So the soldiers came and broke the legs of the first, and of the other who had been crucified with him; but when they came to Jesus and saw that he was already dead, they did not break his legs. But one of the soldiers pierced his side with a spear, and at once there came out blood and water.[16]

A great diagonal fissure in the side of Jesus gushes with scarlet blood; thus Grünewald has depicted a moment after the soldier, known in apocryphal literature as Longinus,[17] had pierced his side.

The unrelenting emphasis on physical suffering and the ghastly realism of the scene is related, we now know, to the writings of a fourteenth-century mystic, St. Bridget. A Catholic scholar found that her *Revelations on the Life and Passion of Jesus Christ and His Mother, the Holy Virgin Mary* was known to Grünewald and was a source of some of his imagery. Indeed, her vision of the crucified Christ reads like a description of Grünewald's painting:

> The crown of thorns was impressed on his head; it covered half of the forehead. The blood ran in many rills. . . . Then the color of death spread. . . . After He had expired, the mouth gaped, so that the spectators could see the tongue, the teeth and the blood in the mouth. The eyes were cast down. The knees were bent to one side; the feet were twisted around the

87. *Crucifixion* detail from Grünewald, *Isenheim Altarpiece.* Courtesy of the Musée d'Unterlinden. Photography by Otto Zimmermann.

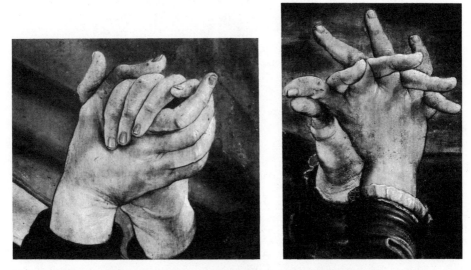

88. LEFT: *Hands of Mary* detail from Grünewald, *Isenheim Altarpiece.* Courtesy of the Musée d'Unterlinden. Photography by Otto Zimmermann.

89. RIGHT: *Hands of Mary Magdalene* detail from Grünewald, *Isenheim Altarpiece.* Courtesy of the Musée d'Unterlinden. Photography by Otto Zimmermann.

nails as if they were on hinges. . . . The cramped fingers and arms were stretched.[18]

St. John the Evangelist tenderly holds the fainting Mary the Mother, who wears a white enveloping shroud. The Magdalen's tremulous little body and electric hair express an anguish that is physical, as well as psychic. St. John the Baptist, anachronistically present at an event that took place after his beheading, is here depicted as the last of the prophets. He is physically larger than the group at the left of the cross and, as prophet, he holds the Scriptures in hand. But he is also present in his role as Baptist, and the healing waters of baptism are alluded to, by the waters behind him, and surely refer, as Andrée Hayum has shown, to the alleviating of pain and possibility of cures for the diseases afflicting those cared for in the Antonite hospital.[19] At his feet is the Agnus Dei, the Lamb slain before the foundations of the world, from whose breast blood flows into the chalice, the sacramental blood of the Eucharist. "The Blood of our Lord Jesus Christ, which was shed for thee, preserve thy body and soul unto everlasting life."[20]

True to a tradition of Christian art, the Magdalen and Mary the Mother represent two contrasting aspects of grieving womanhood. The identity of the Magdalen was argued by the early church fathers, but for Christian art she is not only the Mary who went to the tomb on Easter morning, but also the sister of Martha and Lazarus, and also the woman taken in adultery; she it was who anointed Jesus' feet and wiped them with her hair. She is thus envisioned as a woman of passionate nature, and epitomizes the sinner, who through forgiveness and awakened faith, becomes the saint. Whereas Mary the Mother is immobile with closed eyes and a deathlike pallor, Mary Magdalen's eyes seek her Lord's face, her arms stretch forth and her fingers work, as if she yearned to touch the Christ, to once again anoint his feet and wipe them with her hair. Careful study of the hands of the two Marys shows the contrast between the closed and nerveless hands of the Mother (fig. 88) and the vibrancy and appealing, seeking movements of the Magdalen's hands (fig. 89) whose contours are re-echoed in the repeated, restless curves of her sleeves.

An even greater contrast between these two artists and one which underlines the differing essential features of each master's style, is found in Grünewald's *Resurrection* (fig. 71) from the *Isenheim Altarpiece* and Michelangelo's *Resurrected Christ* (1519–1520: Santa Maria Sopra Minerva, Rome) (fig. 90). Though some of the sculpturing was done by an assistant of Michelangelo's, the conception of this Christ is his as well as much of the carving. He was commissioned by Metello Vari to execute "a life-sized marble figure of Christ, naked, standing, holding a cross in

90. Michelangelo, *Resurrected Christ*, 1519–1520. Marble. Santa Maria Sopra Minerva, Rome. Photograph courtesy of Alinari/Art Resource, New York. (6130).

91. Michelangelo, *Resurrection*, 1532–1533. Black chalk on paper. Copyright the Trustees of the British Museum, London. (W.52).

His arms, in whatever pose the artist judged to be suitable."[21] Michelangelo added the other instruments of the passion, such as the sponge, the lance, the cord. Christ's wounds are minimized and he does not display them: this is the naked figure of an Apollo of noble proportions and a beautifully modeled torso. The Christ figure holds the instruments of the passion against his right side, away from the spectator, and looks to his left, the side from which evil, traditionally, comes. This beautiful Apollonic Christ, who is both transcendent and entirely corporeal, contrasts sharply with Grünewald's Christ of the *Resurrection*, whose material body dissolves in the supernatural light that surrounds the upper half of the Resurrected Christ.

In Grünewald's panel, as Otto Benesch said, Christ flashes upward in the starry Easter night, a phantom consumed by light, as the whitish-blue shroud and the burning carmine-red of his clothes leap like flames consumed by the incandescence of his face.[22] A marvelous contrast to the immaterial face and upper torso of the Christ is found in his lower extremities, with their knobby knees and splayed feet, but even more emphatically in the three soldiers, who are so burdened by their heavy encasing armor that they stumble, dazzled and stupefied, and remain unseeing of the miracle that takes place in their presence.

It is of interest to note that the theologian Paul Tillich, whose sensibilities were trained in the ambience of German Expressionism, found in this *Resurrection* the only acceptable representation of this biblical event, because, he said, of the incorporeality of the Christ.[23] In contrast, the connoisseur and art historian Sir Kenneth Clark, who was nurtured on the Classical and Renaissance tradition, sees the altarpiece, for all its grandeur, as "revivalist art," which, in some panels, has "the vulgarity which accompanies too muchness." He concludes that it is only Grünewald's distinction of style and color that prevents a comparison with Walt Disney.[24]

This final panel, the *Resurrection* of the *Isenheim Altarpiece*, can also be contrasted with a beautiful drawing of the same subject by Michelangelo (1532–1533: British Museum, London) (fig. 91). Here we see the figure of the Christ ascending upward, with a movement of wondrous ease—a movement which seems partly that of the easy upward thrust of his own body and partly that of another source of energy which draws his body unto itself. The body of the Christ is wholly fleshly and yet so permeated by the claims of the spirit that flesh and spirit interpenetrate, transforming the material body into an emblem of the soul. In this beautiful drawing of the *ascenscio* is the upward flight of the spirit to God.

Northern art records the chaos of the real world, the actuality of a thousand details and accidents in all their finite particularity. Classical art

records the cosmos of the natural world with the implied suggestion of a kind of structure, order, and purpose. Northern art strives for spiritual unity and vitality; Classical art for organic and sensuous unity. Northern art is restless, labyrinthine, yearning for the infinite, and striving for it ceaselessly. Classical art is restful, contained and centric, moving back upon itself. Northern art shows the human person as enveloped by a teeming nature under the sway of capricious forces, sometimes demonic and sometimes angelic. Classical art shows humanity dominating nature, and nature as but a backdrop, or theater, for human exploits.

Classical art depicts the human as heroic whose errors, transgressions, and suffering all become mythic in their import. Northern art depicts the human as individual, finite, fallible, and subject to decay, disease, and death. Classical art portrays man and woman in full-blown maturity, opulently at ease with their own sensuous flesh and in complete command of their own strength and energy. Northern men and women scarcely know their own bodies, for they are concealed beneath layers upon layers of garments. In art we know these Northerners mostly by their portrait heads and gesticulating hands, and when they do indeed appear without apparel, they are "naked," rather than nude. Northern art is replete with literary suggestions, storytelling detail, and even the inclusion of actual sentences or captions (as in the St. Anthony panel). Classical art communicates not by literary additions but by the human body, its posture and gestures, which become so fully the vehicle for the psychic and physical states of the man or woman depicted, that we need no additional clues for the communication of meaning.

1981

7

Lucas Cranach, Reformation Picture-Maker

Why the painter Lucas Cranach? Two reasons lie behind this study: first he was a northern artist; second, he had a central role in the Protestant Reformation. Most of us are either Northern or Mediterranean by taste and temperament. This innate source of our preferences determines many of our choices and judgments, even though we may credit our choices to intellectual factors.

Northern art presents intimate and cozy interiors, often crowded with many objects rendered with loving attention to texture and detail. The persons inhabiting these chambers are dressed in heavy, all-encompassing and elaborate garments. The Northern penchant is for crowded and cluttered space; for detail upon detail; for the written word in the painted picture; for a natural world invaded at times by spooks and demons, angels and cherubim; for the human figure concealed by voluminous garments; or when without clothing, naked, rather than nude. This is Cranach's world.

The Mediterranean world is one where interior and exterior are joined, where nature consists of wide and tranquil vistas, serene settings for the activities of gods, saints, and human beings. The human figure is a living, breathing organism at ease with her or his own nudity and at home in nature. The angels abide in their heavens and the demons remain in purgatory and hell.

It was the Northern, rather than the Mediterranean, world that was home to Cranach's work, and it was the northern world that was the locus

"Lucas Cranach, Reformation Picture-Maker" was first presented to the Saturday Morning Club, Hartford, Connecticut, in 1982.

for the Reformation. Lucas Cranach was at the center of the Reformation—a friend of Martin Luther, and the "official" picture-maker of the Reformation. The blatant, programmed destruction of so much art in the cause of the Protestant revolution has given some art historians, myself among them, a strong bias against the Reformation. However, ultimately more harmful than that destruction, has been the subsequent legacy of hostility and indifference to works of art for the church, a legacy which continues to plague Protestant churches to this day. Thus it seems worthwhile to go back to the beginnings of the Protestant revolution and survey the development of the climate that even today influences many churches.

Lucas Cranach was born in 1472 in the small town of Kronach, which was then part of the Holy Roman Empire. He was three years younger than Michelangelo, who outlived him by eleven years. Both men were painters and each created works of art in other media. What they were, and what they created, are dissimilar in almost every other respect.

By 1504, when Cranach was thirty-two, he had become court painter to Frederick the Wise, Elector of Saxony, and, in 1508, was ennobled by Frederick, who gave him as crest of arms the sable serpent with bat wings of the same, crowned with gules and holding in its mouth a ruby mounted on a gold ring.[1] This was Cranach's signature thereafter, which one can see if one examines any of Cranach's paintings. The artist loyally served three successive electors, painting for them portraits and altarpieces, and designing coins and medals, book illustrations, court appointments, costumes, et cetera.

If we even glancingly consider Cranach's various business and civic enterprises, we wonder how he could have had time to paint and supervise his workshop. Records show that he owned four houses and extensive land in Wittenberg. He served as treasurer and councillor of the town government, and repeatedly was mayor of Wittenberg from 1537 to 1544. Cranach was apothecary by appointment of the Elector and with this post came a magnificent house; he sold not only medicines but also spices and sweet wines. He owned a bookshop, and, with a friend, ran a printing works and paper mill.

Wittenberg, which was Cranach's home for the fifty years between 1505 until 1555, when he followed his patron John Frederick the Magnanimous into exile, was the locus of the revolution we refer to as the Reformation. It was here that Luther allegedly posted his theses on the door of the castle church, an act that set Germany and the North against the hegemony of the church and the papacy. Cranach and Luther became friends, and Cranach became the picture-maker of the Reformation.[2] Who, then, was Lucas Cranach the artist?

Cranach represented *The Fall* (c. 1513–1515: Mainfraukirches Mu-

seum, Wurzburg) at the moment when the words of the serpent who was "more subtle than any other wild creature" lured *Eve* into taking and eating from the tree of the knowledge of good and evil.[3] She has already given Adam a branch that bears an apple and also a cluster of leaves, which quite propitiously and modestly covers his pubic zone. Adam's gesture as he points to himself with his right hand, seems hesitant, and his posture, too, seems indecisive. Eve, however, stands firmly frontal, and her expression has a knowing resoluteness.

The bodies of both figures are given a subtle prominence by the amorphous dark background that silhouettes their contours. Within these contours, the flesh gleams softly and sensuously, but with only a suggestion of the bony and muscular organism beneath. We have only to compare Cranach's images of Adam and Eve with Michelangelo's fresco of *The Temptation and the Fall* (1508–1512: Sistine Chapel, Vatican City) (fig. 11), done only a few years previously, to see how, by contrast, Michelangelo with his intensive study of the human body was able to suggest the living, breathing, moving organic unity of the body. Cranach's figures, however, seem relief-like in contrast; they are naked and vulnerable in contrast to Michelangelo's heroic nudes.

In Michelangelo's fresco, the drama of the moment is conveyed more by the posture of the figures than by facial expression—Michelangelo's Adam purposeful reach, his tense buttocks and visible sexual excitation; Eve's opulent inviting, crouching posture and upward gesture. In Cranach's painting, it is Adam's hesitance and curiosity, with his head to one side, that indicates his response; and it is clearly Eve, with her composed and knowing expression, who is in command; the serpent coiled about a branch above and seemingly still talking to Eve, is lodged wholly on Eve's side of the tree. There can be no doubt that Cranach saw Eve as the culprit and Adam as the hesitant accomplice, whereas for Michelangelo, Adam and Eve were equally complicit. Cranach's Adam and Eve experience complex psychic and emotional tugs, which their faces express.

Michelangelo's use of the body to convey meaning rather than facial expression, was not due to the placing of the painting high on the vault of the Sistine Chapel. It is, rather, a general characteristic of Michelangelo's entire oeuvre, as it is of the classical art which he studied with such care. The wholeness of body and soul, flesh and spirit is affirmed by all truly classical art and was reaffirmed by the neoclassical artists of the Renaissance. For the artists nurtured in this tradition, the body expressed the psyche and the flesh was informed by spirit.

By contrast, northern artists like Cranach came out of a different tradition—the tradition of medieval manuscript illuminations. Instead of heroic sculptures of the nude, this tradition is that of the illustration for a

text; tiny in size, exquisite in workmanship, jewel-like in color, and, embellished by decorative detail of great beauty, which has often no relation to the episode in the illustration.

Cranach's *The Garden of Eden* (1530: Kunsthistoriches Museum, Vienna) (fig. 92) illustrates the northern understanding of humanity and nature. The Garden is spread out before us, opulent with flowering bushes and fruited trees, grassy slopes and distant vistas. It is the setting for a succession of events that appear to take place simultaneously. In the lower center, the Lord God blesses Adam and Eve;[4] in the upper left, we see the crouching Adam and Eve trying to hide their nakedness from the Lord God whose head, surrounded by clouds, floats in the sky. At the upper right, he creates Adam while in the center background God pulls the body of Eve from the sleeping Adam's side. Between these two episodes, Eve offers the fruit to an Adam who in perplexity scratches his head, as both are watched by a serpent with the head and torso of a young German maid. The story ends with the episode at the extreme upper left, where the guilty pair scamper out of Eden, only slightly ahead of the cherubim with a flaming sword. It is a charming painting. Rather than resounding with grand mythic overtones, its mood is "once upon a time . . ." Nature is represented as encompassing and bountiful. Cranach has added a variety of birds and animals, mostly in pairs, emphasizing perhaps the Lord God's directive to Adam and Eve that they shall have dominion over "the birds of the air and over every living thing that moves upon the earth."[5]

If we examine any of Cranach's figure groupings in this painting, it shall be seen that the figures seem composed separately, as if cut-out and then placed, like paper dolls, about the natural setting. This separateness of the human figure from its setting is often a characteristic of northern art. Cranach quite literally had one perspectival viewpoint of his figure groups; all of these are seen as if directly in front of us. However, another perspective is used for the rolling landscape, which we see as if from a second- or third-story building, looking down and across the expanse.

The Garden of Eden was painted by Lucas Cranach the Elder when he was fifty-eight years old, and when his two sons, Hans and Lucas the Younger, were both active in his studio. Both sons were so skillful in adopting the style and imagery of their father, that discerning which paintings may be by their hands is a difficult art historical problem. To see Lucas Cranach's style before the time when, as court painter, he had a large and busy studio under his supervision, we turn to an early work, *The Crucifixion* (1503: Alte Pinakothek, Munich) (fig. 93), painted when the artist was thirty-one.

It is a powerful painting. The off-center, foreshortened cross and

92. Lucas Cranach the Elder, *The Garden of Eden*, 1530. Kunsthistoriches Museum, Vienna. (A2.986).

104. Lucas Cranach the Elder, *The Fountain of Youth*, 1546. Courtesy Gemaldegalerie, Staatliche Museen Preussischer Kulturbesitz, Berlin (West). Photograph by Jorg P. Anders. (593).

corpus loom above us at our right. Swirling dark clouds provide an ominous background for the bowed head of the crucified. The two thieves, whose bodies are hung from shortened crossbeams, close in our view of the scene at the left. Between the Christ and these figures, we see John the Evangelist and Mary the Mother, who has been committed into his care, their bodies joined by their interlinked arms. John looks compassionately at Mary, his frondlike fingers interwoven in a curious gesture. Mary stares upward at Jesus, her chin tremulous. Her fingers are also clasped as she wrings her hands in grief. It is not only through facial expression and gesture that St. John and Mary express their grief: their draperies swell and cascade about them and culminate in rolling, grief-full chords that seem unresolved and dissonant.

The analogy to musical motifs and rhythms is suggested also by the extraordinary, large, convoluted, honey-colored loincloth about the figure of the crucified. The loincloth terminates in a roll of drapery with fluttering ends which, freed from the forces of gravity at the time of this cosmic tragedy, levitates miraculously against a pale blue sky. Nature provides a setting that seems integral to the tragedy. Life and death intermingle here; a leafless and dead tree springs from a vigorously growing tree. The foreground is barren of growth and inhabited only by images of death, a few up-curving ribs, and a skull (perhaps the skull of Adam) and a bit of backbone near the cross of Christ; but in the background we see a tranquil scene of hills and mountains, a winding road, and an old castle.

Life and death are juxtaposed most dramatically by Cranach's placing of the interlinked figures of the grieving Mary and John at the center of a triangle formed by the three crosses with their grotesque dead bodies. Cranach emphasized the blood and wounds of Christ, and we are particularly aware of the swollen feet with the great wounds caused by the immense nail's brutal thrust. The thief who hangs frontal to us has a heavy body, a thick neck, and great head. Such a body, hung from the two palms (without any pinning of the feet to the lower cross), causes us to shudder. But look again, the one arm which is visible seems raised, almost in salutation. This is the thief who repented and whom Jesus promised from the cross, "Today you will be with me in Paradise."[6] Traditionally in art, he is shown to be less tormented than the unrepentant thief. This painting of the *Crucifixion* by Cranach shows his own hand at the beginning of his career.

Thirty-three years later, he painted a smaller panel, *The Crucifixion with the Converted Centurion* (1536: National Gallery of Art, Washington, D.C.) (fig. 94). Longinus is the legendary name of the Roman centurion who was posted at the foot of the cross, and who, as Jesus

"breathed his last," declared, "Truly this man was the Son of God!"[7] We see these words written out in German, parallel with the mouth of the centurion. Above the Christ, again in German, is the so-called Seventh Word of Christ spoken from the cross, "Father, into thy hands I commit my spirit!"[8] The Christ and the two thieves are hung high against turbulent dark clouds that hang over a rainbow sky ranging from blue to pink to orange to yellow. The three crosses are placed on a barren moonscape of land at the edge of the world. The Christ looks upward and his arms stretch forth serenely, while his body bears little evidence of wounds or suffering. His fleshly body, with its pirouetting white loincloth, contrasts strangely with the heavy steel armor which encases the Longinus. The red velvet hat of the centurion, with its elegant ostrich feathers, is an oddly frivolous and worldly detail in so somber a scene.

From the early *Crucifixion* with its emotional intensity to this highly finished, "cool" scene is a jolting shift. The thirty-three years that separate them were busy, productive years for Cranach, and two changes in his life must be noted. First, he had become court painter to Frederick the Wise the year after completing the early *Crucifixion;* the appointment involved him in many commissions such as portraits and easel paintings, court decorations, book illustrations, costume and jewelry design, and so forth. He headed a large studio, indeed some art historians refer to it as a "factory," for the production of this diversity of items. His style as carried out by his workshop became more refined, stressing the outlines of figures and objects, often against a dark background. The surfaces of the paintings became glossy and miniature-like, the colors cooler and sometimes slightly dissonant.

Some of these changes result from the workshop setting, such as the change from an impassioned personal brushstroke to a glossy surface where the individual brushstroke is hidden. Changes in the color scheme are related in part to a general stylistic change in the painting of the time. Northern art and the art of Italy evolved in the sixteenth century toward a style termed "Mannerism." The slightly dissonant colors and "cool" emotional tonality of Cranach's later paintings are Manneristic.

The advent of the Reformation was another change that occurred between Cranach's painting of the two *Crucifixions.* Cranach was a friend of Luther's and had been a witness at Luther's marriage to the former nun, Katharina von Bora. As one scholar remarked, that must have taken a certain amount of courage on Cranach's part, for even Luther's friend, Melancthon, had refused to come to the wedding.

Cranach and his sons became the picture-makers of the Reformation, turning out portraits of Luther, and of his friends, such as the group portrait, *Martin Luther and the Wittenberg Reformers* (c. 1543: The

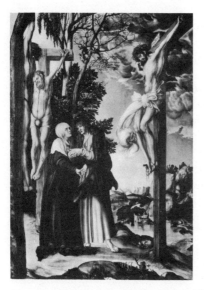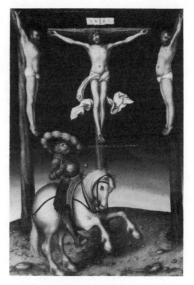

93. LEFT: Lucas Cranach the Elder, *The Crucifixion*, 1503. Oil on wood; 138 × 99 cm. Alte Pinakothek, Munich. (#1416).

94. RIGHT: Lucas Cranach the Elder, *The Crucifixion with the Converted Centurion*, 1536. Oil on wood; 0.508 × 0.349 (20 × 13¾ in.). Samuel H. Kress Collection, National Gallery of Art, Washington, D.C. (1961.9.69 [1621]).

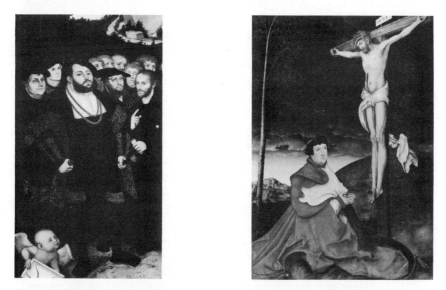

95. LEFT: Lucas Cranach the Younger, *Martin Luther and the Wittenberg Reformers*, c. 1543. Oil on wood panel; 158 × 112 cm. The Toledo Museum of Art, Gift of Edward Drummond Libbey. (26.55).

98. RIGHT: Lucas Cranach the Elder, *Cardinal Albrecht Kneeling before Christ on the Cross*, c. 1520–1525. Oil on canvas; 158 × 112 cm. Alte Pinakothek, Munich. (#3819).

Toledo Museum of Art, Toledo) (fig. 95), featuring Luther, Melancthon, and the elector John Frederick the Magnanimous. We know that, together with a fellow member of the Council, Cranach helped launch Luther's translation of the New Testament.[9] It was because of Luther's translation of Scripture into German that Cranach could and did use German rather than Latin in the inscriptions on *The Crucifixion with the Converted Centurion.*

Returning to that painting, we are aware of the specifically "Protestant" thrust of the quotations within the painting. Both emphasize faith—the centurion's awakened faith in his affirmation, "Truly this man was the Son of God," and Jesus' faith expressed in his last words, "Father, into thy hands I commit my spirit."[10] The painting is illustrative of Luther's emphasis on faith over good works. The inclusion of the inscriptions, and thus the intrusion of verbal dicta in a characteristically visual mode of expression, is another evidence of the centrality of teaching among the Reformers and Protestants.

In Reformation art, scriptural quotations are frequently incorporated into the work of art to underline the true (i.e., approved) meaning of the work of art. It should be noted, however, that the glory and the power of great works of art lie in their capacity to express a range of profound meanings, including ambiguous or contradictory meanings, by wholly visual means. The early Reformers saw the abuse of art in Roman Catholicism of their day and narrowed the range of meanings, emphasizing didactic values and including inscriptions within the work of art.

An interesting sidelight into the religious history of the times is provided by the group of paintings that Cranach did for Luther's arch enemy, Cardinal Albrecht of Brandenburg, who of course was a Papist and in favor of the sale of indulgences. "Albrecht of Brandenburg, who had bought himself the Cardinalate of Mainz as a young man" was one of the most wealthy men of his time.[11] He employed two other famous German artists, both admirers of Luther—Albrecht Dürer and Mathias Grünewald.[12] Thus, it is evident that artists found employment on both sides of the religious feud.

Cranach's painting of *Cardinal Albrecht of Brandenburg as St. Jerome* (1526: The John and Mable Ringling Museum of Art, Sarasota, Florida) (fig. 96) is a curious painting based on an engraving by Dürer, *Saint Jerome in his Study* (1514: National Gallery of Art, Washington, D.C.) (fig. 97). Whereas Dürer's *Saint Jerome* breathes the sunny, quiet tranquility of the scholar's study, Cranach's painting has an uneasy and surrealist sense of tipped and tilted space that is inhabited by bizarre and unrelated objects. Dürer's great pussycat of a lion seems comfortably at home in the saint's study; but lion, deer, parrot, beaver, and pheasants

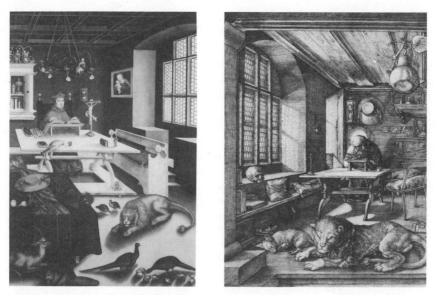

96. LEFT: Lucas Cranach the Elder, *Cardinal Albrecht of Brandenburg as St. Jerome*, 1526. Oil on wood panel; 45¼ × 35⅛ in. The John and Mable Ringling Museum of Art, Sarasota, Florida. (S. N. 308).

97. RIGHT: Albrecht Dürer, *Saint Jerome in his Study*, (Meder 59) 1514. Engraving. Rosenwald Collection, National Gallery of Art, Washington, D.C. (B-6549 [1943.3.3524]).

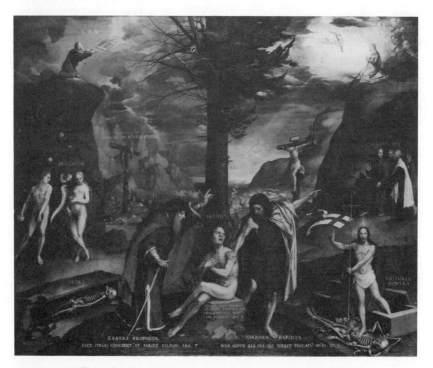

99. Hans Holbein the Younger, *Allegory of the Old and New Testaments*, c. 1532. National Galleries of Scotland, Edinburg. (NG 2407).

seem an odd intrusion into Albrecht's study. Dürer's *Saint Jerome* sits with pen in hand, his head bent over his writing, while Cranach's Albrecht, alias St. Jerome, stares forth dourly and vacantly into space.

As for Cranach's painting of *Cardinal Albrecht Kneeling before Christ on the Cross* (c. 1520–1525: Alte Pinakothek, Munich) (fig. 98), Pierre Descargues's description is splendid:

> The figure of Christ is bleeding . . . but the body is outstretched as if about to fly while the loincloth floats out behind the Cross, above rising ground whose rounded shape suggests the earthly planet itself. The bleeding feet of Christ contrast horribly with the plump beringed hands of the Cardinal, who kneels on an enormous cushion of the same scarlet as his gorgeous robes. This stream of red seems to be fed by the blood flowing from the Cross . . . A heavy sky . . . covers half the picture, as if portending the end of the world, lending grandeur to this painting of a fat red man kneeling comfortably in a desert at the feet of a crucified Christ.[13]

Cranach's distaste for this worldly cleric comes through this striking, but unpleasant painting.

Cranach's identification with Luther and the Reformers was, however, well documented. From his studio came the original version of the painting, *Allegory of the Old and New Testaments* (c.1532: National Galleries of Scotland, Edinburgh) (fig. 99), which diagrams the Protestant teachings. This painting is attributed to Hans Holbein the Younger (1497/8–1543), who was a slightly younger contemporary of Cranach's.

The viewer will note the numerous inscriptions and identifications within the painting that are needful for the correct interpretation of the work of art; without the labels for the various episodes and knowledge of the scriptural events and their context, the painting is as surrealist as the wildest fantasies of Salvador Dali. With the labels the painting is a document of the Reformers which illustrates afresh, with new emphases, the Protestant interpretation of Scripture. The message of the painting is conveyed by the inscriptions visible to the attentive viewer. Decoded these inscribed words yield the following message:

> The subject is the opposition of the Law *(LEX)* and Grace *(GRATIA)*, one of the most important in Reformation iconography. Implicit in it is the Lutheran doctrine of Justification by Faith. Reliance on the Law which Moses received on Mount Sinai leads to sin *(PECCATUM)* and death *(MORS)*. Belief in Christ who conquered sin and death *(VICTORIA NOSTRA)* leads to salvation. Man *(HOMO)* is presented with a choice. His attention is however drawn by Isaiah *(ESAYAS PROPHETA)* to the Virgin kneeling on Mount Sion who is being infused with the soul of Christ *(ECCE VIRGO CONCIPIET ET PARIET FILIUM. ISA. 7)*; while John the

Baptist *(IOANNES BAPTISTA)* points to Christ *(AGNUS DEI)* and his disciples (the *Agnus Dei* is unusual here in that it is normally represented by the Paschal Lamb). The example of Christ who obeyed God's will *(ECCE AGNUS ILLE DEI, QUI TOLLIT PECCATA MUNDI. 10.1)* is contrasted with the disobedience of Adam and Eve. The Brazen Serpent *(MYS-TERIUM IUSTIFICATIONIS)* raised above the plague-stricken Israelites with the Fall of Manna depicted beyond is included as a prototype of the Crucifixion *(IUSTIFICATIO NOSTRA)*. Here however the idea of the new dispensation as a fulfillment of the old ends, and the marked Lutheran character of the allegory, in which the two are polarized, lies in the fact that the tree is bare on the side of the Law and in leaf on that of Grace. The choice and tone of the quotation from Paul's Epistle to the Romans: "Wretched man that I am! Who will deliver me from this body of death? Thanks be to God through Jesus Christ our Lord" *(MISER EGO HOMO,/ QUIS ME ERIPIET EX/HOC CORPORE MORTI/OBNOXIO RO. 7)* is characteristically Lutheran; as is the Virgin's diminutive role. [14]

Man *(Homo)* is central to the composition but he is perplexed and beset, and exhorted by the Prophet Isaiah and by St. John the Baptist. That Man, that is, *Everyman*, should be the central character in the drama is a quite fascinating development and an innovation of the Reformers. In previous religious art, there is no real parallel. In the crowds about Jesus, or the saints, we saw the followers and the persecutors but not Everyman. Here Everyman is between two alternatives and is instructed about the meaning of each. The painting is an illustrated lecture propelling Everyman toward the Gospel and away from the Law.

Carl Christensen notes that Luther contrasted the doctrines of Law and Gospel. Luther said:

> This difference between the Law and the Gospel is the height of knowledge in Christendom. Every person and all persons who assume, or glory, in the name of Christian should know and be able to state this difference. If this ability is lacking, one cannot tell a Christian from a heathen or a Jew; of such supreme importance is this differentiation. [15]

Clearly, the painting was intended to instruct the Christian in this Protestant interpretation. The problem is that this is more of a burden of meaning than the visual arts can carry and still retain the integrity of the work of art as art. Though numerous copies of Cranach's original paintings were made, those and the Cranach studio originals are regarded as minor works of art. They have been ignored by art historians until the recent interest on the part of intellectual historians in the general cultural setting of the Reformation.

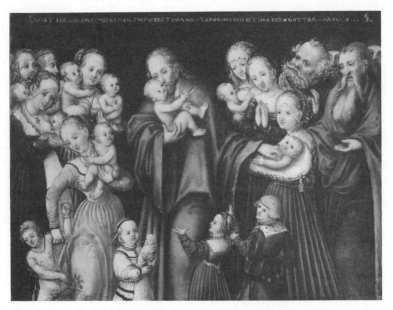

100. Lucas Cranach the Elder, *Christ Blessing the Children*, 16th century. Oil on wood; 6¼ × 8¾ in size.

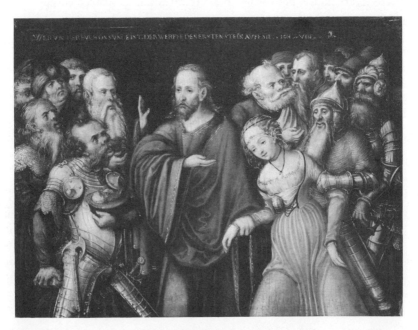

101. Lucas Cranach the Elder, *Christ and the Adultress*, 16th century. Oil on wood; 6¼ × 8½ in.

Two other themes that Cranach painted in many versions and that are interpreted as Lutheran and Protestant themes are the themes of *Christ Blessing the Children* (16th c: The Metropolitan Museum of Art, New York) (fig. 100) and *Christ and the Adultress* (16th c: The Metropolitan Museum of Art, New York) (fig. 101). Both themes were represented in pre-Protestant times, but the revived popularity of the subjects among German Lutherans is attested to by the existence of the many paintings on both themes from Cranach's studio. We know that the staunchly Lutheran Elector of Saxony, John Frederick the Magnanimous, bought paintings on the subject of *Christ Blessing the Children* in 1539, again in 1543, and again in 1550. Christensen opines that the frequent representation of the subject may be explained because the early Lutherans were affirming the baptism of infants over against the challenge of the Anabaptists who argued for adult baptism and the conscious commitment of the individual in coming to Christ.[16]

Luther wrote,

Christ commands the children to come and to be brought to him, and in Matthew 19[:14] says that theirs is the kingdom of God. The apostles baptized entire households [Acts 16:15]. John writes to little children [I John 2:12] . . . If all of these passages do not suffice for the enthusiasts, I shall not be concerned. They are enough for me, to stop the mouth of anyone from saying that child baptism does not mean anything.[17]

However that may be, the subject allows for the representation of mothers and children with emotional overtones ranging from tenderness and compassion to cloying sentiment. The paintings from Cranach's studio avoid the latter pitfall, but do exhibit an uncomfortable too-muchness. Jesus holds in his arms one child and caresses a second child held up to him by the child's mother. But all about him women with cupidlike babes press in upon the figure of Jesus. They are crowded into an airless, too narrow space, against an amorphous black background. The contrast of the women's white faces and the infant's squirming white bodies against the dark pattern of garments and background gives an uneasy restlessness to the design of these *Christ Blessing the Children* panel paintings.

Somewhat similar in effect are the *Christ and the Adultress* paintings, which also exist in multiple copies from the Cranach studio. Again, a group of figures is pressed closely together in a narrow, airless space. Jesus holds the arm of the woman and with his other hand gestures toward her as he addresses a group of caricatured, evil-looking old men led by one leering figure who holds a stone in hand. Jesus' followers are crowded

together at the right, the side of righteousness, and they watch the proceedings curiously and anxiously. Again Luther's teachings are behind the works of art. Luther said that the episode of Jesus and the Adulteress was told in order

> to show the clear distinction between the Law and the Gospel, or between the kingdom of Christ and that of this world . . . In Christ's realm no punishment is to be found, but only mercy and forgiveness of sins, whereas, in the realm of Moses and the world, there is no forgiveness of sins, but only wrath and punishment for he who sins is to be stoned and killed.[18]

Thus the real subject of the painting is analogous to the *Allegory of the Old and New Testaments* painting. The inscription on the painting reproduces the words of Christ, "Let him who is without sin among you be the first to throw a stone at her."[19] Luther said, "The grace of God . . . is the absolution which the adulteress receives here from the Lord Christ."[20]

The paintings just discussed are essentially didactic works that visually expound the teachings of the Reformers. Some versions of the two themes that are extant, exhibit the hard surface, the turgid forms, the insistent linear patterns, and the crowded compositions that characterize works from the Cranach studio.

A more commanding work is *The Feast of Herod* (1531: Wadsworth Atheneum, Hartford) (fig. 102). Though signed at the upper right with Cranach's device, the dragon with raised (batlike) wings, and dated 1531, the painting may show the work of Cranach's sons, Hans and Lucas the Younger, as well as the master's hand. It is a strange painting about a strange episode, laconically recorded in Mark's and Matthew's Gospels: the ugly, immoral assassination of John the Baptist at the behest of the vengeful Herodias. The Baptist denounced Herod for marrying Herodias, who was his brother's wife. At Herod's birthday feast, Herodias's daughter, Salome, dances so enchantingly that Herod vows that she shall have any reward she wishes. At Herodias's instigation, Salome asks for the Baptist's head on a platter. Cranach showed us the victorious Salome bearing the platter with its grisly burden, the Baptist's head with eyes that seem to look appealingly at us, while the gory neck oozes blood onto the silver platter. A servant enters also carrying a platter, but one heaped with fresh fruit, which quite pointedly contrasts with Salome's burden.

Salome, both in face and figure, is a type often found in Cranach's art. The high rounded forehead, small eyes, fleshy cheeks, and small, round chin have a soft pallor and a composed sensuality. Coif, face, neck, breasts, arms, and gown all are made up of ovoid forms, linked together,

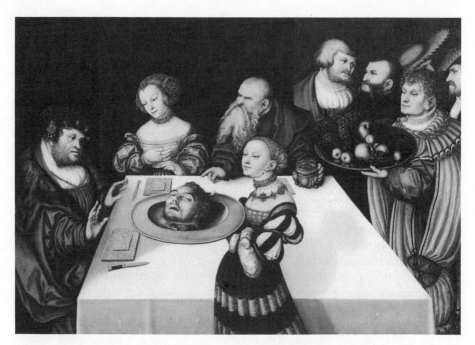

102. Lucas Cranach the Elder, *The Feast of Herod,* 1531. Oil on panel; 37 × 47½ inches (81.3 × 119.7 cm). The Ella Gallup Sumner and Mary Catlin Sumner Collection, copyright Wadsworth Athenaeum, Hartford.

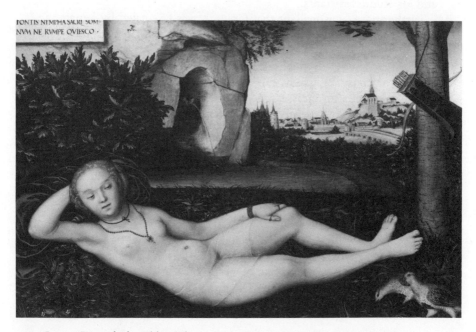

103. Lucas Cranach the Elder, *The Nymph of the Spring,* after 1537. Oil on wood; 0.485 × 0.729 (19 × 28⅝ in.). Gift of Clarence Y. Palitz, National Gallery of Art, Washington, D.C. (1957.12.1 [1497]).

forming a serpentine entity. Salome seems to undulate forward with her fearful burden. Herod, at our left, starts, his hands seemingly ready to push away her platter. His expression combines dismay and fascination. He is richly dressed in a green velvet jeweled cap and a voluminous red woolen cloak with a great fur collar. The textures of the fabrics, jewels, and furs are rendered with a fidelity that invites our fingertips to verify this trompe l'oeil illusion. Egbert Haverkamp-Begemann suggests that Herod resembles Cranach's patron Frederick the Wise Elector of Saxony (1463–1525), an unconvincing proposal either on the basis of known portraits of the elector, or on the probabilities involved. After all, Herod was condemned by the Baptist and was the one who commanded the Baptist's execution. Would the loyal Cranach have connected his patron with this biblical villain?

He also suggests that "the historical power of women as exemplified in Cranach's painting undoubtedly was seen as a warning to the men of the artist's own generation."[21] This statement seems to me to be strictly women's movement rhetoric of our day, and an example of reading back into the past our present-day urgencies. The fact is that Cranach was fascinated by women's capacity for violence; he repeatedly represented Judith with the head of Holofernes. There are other Salomes; Lucretia, the virtuous Roman woman, who was raped and then committed suicide, was painted more than twenty times between 1526 and 1537 by Cranach and his studio assistants.

Furthermore, it is evident that Cranach was fascinated by female sensuality and the female nude. His *The Nymph of the Spring* (after 1537: National Gallery of Art, Washington, D.C.) (fig. 103) is a dreamy-eyed, languorous nude wth thighs spread and provocatively covered by the sheerest of transparent veils. Her soft body seems boneless as she reclines amid the undulating grasses and against her own crumpled garments. Behind her an ovoid cavern in the rocks enframes a dark stone lip from which flows a jet of water. The Latin legend at the upper left says, "Do not break the slumber of the nymph of the sacred well."[22] The *Nymph of the Spring* is another subject done repeatedly by Cranach, and some critics credit this particular painting to Lucas Cranach the Younger. It has the device of the dragon with folded wings that appears on paintings after the death of Hans Cranach in 1537.[23]

When he was seventy-four years of age, Cranach painted this panel of *The Fountain of Youth* (1546: Gemaldegalerie, Staatliche Museen Preussischer Kulturbesitz, Berlin [West]) (fig. 104). It is thought to be wholly by Cranach's hand because of its superlative quality.[24] It is a poignant and wonderful gerontologist's dream. At the left, we see the elderly and infirm being brought by piggyback, by wheelbarrow, by litter, and wagon

to the edge of the great central pool. At the center of the pool, a fountain, which is hardly commanding of proportions or abundant in its flow of water has sculptures of Venus and Amor crowning its column. It is the dividing line which seems to govern the transformation which the bathers undergo; thus the miraculous power of the fountain is love. Whereas the female nudes at the left are aged, scrawny, and awkward, and have pendulous breasts, the women in the pool at the right are youthful sylphs who preen and swim and cavort. One winsome lass at the center extends both arms joyously as if dancing. As the women emerge from the pool at the right, a courtier gestures to the tent, which a young nude is seen coyly entering as several elegantly attired ladies emerge from the side. In the bushes in the background, a banquet is taking place with men and women seated about a table, servants bringing platters of food, and couples gaily dancing to music provided by a drummer and a flutist.

It is a strange painting. We note that whereas men help the aged women to the pool, and appear as their lovers in the banqueting scene, the pool's miraculous properties are not for them. However, the men at the left are grizzled with age and are in modest garb, whereas the men at the right are young and dashing courtiers fashionably attired. Have they, too, been miraculously rejuvenated, without immersion? The delight of the love of the young women appears to be the agent of their regeneration. The background for the scene is also of interest: at the left, we see primitive rocky outcroppings with scrubby bushes, which seem extruded from the barren terrain. At the right, the sky is lighter and the clouds fewer and filmier, and they float above a wooded and serenely pastoral landscape. Towers of a city gleam in the distance. The contrast between the left side of the painting with its aged and humble humanity and its torturous and barren nature, and the right side, where transformed humanity frisks and gambols in a verdant setting, suggests another painting deriving from Cranach's studio, the so-called *Law and Gospel* painting. But, whereas the *Law and Gospel* painting was concerned with "last things,"—eschatology as viewed by the Reformers—Cranach's *Fountain of Youth* is concerned with the age-old dream and hope of humanity for regeneration and a paradise in which all the pleasures of the flesh shall be enjoyed without guilt or regret, endlessly.

Though he was the preeminent painter of Reformation themes, Cranach did not develop a style, that is, a technical language of form, for the expression of the new religious content of emerging Protestantism. It was left to Rembrandt, with his use of light and dark, to speak a new artistic language of the soul for Protestantism.

In the work of Cranach we have seen choices of subject matter and shifts of emphasis in interpretation of biblical themes that bespeak what

could be described as a Protestant viewpoint. Cranach's biblical and religious works are, many of them, created not for the sanctuary but for churchly patrons (both Catholic and Protestant) and for private citizens. Not intended for a place of worship as Titian's and Bellini's altarpieces were, these paintings address themselves to the individual rather than to corporate worship. Many are didactic works such as the *Law and Gospel* painting; others emphasize moral teachings, such as the *Feast of Herod*. Also, an increase in sentiment and the appeal to our emotions are characteristic of Cranach's biblical works, such as the sentimentality seen in *Christ Blessing the Children* and the appetite for suffering and horror as seen in the early *Crucifixion*.

A shift has occurred, not in the style of the work of art, but in the themes, and it is at this level that the ethos of the nascent Protestantism was being formed.

1982

8

The Image of Evil in Nineteenth- and Twentieth-Century Art

The great imaginative representations of Satan and Hell come from the Romanesque period and from the time of the last flowering of the Middle Ages. Before the year 1100 the Devil and his demons appear infrequently in the art of the Western world. Moreover after Renaissance humanism, and then the philosophy of the Enlightenment, there was a decline in status of the Prince of Darkness. It is thus symptomatic that in the early nineteenth century Goya epitomized evil not by the Devil but by the classical god Saturn. In his painting the gigantic and malevolent figure of the god crouches on the rim of the world, gluttonously devouring puny and helpless man.

The significance of Goya's image of evil and the subsequent representations of the late nineteenth century and of our own era can best be understood by contrasting them with the earlier iconography. One of the finest examples of the early iconography is the fifteenth-century engraving by the Master LCZ (Lorenz Katzheimer), *Temptation of Christ* (c. 1492: National Gallery of Art, Washington, D.C.) (fig. 105), which presents us with a Satan who is the quintessence of northern medieval iconography.[1] Following a medieval convention, he has shown the three temptations as occurring simultaneously in one continuous scene. In the foreground we see the Devil pointing to a stone on the ground between the two figures, presumably uttering the words, "If you are the Son of God,

"The Image of Evil in Nineteenth- and Twentieth-Century Art" first appeared in *Drew Gateway* in 1958. It is reprinted here in revised form with permission.

command this stone to become bread."[2] The emaciated face of Jesus, the deep-set, dark-shadowed eyes give credence to the reality of this temptation. Behind the figure of Jesus is a grove of trees where a wolf and a squirrel are seen amid the dense foliage, and a snake lies curled against a hillock. Just above the grove of trees and in the background, a rocky promontory rises. Here Jesus, represented with a nimbus of light rays about his head, is seen again, the devil at his side. Satan shows Christ "all the kingdoms of the world" vowing that they will be his if he will but fall down and worship him.[3] The last temptation is in the far distance, where we see a tiny but exquisite depiction of a walled and turreted medieval city. On a bizarre round building with an onion-shaped dome, the wildly gesticulating devil stands with the impassive Christ at his side: "If you are the Son of God, throw yourself down from here; for it is written, He will give his angels charge of you, to guard you, and On their hands they will bear you up, lest you strike your foot against a stone."[4]

Returning to the foreground, what words can describe the awful figure of Satan? He is a wild compound of the most terrifying and loathsome characteristics of animals and birds. The monstrous, leering face is echoed by the grotesque and differentiated faces on the abdomen and genital area, the buttocks, and the knees. The artist vividly contrasted the jagged, elaborated complicated profile of the devil's body and its aggressive forward movement with the simple, statuesque, and immobile figure of Jesus. One of the curious features of this Satan—one shared with other demons of northern medieval art—is the functional believability of this creature of the artist's imagination. His disparate parts are put together with a sense for organic unity. The bird's beak and beady eyes which seem to form the kneecap of the monster are so united to the structure of the leg that the leg seems entirely capable of movement. Thus what might seem merely grotesque becomes frightening.

Considering the Italian Renaissance depictions, we find that these Mediterranean representations have little in common with the northern European conceptions, exemplified by the Master LCZ's Satan. The Italian artist's mind was so saturated with classical reminiscences that the grotesque and the fantastic were uncongenial to him. Four or five decades after the Master LCZ engraved this plate, Michelangelo painted his *Last Judgment* (1536–1541: Sistine Chapel, Vatican City) (fig. 86) on the back wall of the Sistine Chapel. In this vast fresco, we find no depiction of Satan at all; his representative in this mighty drama is Charon, who furiously belabors the damned, but whose body is that of a fine athlete. His demonic characteristics are his eyes and his pointed ears. Michelangelo's Charon derives from Dante's *Inferno*, Canto III, Verse 109:

Charon, the fiend, with eyes of living coal
Beckoning the mournful troop, collects them there
And with his oar strikes each reluctant soul.

The demons who assist Charon are also fine physical specimens, their
only subhuman characteristics being pointed ears, small horns, and
pointed nails added to the toes of an otherwise human foot. Though
Michelangelo's art shows a reverence for the beauty and nobility of the
human body that is peculiar in its intensity—and its pathos—to this artist
alone, all Mediterranean art to some extent shares this heritage from
classical art. Medieval northern European art springs from different roots.
The grotesque demons that people northern art are more organically
mobile and believable than their occasional nude human figures that
usually look stiff and chilly, embarrassed and incapable of movement.

These preliminary contrasts between northern Medieval and Italian
Renaissance images of evil set the stage for the examination of the nine-
teenth-century depictions. One of the most interesting artists for this
study is the English painter and poet, William Blake, whose lifetime
bridged the eighteenth and nineteenth centuries. In the last two decades of
his life he did a remarkable series of drawings to illustrate John Milton's
Paradise Lost, the Book of Job, and many other watercolors of biblical
subjects. In all of these, the themes of good and evil are given visual
expression, and a new and distinctively Blakean iconography is created.
Some of the characteristics of this iconography are to be seen in the
fascinating drawing *Angel Michael Binding Satan* (18th/19th.: Fogg Art
Museum, Harvard University, Cambridge) (fig. 106).[5] The Archangel
Michael, the traditional defender of the Celestial City, is here seen locked
in a wheeling struggle with the Evil One. The vision of this conflict is
described in the Book of Revelation: "Then I saw an angel coming down
from heaven, holding in his hand the key of the bottomless pit and a great
chain. And he seized the dragon, that ancient serpent, who is the Devil
and Satan, and bound him for a thousand years, and threw him into the
pit . . ."[6]

Blake represented Satan as an enormous serpent with an oddly human
face. Its expression has a wild intensity, but also a suggestion of craftiness
as it glares up at Michael. Michael's expression, however, has a corre-
sponding intensity. The furious concentration shown in the eyes and
arching brows and the half-open mouth partake of the demonic too. The
real contrast between these heads is in type rather than in expression. The
serpent has a bestial face; Michael, a romantic, matinee-idol face. Note his
Greek-type profile and his hyacinthine locks. But the conflict with "that

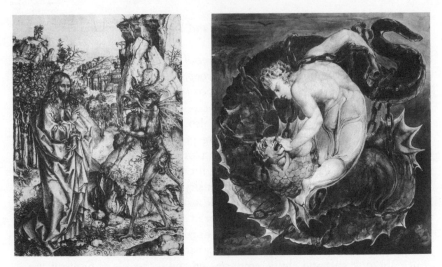

105. LEFT: Master LCZ (Lorenz Katzheimer), *Temptation of Christ*, c. 1492.
Engraving; 8¹⁵⁄₁₆ × 6½ in. Rosenwald Collection, National Gallery of
Art, Washington, D.C. (B-11149).

106. RIGHT: William Blake, *Angel Michael Binding Satan*, 18/19th century.
Watercolor, black ink, and graphite on off-white paper; 359 × 325 mm. Gift of
W. A. White, Fogg Art Museum, Harvard University, Cambridge,
Massachusetts. (1915.8).

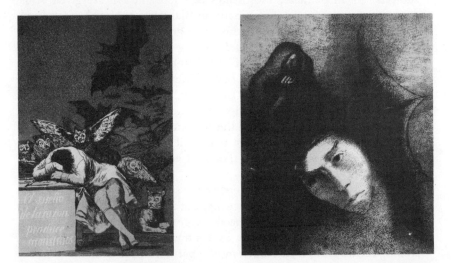

107. LEFT: Francisco de Goya, *Los Caprichos: El Sueno de la Razon Produce
Monstrous (The Sleep of Reason Produces Monsters)*, (first edition), Plate #43
published 1799. Etching. Rosenwald Collection, National Gallery of Art,
Washington, D.C. (B-7354).

108. RIGHT: Odilon Redon, *Anthony: What is the object of all this? The Devil:
There is no object!* Plate 18 from *The Temptations of St. Anthony*, 1896.
Lithograph, comp.: 12¼ × 9⅞". Collection, The Museum of Modern Art, New York.
Gift of Abby Aldrich Rockefeller.

ancient serpent" involves Michael to the extent that he shares some of the characteristics of the serpent. Thus in this drawing we see a certain ambivalence in regard to good and evil.

The body of Michael inscribes a beautiful arc and is encompassed by the curves of the serpent's body. The design is reminiscent of the oriental Tomoe, a conjoined union of opposites, whose function is to wheel endlessly.[7] S. F. Damon writes of this drawing:

> Blake believes that Good and Evil are coexistent illusions; as long as one lasts, the other lasts. Therefore, by the geometry of his design he showed, not the ultimate triumph of Good, but the revolution of both until both are destroyed.[8]

We might add to his statement that not only do good and evil wheel endlessly in this drawing, but each partakes of the nature of the other.

Blake's conception contrasts vividly with that of the Master LCZ who physically and psychologically separated the figures of Satan and Christ in his engraving. Christ is enveloped by a heavy mantle and set apart in space; his eyes seem to see the devil, to see beyond him, and to be inward in expression at one and the same time. In the engraving, Christ's figure and expression remain untouched by evil.

Blake's conception of good and evil and his depiction of these forces as no longer possessing an absolute character is symptomatic of a shift in the understanding of good and evil at the beginning of the nineteenth century. Blake's contemporary, the Spanish artist Francisco de Goya, has been called "the first modern artist who could contemplate *volubilitas rerum*, the mutability of all relations, the mysterium tremendum before which all men fear and tremble."[9]

He did not symbolize but revealed the "absurdity of being human." After a complete physical and mental breakdown in 1792, he beheld the awful face of the god who devours his own children—Saturn. His painting of this vision, *Saturn Devouring His Children* (1820–1822: Prado, Madrid), shows a god with ghastly eyes, wild unruly hair, and a gluttonous mouth. He clutches the torn and headless figure of a man with compulsive force. It is a terrifying image.

One of Goya's sketches for the *Los Caprichos* series (fig. 107) also has relevance for this inquiry. The artist inscribed the title on the plate: "The sleep of reason produces monsters." In the etching the artist himself is represented at his desk, with his head on his arms, having fallen asleep as he worked. The details of his physical environment are eliminated by an all-enveloping shadowy darkness, but this darkness is filled with menacing birds and bats and cats that flock about the sleeping figure. An evil-

looking owl holds one of the artist's instruments in his claws. A bat threateningly wheels above him. A cat lying upon the floor stares malevolently at the quiescent figure of the artist. These creatures are not epitomizing or symbolizing an evil that has an objective reality, but rather are represented as the actual visual images of the subjective mind. Evil is no longer represented in allegorical terms in this etching, but is conceived as being a result of "The sleep of reason."

As André Malraux has remarked, Goya does not premeditate his images but accepts them; they are "images less of dreams than of dreaming."[10] Goya added the additional commentary on this plate, "Imagination deserted by reason begets impossible monsters. United with reason, she is the mother of all the arts, and the source of their wonders." Many critics and historians have interpreted Goya's art as entirely consonant with the thought of the Enlightenment. He is seen as one who would hold up the mirror to humans showing them their ignorance, stupidity, and vice, with the hope of thus shocking them into a return to reason. It is true that the Los Caprichos series deal for the most part with subjects that justify this interpretation. A small group in the series, like the plate just discussed, have the added dimension of accenting the power and fascination of evil that is within all of us.

In the decades between the death of Blake and Goya, 1827 and 1828 respectively, and the end of the century, there are many shifting tendencies and vigorous controversies in the field of art. The principal battlefield, however, is style. The iconography of good and evil developed new forms of expression in literature rather than art. Lord Byron created the demonic, narcissistic hero, who, possessed and deluded, hurls himself and all who come in contact with him to destruction.

> The idea of the "fallen angel" possessed an incomparable power of attraction for the disillusioned world of romanticism struggling for a new faith. There was a general feeling of guilt, of having fallen away from God, but at the same time, a desire to be something like a Lucifer if one was already damned anyway.[11]

Baudelaire's *Litanies of Satan*, Rimbaud's *Season in Hell*, Gustave Flaubert's *Temptations of St. Anthony* all are concerned with the image of evil.

It is in connection with these literary works that new iconographic interpretations were created. Odilon Redon, the French lithographer, was commissioned to illustrate Flaubert's *Temptations of St. Anthony.* One of the most beautiful of these illustrations has the caption, *"Anthony: What is the object of all this?/The Devil: There is no object"* (1896: The Museum

of Modern Art, New York) (fig. 108). In this lithograph, we see the head and shoulders of a brooding figure in the immediate foreground and in the left background a hooded figure, his hand thoughtfully raised and beneath his chin. The hooded figure is St. Anthony. The face in the foreground is obliquely tilted, the eyes glancing sidelong, but lacking any sense of focus. These eyes seem to record an inward experience rather than an exterior event. The features of the face are softened in contour, but the eyebrows slant diagonally upward, and the mouth is sensuous and drooping. The identity of the figure is suggested by the batlike wing that curves along the right margin of the print. It is Satan who has just revealed to St. Anthony all of the secrets of the universe. The Saint turns to Satan and asks, "What is the object of all this?" and the Devil replies, "There is *no* object."

Although the physiognomy of Redon's Satan retains some of the usual iconographic characteristics, it is permeated by a mood that has transmuted the ancient image into one entirely accessible to our understanding. There is a fin de siècle and human world-weariness in the eyes of Satan. His reply, denying any meaning to existence, is sadly given, with a suggestion of nostalgia, rather than triumph. There is also the suggestion of the double image, of the man and his "shadow"—"on the one hand one has a man's ideals, aspirations, endeavors, what he will admit to and identifies himself with. On the other the impulses, attitudes, desires which conflict with this . . . and are mostly unknown and unacknowledged, or are repelled and repressed" by him.[12]

A contemporary of Redon, the Belgian artist James Ensor, depicted in his art a haunted world in which the superhuman and the demonic intrude upon the ordered middle-class life of the late nineteenth century. His painting entitled *Haunted Furniture* (1885: Destroyed during World War II)[13] shows a young girl and her mother seated at a table in an elaborately furnished room. The mother tranquilly bows her head over her sewing, but the child stares up over her book at us in terror. The cause of her fear is seen in the apparition of a skull at the edge of her table and the evil and stupid masks that threateningly leer at her from the corners. This painting parallels the Goya print in which the artist is seen asleep at his desk, beset by evil bird and animal forms. Goya conceived of these creatures as being released when reason and the conscious control of the intellect slept. Reason would be represented in Ensor's painting by the woman placidly sewing. And the child, reasonably understood, would be suffering a hallucination. Nevertheless, Ensor succeeds in imparting to us a sense of the reality of the hovering skeletons and masks, making the child's terror reasonable and the mother's tranquility a result of her self-preoccupation and psychic isolation.

Ensor had read and was greatly impressed by the works of Edgar Allen Poe in the translations by Baudelaire.

> In such a painting as *Haunted Furniture* Poe's unhappy ghosts were made to come to life for the spectator and for the petrified little girl who stares helplessly out of the picture. Ensor's must have been a peculiarly vivid sense of the subtle menace and the cruelties sheathed in the brilliance of Poe's carnival pageant.[14]

In the 1880s and the 1890s, Ensor's work is populated with demons and skeletons. *The Dance of Death,* a frequent subject of medieval art, and one in which iconographic patterns attained to a crystalline form in the woodcut series by Hans Holbein, appears again in Ensor's work. Peculiar to Ensor's "Dance of Death" is the sardonic humor of such paintings as *Death Pursuing the People* (1896: National Gallery of Art, Washington, D.C.), *Masks Confronting Death* (1888: Gustave van Geluwe, Brussels), and *Skeletons Trying to Warm Themselves* (1889: J. Paul Getty Museum, Malibu). One amusing little etching is entitled *My Portrait in 1960* (1888: The Museum of Modern Art, New York). In it we see a skeleton bolstered by a rock—the bodily frame in a position of slumped languor, the head with a halo of hair about the skull, a ridiculous grin on the bony features. The mood of this etching contrasts sharply with a famous seventeenth-century engraved portrait that parallels it in certain other respects. John Donne, the English poet and Dean of the Cathedral of St. Paul, London, preached his own funeral sermon, later published under the title *Death's Duell, or, A Consolation to the Soule, Against the Dying Life, and Living Death of the Body.* The published edition was accompanied by a portrait of Donne who had posed for the artist wearing a winding sheet and with closed eyes, simulating the effect of death. An intensity and sobriety of purpose about this engraving prevent it from seeming ludicrous. In the introduction to *Death's Duell* Donne wrote,

> Death is every mans enemy, and intends hurt to all; This enemy wee must all combate dying; whom hee living did almost conquer; having discovered the utmost of his power, the utmost of his crueltie.[15]

Death, for Donne, was the Adversary, and his own struggle with this adversary was heroic in character and epic in dimension. Not so for Ensor. There is often a wry humor to his representations of death. He knew his skeletons and demons so well that he could joke with them. Then too it must be noted that his demons and death-heads are of the lower and more anonymous ranks . . . not the Prince of Darkness himself.

In 1888, Ensor also was concerned with the symbolic use of the mask. His most famous painting is an immense canvas entitled *Christ Entering Brussels in 1889* (1888: The J. Paul Getty Museum, Malibu) (fig. 109). In it a great crowd of people, most of whom are masked, are represented as participants in a vast carnival parade. In the background, behind a military phalanx, a solitary figure seated on a humble ass and identified by the traditional nimbus, is set apart by his own quietude and self-containment from the milling multitudes. The individual masks of the crowd have a grotesque kind of vitality and life-full character that communicates the eerie notion that it is the masks that are indeed alive and that only a nothingness lies behind them.

The crowd in Ensor's *Christ Entering Brussels in 1889* moves inexorably toward us. We, as spectators, seem to be at eye-level with the first row of figures, but the row is so solid that one is not allowed an escape. The forward movement of the mass seems about to engulf us. The stupid, empty-eyed masks make us despair of ever being able to communicate with these beings, and we feel that were we to persuade them to stop or break ranks, the next group would be upon us. This is the mob. The individuals who make up the mass have lost all personal volition and are mere segments of a whole that possesses its own will.

The theme of the painting is what Søren Kierkegaard described as "diabolic possession in modern times," showing how *humankind en masse* gives itself up to evil. This is a

demonical pleasure which consists in losing oneself in order to be volatilized into a higher potency, where being outside oneself one hardly knows what one is doing or saying, or who or what is speaking through one, while the blood courses faster, the eyes turn bright and staring, the passions and lust seething.[16]

Denis de Rougemont, in his profound and wittily written book *The Devil's Share,* remarked

Kierkegaard understood better than anyone and before anyone the creative diabolical principle of the mass: fleeing from one's own person, no longer being responsible, and therefore no longer guilty, and becoming at one stroke a participant in the divinized power of the Anonymous.[17]

Undoubtedly de Rougemont was correct in pointing to Kierkegaard as the first writer to express an understanding of the mob. Nevertheless, painters have given visible expression to this understanding long before the time of Kierkegaard. Pieter Brueghel's paintings of the *Way to Calvary*

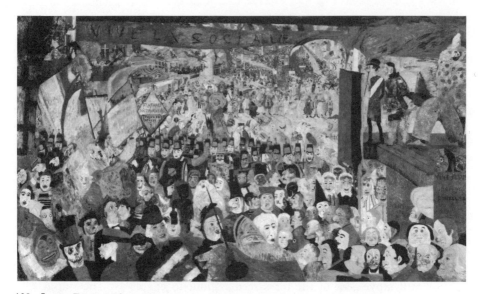

109. James Ensor, *Christ Entering Brussels in 1889*, 1888. Oil on canvas; 102½ × 169½ in. Courtesy The J. Paul Getty Museum. (87.PA.96).

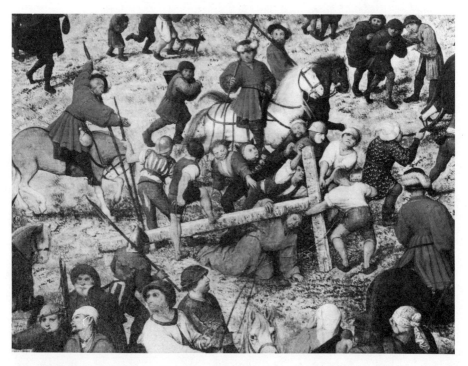

110. Pieter Brueghel, *Way to Calvary*, 1564. Kunsthistorisches Museum, Vienna.

(1564: Kunsthistoriches Museum, Vienna) (fig. 110) and the *Massacre of the Innocents* (c. 1566: Kunsthistoriches Museum, Vienna) bespeak this knowledge of mob psychology. Even Giotto, whose art presents the essentially classical image of humanity, knew the diabolic principle of the mass and gave us memorable depictions of it in the *Kiss of Judas* (c. 1305: Arena Chapel, Padua) (fig. 111) and the *Massacre of the Innocents* (c. 1305: Arena Chapel, Padua). And Goya, about fifty years before Kierkegaard wrote those passages in his intimate diary, depicted in one of the most haunting etching of the *Los Caprichos* series, the diabolic, depersonalized fury of the mob. The etching entitled *There Was No Cure* (1796–1798: National Gallery of Art, Washington, D.C.) shows an innocent woman being taken to her execution surrounded by a crowd with bestial, gloating, and stupid faces. Both in subject matter and the depiction of the mass of people, this etching parallels Ensor's painting of *Christ Entering Brussels* in 1889. Here, too, innocence is the victim of the brutish, maudlin, anonymous mass. Though the satanic figure is not visibly present in the scene, the image of evil is implicitly present.

"The dragon, that ancient serpent, who is the Devil and Satan" is seldom represented in Ensor's work. However, evil as resident within humanity is his constant theme in the 1880s and 1890s. This shift in emphasis portends the development of the twentieth-century image of evil.

In the early years of 1900, in the middle of the triumphant festivities and noisy jubilations of the peoples of the West, all quite intoxicated at the thought of the coming century of Progress in which man's final happiness was to be realized, the authentic face of the Prince of Discord appears with the effect of a thunderclap. This time Satan chooses to make his appearance in negro masks, and in Picasso's *Desmoiselles d'Avignon* of 1907 his grin leers out in prophecy of the bestiality which was to be unleashed upon the world a few years later . . . Thirty years later the same prophetic genius, inspired by the civil war that was devastating his own country, Spain, conceived, in *Guernica* (1936) the callous disintegration of the human countenance which preceded in painting the frightful outrage that man was about to perpetrate upon himself in fact.[18]

Though opinions may differ in regard to Picasso's genius and his art, there is no doubt that he has been the most influential artist of our day. The major event of the art world in 1957 was the Museum of Modern Art's exhibition of his works on the occasion of his 75th birthday. The exhibition was originally intended to be titled "Picasso: Sixty Years of his Art." In the painter's lifetime of creative activity he produced a prodigious number of paintings, drawing, prints, sculptures, collages, ceramics. Is

Germain Bazin correct in seeing in two of Picasso's major works "the authentic face of the Prince of Discord"?

We know that in *Les Desmoiselles d'Avignon* (1907: The Museum of Modern Art, New York) and *Guernica* (1937: Prado, Madrid) (fig. 112) the artist had a specifically didactic intent. In the case of *Les Desmoiselles*, the preparatory sculpture show the figure of a sailor surrounded by women, flowers and fruit, while at the left a warning figure enters bearing a skull as a memento mori. Thus the painting was intended originally as an allegory of the wages of sin.[19] But as it evolved the composition was changed and the sailor and flower were taken out, leaving behind some fruit and what Alfred Barr referred to as "five of the least seductive nudes in the history of art."[20] In these nudes their grins leer out "in prophecy of the bestiality which was to be unleashed upon the world a few years later."

Many of the stylistic characteristics of *Les Desmoiselles d'Avignon* are to be seen in a painting known as *Nude in an Armchair* (1929: Musée Picasso, Paris). If it is a human being that is being depicted in this painting, it is one which has lost all its humanity. The lolloping body and yawping face have less relation to actual bodily forms than archaic Greek sculptures or the depictions of primitive peoples. The difference lies in the fact that all primitive art uses the human body as its referent, whereas Picasso in a very sophisticated and manneristic way destroys the unity of the body and willfully puts the parts together in a wholly arbitrary way. At the same time the parts themselves suffer a radical deformation. To this is added strident and dissonant colors and the contorted and ugly movement of the boundary lines of the forms. All of these factors create in the spectator feelings of loathing and disgust. Many of the characteristics described above are to be seen in other works by Picasso that are merely witty or decorative. But a small group of his paintings—*Les Desmoiselles*, *Three Dancers* (1925: Musée Picasso, Paris), *Nude in an Armchair*—combine these characteristics with such heightened intensity that they possess a diabolic spirit that sets them apart from his other works. In these paintings there is a nihilism in regard to all values and an utter negation of meaning for human existence.

Guernica does not belong to this group. Picasso painted the immense canvas (11 feet by 25 feet) by this name after having learned of the total destruction of the little town of Guernica in northern Spain. The fascist countries of Germany and Italy helped the fascist Spaniards overthrow the Loyalist goverment. In an attempt to demoralize the Loyalists, the little civilian town of Guernica was unremittingly bombed—the first use of saturation bombing—until it was entirely demolished. Picasso painted "this immense horror—the pieces of reality, men and animals and in-

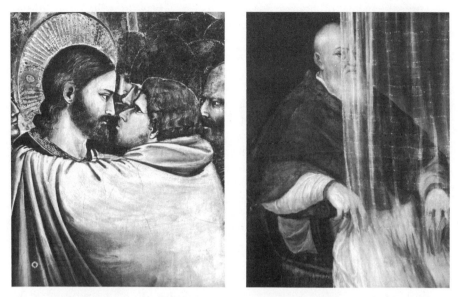

111. LEFT: *Kiss of Judas* detail from Giotto, Arena Chapel, Padua, c. 1305. Fresco. Photograph courtesy of Alinari/Art Resource, New York. (27053).

113. RIGHT: Titian, *Filippo Archinto*, c. 1588. The John G. Johnson Collection of Philadelphia, The Philadelphia Museum of Art. (J# 204).

112. Pablo Picasso, *Guernica*, 1937. Oil on canvas; 12 × 26 feet. Prado, Madrid. Photograph courtesy of Photographie Giraudon/Art Resource, New York.

organic pieces of houses all together—in a way in which the 'piece character' of our reality is perhaps more horribly visible than in any other of the modern pictures."[21]

The shattered forms and distortions of this painting are, however, contained within a highly integrated compositional structure and are directed toward a noble purpose. The artist's deformations cry out against the deformations, death, and destruction that are the result of war. The painting is one of protest but not one of negation.

Denial of all values and negation of all meaning for human existence are the diabolic characteristics peculiar to twentieth-century art. Examples in the art of Picasso have been noted, but they are not limited to this energetic genius of our day. The ingenious English artist, Francis Bacon, has expressed a kind of diabolism in his art. He has evolved techniques with which "to trap the object at a given moment."[22] The word "trap" is well chosen. In his portraits he represents the individual sitter with a competent naturalism, exhibiting a great skill for catching the "likeness" of the individual. However, once having gotten to that point, he deforms the physiognomy, seemingly having drawn his fingers through the still-moist paint, twisting the image of his own creation with a sardonic and destructive movement. It is interesting that a somewhat parallel technical device was used by Titian some four hundred years earlier in one of his most fascinating portraits, the painting of *Filippo Archinto* (c. 1558: The Philadelphia Museum of Art, Philadelphia) (fig. 113). Titian showed the prelate seated, staring out of the canvas at the spectator. But a thin curtain is hung between us and the cleric, and we see his harsh features and mouth through the transparent folds of the curtain. The effect is similar to that which Bacon achieves by blurring the contours by vertical brushstrokes. In Titian's painting the edge of the curtain cuts through the pupil of the sitter's beady eye, giving the half that is uncovered a malevolence of the greatest intensity. However, in Titian's portrait we feel that evil resides within the person portrayed and not within the artist's intention. Titian expressed his perception in regard to this individual with perhaps the wider suggestion of some anticlericalism present. There is no negation of the meaning of human existence as such, as we see in much of Bacon's work. Bacon has said, "I would like my pictures to look as if a human being had passed between them, like a snail, leaving a trail of the human presence and memory trace of past events, as the snail leaves its slime."[23] It is only the slimy trail of the human presence that Bacon records in his destructive and macabre paintings.

The image of evil has assumed many differing faces and forms throughout the history of art. The changes we have noted in a few selected

works of art have suggested a development from a medieval concept of evil to a modern subjective one. To the Master LCZ Satan had an objective existence apart from our notions or theorizing or theologizing about him. Satan was wholly evil. If evil is a perversion of the good, the evil here depicted has obliterated all traces of its origin. The Master LCZ's Satan represents northern medieval concepts of evil, and this imagery remained dominant in the north of Europe long after the Renaissance had flowered in Italy. Only about forty years separate the Charon of Michelangelo and the Master LCZ's Satan. Yet the Charon derives, through Dante, from classical mythology, and the visual image presented to us is that of a superhuman, not an inhuman and fantastic being.

Moving from medieval times and the Renaissance to modern times, we noted Goya's view of evil as something within humanity that is released "when reason sleeps." Blake, Goya's contemporary, at the beginning of the nineteenth century used the familiar iconographic figures—the serpent, Satan, demons—but represented them in a complex and ambivalent way, showing good and evil each to be touched by the character of the other. Redon, in the late nineteenth century also represented Satan, but endowed him with a physique, physiognomy, and psychic character which is human and accessible to our understanding. His image of Satan is opposite in every respect to that of the Master LCZ. The power of the medieval image is in its ugliness and loathsome character. The power of the late nineteenth-century image is in its seductive charm.

Ensor's depiction of the mass as a force of evil brought our study to the beginning of the twentieth century, in which Satan is no longer a visible member of the dramatis personae. But has Satan really left the stage? Baudelaire's often quoted observation is pertinent: "The Devil's cleverest trick is to persuade you that he does not exist."[24] He has worn many masks throughout the centuries and perhaps finds a special diabolic pleasure in occasionally wearing in our day—in some of the paintings of Picasso and artists such as Francis Bacon—the mask of humanity, who, Genesis tells us, was made in the image of God.

<div align="right">1958</div>

9

Picasso's Transformations
of Sacred Art

In his long and productive lifetime, the prodigious artist Pablo Picasso
had two known overtures from religious bodies who were interested in
commissioning him to create works of art for specific places of worship.
Immediately after World War II, he was visited in his Paris studio by
Canon Devemy of the Church of Notre-Dame-de-Toûte-Grace at Âssy,
France. Canon Devemy had been familiar with Picasso's early paintings
from the Blue and Rose periods, with their lonely laborers and laun-
dresses, their dreaming adolescents and poetic circus performers—figures
portrayed with a sense of sympathetic identification which, at its best,
was nostalgic, but which, in some works, became sentimental. On this
visit the Canon found Picasso surrounded by his creations of the terrible
war years when his paintings showed the human figure with distortions of
the most violent kind—the face and body torn asunder and rejoined
together with radical dislocations.

Canon Devemy had come to the studio to propose that Picasso create a
work of art for one of the side altars of the church of Âssy, representing
St. Dominic. Since St. Dominic was Spanish-born, the canon felt that the
Spanish artist Picasso might respond to this particular subject. William

"Picasso's Transformations of Sacred Art" is a revision of two previous essays:
"*The Man with the Lamb* and *The Corrida Crucifixion* by Pablo Picasso" in Jane
Dillenberger, *Secular Art with Sacred Themes* (Nashville: Abingdon Press, 1969),
pp. 77–98, and "Picasso's *Crucifixion*" in *Humanities, Religion, and the Arts
Tomorrow* ed. Howard Hunter (New York: Holt, Rhinehart and Winston, 1972),
pp. 160–184. This revision is published with permission.

Rubin documented this encounter in which the artist, surprised by the canon's visit, shocked his guest with the extreme expressionistic style of his most recent works. "Concluding that Picasso was unsuited for the task, Devemy thanked the artist for his time and took his leave."[1]

Picasso was also asked if he would design a group of stained-glass windows for the Cathedral at Metz, France. Two French artists of Picasso's generation had already designed stained glass windows for places of worship. His friend, Henri Matisse, had designed windows for a convent chapel in southern France, at Vence, and the elderly French artist Georges Rouault, who had created works of art with religious subject matter all of his long life, had finally been commissioned by the church at Âssy to design four stained glass windows for the facade wall of the church. Picasso accepted the proposal made by Robert Renard, chief architectural advisor for the Cathedral of Metz. But subsequently the archbishop of Metz and the papal nuncio opposed it.

Picasso had been condemned by conservative Roman Catholics in a much circulated document now referred to as "The Tract of Angers," which came out in 1951, at the time of the vivid reaction of some of the Roman Catholic clergy and hierarchy to one of the works of art created for the church at Âssy. A sculptured crucifix, designed by Germaine Richier, touched off the growing opposition by the conservative Roman Catholic clergy to commissons then being given to distinguished artists. The document, signed "A Group of Catholics," indicted painters belonging to a school led by "Picasso—Communist Artist and Enemy of God."

Picasso had indeed become a member of the Communist party during the occupation of France by the Germans. Many French Communists were heroic workers in the Resistance, a fact that commanded the respect and gratitude of many Frenchmen. Some of the intellectuals, too, were Communists, among them, Picasso's friends, the poets Paul Éluard and Louis Aragon. It was through the influence of Laurent Cassanova, a Resistance figure who had made three escapes from German prison camps, that Picasso became a member of the Communist party during the war.[2]

The relationship of the artist Picasso to that enemy of the church, the Communist party, is an interesting one. The Communists did not favor his art but well understood the importance of his name. Picasso's friend, the poet Louis Aragon, who was an intellectual leader among the French Communists, came to the artist's studio to request a poster advertising the Communist World Peace Congress. Looking about Picasso's studio, he saw a handsome lithograph of a pigeon, which gave him the idea of using it as a dove, the symbol of peace, for the congress. Picasso consented to

the suggestion and the poster, made from the lithograph of the pigeon, was widely reproduced; thus the dove of peace flew about the entire Western world advertising the World Peace Congress.

After the death of Joseph Stalin, Aragon pressed Picasso again, this time for a portrait of Stalin to be published in his weekly paper, *Les Lettres Françaises*. Haste was necessary, for the paper was to go to press. Picasso was irritated by the pressures, protesting that he had never seen Stalin and didn't recall what he looked like, "except that he wears a uniform with big buttons down the front, has a military cap, and a large mustache." But he grudgingly complied, using an old newspaper photo of Stalin for his interpretation.[3] Several days after the drawing was published, he was visited by journalists who asked if it were true that he was making fun of Stalin in this portrait. The Communist party condemned Picasso, but as the news of the episode got about, the amusement in the worldwide press embarrassed the Communists, and they apologized to Picasso.

Picasso' relationship with the other political ideology of the twentieth century was of a totally different nature. He was uncompromising and unflinching in his hostility to nazism. *Guernica* (1937: Prado, Madrid) (fig. 112) commemorated the bombing, by the German Luftwaffe, of a town in his Spanish homeland. He lampooned Hitler's ally, Francisco Franco, in his *Dreams and Lies of Franco* (1937: The Museum of Modern Art, New York). He had been denounced by Hitler, but he remained in Paris during the four years of Nazi occupation, though many French artists had left for sanctuary elsewhere and some few had become collaborationists. Reports from Paris during and immediately after the period of the occupation indicate that his presence in the city was of great importance to the French Resistance movement. Recalling this time, Picasso told an American interviewer six days after the liberation.

> Do you know Hitler himself once did me the honor of naming me in one of his speeches as the wicked corrupter of youth. So for four years I've been personally forbidden to show or to sell my works. . . . I have not painted the war because I am not the kind of painter who goes out like a photographer for something to depict. But I have no doubt that the war is in these paintings that I have done. Later on perhaps the historians will find them and show that my style has changed under the war's influence. Myself, I do not know.[4]

Picasso's style did indeed change during the war, and it was the paintings of this period that Canon Devemy saw when he had visited the

artist's studio with the intention of commissioning Picasso to create an image of the Iberian St. Dominic for the church at Âssy. The very features that caused Hitler to condemn Picasso's art as degenerate and the Communist officials to condemn his portrait of Stalin caused the clergyman to withdraw. Canon Devemy visited Picasso before the program for the commissioning of fine contemporary French artists for the church at Âssy had been fully developed and articulated.

Soon after the canon's withdrawal from Picasso's studio, two other Dominican priests, Father Couturier and Father Rêgamey, vigorously began to pursue a program to get the greatest living artists to work for the church. They courageously sought out and commissioned Ferdinand Leger, Marc Chagall, Jacques Lipchitz, Jean Lurcat, Georges Rouault, Henri Matisse, Pierre Bonnard, and Georges Braque to create works of art for the little Alpine church at Âssy. The crucifix executed by the French sculptor Germaine Richier set off the debate between the conservative clergy (the Integrists) and the Modernist group in the French Dominican order. In the exchange of verbal hostilities that followed, an unnamed Dominican father was quoted by Jean Cassou as saying, "Modern art will have had three enemies, Hitler, Stalin, and the Pope." Another critic, Bernard Dorival, revised his triumvirate, saying that the conservative bishops were "in accord with the Kremlin, the White House, and the late Mr. Hitler."[5]

It was during the years of the German occupation that Picasso created the masterpiece of sculpture, *Man with a Lamb* (1943: The Philadelphia Museum of Art, Philadelphia) (fig. 114). Though the title does not suggest religious subject matter, the conception and content of this somber sculpture are rooted in Western religious consciousness. The prototype in the early Christian era is the *Good Shepherd* (3d/4th centuries: Vatican Museums, Vatican City) (fig. 115) and in early sarcophagi. The early Christians were loath to represent Jesus Christ pictorially and depicted him allegorically on the basis of the parable of the lost sheep, wherein the shepherd, on finding the lost sheep, "Lays it on his shoulder, rejoicing."[6] Thus the New Testament image adds another dimension of meaning to the significances the Old Testament image had already received from its poets and prophets. The Twenty-third Psalm, with its familiar pastoral image is well known to Christians. The archetypal image of the Lord as shepherd was projected, as Gilbert Cope noted,

upon the image of Israel's ideal king, David, who is called from his sheep to be the anointed shepherd-king; it is then further developed in connection with the figure of the Messiah.[7]

116. *Calf-Bearer,* Greek Archaic Period. Marble; about 5 feet high. Acropolis Museum, Athens.

114. ABOVE: Pablo Picasso, *Man with a Lamb,* 1943. Bronze; 88" high. The Philadelphia Museum of Art. (68.115.8)

115. RIGHT: *Good Shepherd,* 3d/4th centuries. Marble; about 48 in. high. Vatican Museums, Vatican City. Photograph courtesy of Office of the Director, Monumenti Musei e Gallerie Pontifici, Città del Vaticano.

In Ezekiel 34, we read,

> For thus says the Lord God: Behold I, I myself will search for my sheep, and
> will seek them out. As a shepherd seeks out his flock when some of his sheep
> have been scattered abroad, so will I seek out my sheep; and I will rescue
> them from all places where they have been scattered on a day of clouds and
> thick darkness (vv. 11–12 RSV).

The artists of the early Christian era had a model within the classical
repertoire, the statue of Hermes Criophoros. The god Hermes was not
only the giver of fertility to field, flock, and herd, but also conducted the
souls of the dead to Hades. In these representations, the pagan messen-
ger god is shown carrying a kid or a goat. The most common form for
the representations is an upright male figure with the animal held over the
shoulders and the front legs grasped by one hand, the back legs by the
other, like the famous archaic *Calf-Bearer* (Greek Archaic Period: Acro-
polis Museum, Athens) (fig. 116). At least one early Greek sculpture
shows the figure holding the animal in front of the chest as Picasso has
done with his *Man with a Lamb*.[8] A small bronze sculpture shows
Hermes Carrying a Ram (c. 530: National Museum, Athens) under one
arm. Egyptian and Mesopotamian art also had images of the shepherd
carrying a lamb or calf. So this image, rich with many accretions of
significance, lies deep within the multilayered strata of Mediterranean
consciousness. To this Picasso was heir, for he was born in Malaga, Spain,
and resided for most of his mature life in southern France near the borders
of the blue Mediterranean.

Man with a Lamb was born out of the troubled war years. Picasso had
made an etching of a frieze depicting a family group with a man carrying a
sheep in the center. Telling François Gilot how the sculpture was created,
he referred to this etching and a series of preliminary drawings.[9]

The plaster of the original *Man with a Lamb* remained in that form for
six years, for during the war it was impossible to have sculpture cast in
bronze. The Germans used all available bronze, even some of the statues
of the Parisian public parks. Some time later, Picasso went to an Italian
bronze caster by the name of Valsuni and persuaded the reluctant crafts-
man to try casting *Man with a Lamb*. Three copies were made. One
Picasso retained in his own collection; one he gave to the town of
Vallauris as a war memorial dedicated to those killed during the hostilities;
and one was sold and now is in America at the Philadelphia Museum of
Art.

Man with a Lamb is larger than life size. The total height, including the
small patch of terrain upon which he stands, is seven feet, four inches.

When we view the group from the front, we see the man standing, his right foot advanced, the struggling animal held in front of him. With his right hand under the buttocks of the animal, he supports the lamb's full weight. With his left hand he clasps three of the animal's legs, while the fourth hangs loosely, protruding at a sharp angle. The square-set lines of the man's shoulder are surmounted by a massive head with heavy brows and deep eye sockets, in which are set projecting eyeballs. The pupil itself projects sculpturally from the surface of the eyeball, giving the eyes both a far-seeing and an inward-seeing look. What is *not* in focus for this man is the visible world. He clasps the large, struggling lamb against his body, in an endeavor to support the off-center weight of the lamb. Yet he retains his own, somewhat precarious footing, upon a minimal suggestion of earth.

From the side, this impression of an uneasy balance, precariously obtained and held, more through an effort of will than through purely physical means, is strengthened. The animal's neck seems unnaturally long as it cranes forward and away from the man's body, but this movement is sharply terminated by the head, which bends back toward the man's shoulder and head. The massive weight of the lamb's body, together with its angular, struggling extremities, is just barely held by the man. His legs press the minimal earth. His buttocks are tense, his shoulders rigid. The man, though virile and sturdy of build, has been modeled wholly nude, but without genitals. This is unusual in Picasso's art, which characteristically shows a natural acceptance of male and female sexuality, and candor in representing the sex organs.

The bronze retains the spontaneous, creative gestures of the artist as he worked the clay over his armature. The exact size and shape of some of the bits of clay are visible, particularly in the upper part of the sculpture. We are reminded that Picasso said, "The conception was a year or two in taking shape, but when I went to work, the sculpture was done almost immediately."[10] The legs show the broad strokes of the instrument that cut away the excess clay and shaped that which remained. The entire surface of the statue has the alive and vivid movement that bespeaks the spontaneous gesture of the artist's hands as he formed this man out of clay, out of "the dust from the ground."

Man with a Lamb does not walk into our world born out of a paradisical or idyllic pastoral realm. He seems, instead, like a survivor of Hiroshima or Auschwitz, one who has seen and known only suffering, one who was "cut off out of the land of the living," his soul "poured out to death." He returns "as one from whom men hide their faces."[11]

The image of the shepherd is woven throughout the Bible. His role is that of one who is self-sacrificing, and his care for his sheep is empha-

sized. But the shepherd who rescues the sheep and cares for them is also the one who, in a priestly role, sacrifices the animal in a ritual offering to the Lord. Picasso's somber figure holds the lamb in front of him, at once steadying and staying the struggling weight and seeming to offer it; but the offering—if, indeed, it can be so interpreted—is made with the grim finality of an Abraham who journeyed three days with Isaac, knowing that his beloved son was to be the sacrificial offering. *Man with a Lamb* is at once the shepherd and the priest. In an ancient mass for the dead, the good shepherd is the one who carries the dead, "through the darkness, over the abyss, past the jaws of the Lion, to the fields of light."[12] The "fields of light" do not exist for Picasso's *Man with a Lamb* either as a hope or as a recollection. He inhabits the darkness, the abyss, the jaws of the Lion.

He seems a figure involved in "the journey to Hades, the descent into the unconscious, and the leave-taking from the upper world," as Carl Jung described some of Picasso's art. This statement is in an interesting, sharply criticized essay on Picasso, written at the time of a large exhibit of Picasso's work held in Zurich in 1932.[13] The criticism was provoked primarily by a paragraph describing characteristics of images produced by neurotics as over against schizophrenics. In saying that Picasso belonged to the latter group, Jung intended to propose that it was the imagery, not the artist himself, which belonged to this latter group. He described schizophrenic art as being fragmented and having " 'lines of fractures'— that is, a series of psychic 'faults' " which run right through the picture. The picture then, according to Jung, leaves one cold, or disturbs one by its paradoxical unfeeling and grotesque unconcern for the beholder.[14]

The journey to Hades, or

> . . . the Nekyia is no aimless and purely destructive fall into the abyss. . . .
> The journey through the psychic history of mankind has as its object the
> restoration of the whole man, by awakening the memories in the blood. . . .
> It is he who at all times of upheaval caused the tremor of the upper world,
> and always will. This man stands opposed to the man of the present, because
> he is the one who ever is as he was, whereas the other is what he is only for
> the moment.[15]

Picasso's *Man with a Lamb* was created long after Jung wrote these words about Picasso's art. But when we look again at the intense, yet unfocused gaze of this man with his burden of struggling animal flesh and bone, "the tremor of the upper world" is experienced in the presence of one so naked in flesh and spirit. We recognize the presence of "one who ever is as he was."

118. LEFT: Pablo Picasso, *Crucifixion Drawing*, June 8, 1929. Pencil on paper. Musée Picasso, Paris. Photograph courtesy of Réunion des Musées Nationaux, Paris. (MP #1878).

119. RIGHT: *St. John the Baptist* detail from Grünewald, *Isenheim Altarpiece*, 1515. Oil on wood; c. 12′3″ × 17′9″ overall with wings. Courtesy of Musée d'Unterlinden, Colmar. Photograph by Otto Zimmermann.

117. Pablo Picasso, *Crucifixion*, 1930. Oil on wood; 20 × 26 in. Musée Picasso, Paris. Photograph courtesy of Réunion des Musées Nationaux, Paris. (MP #122).

Among Picasso's prodigious output, there is a small, unique painting, the *Crucifixion* (1930: Musée Picasso, Paris) (fig. 117), painted when Picasso was forty-nine years of age. Brilliant in color, crowded in composition, filled with strange images and distorted forms, it communicates a cryptic content. The subject matter appeared unexpectedly within the work of the artist, whose large output up to that time had been concerned with persons, places, and things taken from the visual data that he saw about him. It was during this period (from 1927 to 1935) that the *Crucifixion* was painted, and a series of studies on this theme related to this painting, and to Mathias Grünewald's great sixteenth-century *Isenheim Altarpiece* (1515: Musée d'Unterlinden, Colmar) (fig. 68), were done.

Within the early "heroic" years of Surrealism, Picasso created his first known (i.e., published) crucifixion composition (1927).[16] It is a drawing that bears the evidence of numerous revisions of form. Here we see the surrealist's curving line that arbitrarily swells, defining a monstrous arm and hand like a catcher's mitt, and diminishes to indicate a mere round protuberance for a head. Though the line itself ebbs and flows with only minor changes in width or rhythmic speed, it has the magical property of suggesting a three-dimensional form, as if the drawing were for a bas-relief, rather than collage-like. So much for the surrealist biomorphic style of drawings.

The iconography—the reading of the images—begins with the Christ. His small head encircled by a crown of thorns and set in an egg-shaped halo is in the center of the upper part of the composition. His bulbous arms stretch the length and breadth of a wide crossbeam, the hand at our right being palm up, with a large ovoid nail at its center. At the left, an enormous hand grasps a diagonal ladder, and a swollen foot is tilted forward below. Several figures merge into each other at the left side of the corpus, and at the right a horseman with a two-pronged lance in one hand is about to plunge it into the side of the Christ, while holding a shield in the other hand.

This figure, referred to in John's Gospel simply as "one of the soldiers [who] pierced his side with a spear,"[17] long ago was given the name Longinus. The name is obviously derived from the Greek work for spear or lance, and so the spearman is called in the Acts of Pilate (from the pseudo-Gospel of Nicodemus), and named in early manuscripts (such as the sixth-century Rossano Gospel). One of the curious conflations of Christian iconography is the later interpretation that the soldier who pierced the side of Jesus was one and the same as the centurion who was converted after the death of Jesus and exclaimed, "Truly this man was the Son of God."[18] Trecento paintings most often represent Longinus, as

Picasso did here, firmly astride a horse, and among those gathered at the foot of the cross.[19] We shall see that in Picasso's later drawings the horse and Longinus are both present, but in the 1929 drawings Longinus is no longer astride the beast. In the 1930 crucifixion painting, he returns to his mount, his lance in his hand.

By studying the drawings together we are able to see that the first undulant line at the left is the contour for the arm and hand of a man who is much larger in scale than any other persons or objects. We suddenly sense him to be very near us, his armpit visible, but the palm is turned away from us as he grasps the ladder and turns his head with open mouth to the nightmarish scene in which we see the legs of the crucified, and the Magdalen, her face bent back to her buttocks.

Some of the female faces are seen Picasso-wise, that is, simultaneously in full-face and profile; others Janus-like, are at the right of the legs of the crucified. Longinus appears wearing a Greek helmet and carrying a shield and lance. In the first drawing the lance is thrust vertically in front of him, while in the drawing of June 8 (fig. 118), it seems to be held at his side, and has become the staff that holds a flag—a flag that has a double profile upon it, a white classical head with open mouth, whose profile creates a complimentary interlocking negroid profile. Just below this image on the flag we find a similar double profile, dark and light. A reminiscence of Grünewald's Magdalene with her interlacing fingers (fig. 89) is to be seen in the undulating lines with fingers and fingernails carefully indicated. The drawing of June 8 has two iconographic additions—in the center front a drum like structure with upturned top on which we see a single dice, and at the center right, an arm and hand with pointing finger, which certainly is related to Grünewald's John the Baptist's large hand with its insistently pointing finger (fig. 119). Below a crowd of spectators are seen in profile; Longinus's horse, far from bearing his master, munches amiably on a tuft of grass. Both drawings show a slight indication of setting, several Roman arches.

Two days later on June 10, 1929, Picasso did another sketch with further transformations and additions (fig. 120). The great man at the left, holding the ladder, undergoes another metamorphosis as his profile now can be read both as the boundary line of his lips and chin and as the toes of the foot—a foot that presumably belongs to the crucified figure who is only partially seen in these drawings. The Magdalen has been even more cruelly transformed, a long phallic-like nose again pressed against her buttocks, the eyes set one over the other, the mouth in profile surrounded by teeth that enframe a sharp triangular tongue. The hand with the pointing finger, which has come to look more like a directional sign than like the hand of Grünewald's St. John, has acquired a head and suggestion

121. LEFT: Pablo Picasso, *Corrida Crucifixion, Drawing V,* March 2, 1959.
Ink on paper; 14 × 12 in. Musée Picasso, Paris. Photograph courtesy of
Réunion des Musées Nationaux, Paris.

122. RIGHT: *Alexaminos Worships [his] God,* 3d century. Graffito.
Terme Museum, Rome. Photograph courtesy Office of Director, Monumenti
Musei e Gallerie Pontifici, Città del Vaticano.

120. Pablo Picasso, *Crucifixion Drawing,* June 10, 1929. Pencil on paper.
Musée Picasso, Paris. Photograph courtesy of Réunion des Musées Nationaux,
Paris. (MP #1875.48).

of garments. This profile seems a kind of prophet type, grave of expression with one all-seeing eye, a large nose, and flowing beard.

A rather charming, imaginative addition is the filling of the space between the horse's neck and thigh with a woman's head. She seems to peer outward toward us, though one eye is in profile and the other full-face. The inclusion of this face and the turning of the horse's hoof so that we see the horseshoe with its nails are gratuitous additions of Picasso, whose mind was forever in ferment, creating and recreating—a strange and fascinating mix of forms taken from traditional iconography, from other masters, and from his own repertoire of created images.

Nine months later on February 7, 1930, Picasso painted his *Crucifixion* (fig. 117). Not large in size, approximately twenty by twenty-six inches, it was painted on wood and it is one of a group of works that the artist never sold, retaining it in his own possession. It has been exhibited a few times in the large surveys of the artist's work, but most of the sixty years since its creation, it was in Picasso's own hands.

The painting must have had a special significance for Picasso himself. But what is its meaning to us? With the preparatory drawings in mind, we can find the figure on the cross with its flat round head and mere dots for features, its paddle-like hands upon the cross beam. A pin like figure stands on a ladder hammering a nail through one palm. At the foot of the ladder two crumpled figures are perhaps those of the two thieves, whose tau-shaped crosses are seen, very small in size at the lower left and upper right. In the foreground, a figure wearing a helmet holds across his shoulder the tunic which "was without seam, woven from top to bottom,"[20] and watches the throw of the dice by a monstrous creature who is casting lots with him.

Above at the right, the arms which reach upwards with clasped hands surmount a strange triangular flow of garments. From this, or from behind it emerges, a grotesque sculptural monstrosity, beaklike nose and dots for eyes, jaws with teeth that close vertically rather than horizontally. It suggests a great praying mantis, a strange insect that still inhabits the twentieth-century world, yet seems to come into it out of a prehuman era. The insect fascinated Picasso. Its form may have inspired Picasso's *The Woman Bather on Beach* (1929: The Art Institute of Chicago) and *Abstraction* (1929: The Art Institute of Chicago). Certainly, both of these paintings were related to the *Crucifixion* of a year later.

Another antecedent painting of Picasso's that may assist us in understanding the development of certain forms is the strange demonic *Nude in an Armchair* (1929: Musée Picasso, Paris). Her great yawping mouth, with its teeth like nails in a pincerlike jaw is the prototype for the strange head that seems about to close its jaws about the wound in the side of the

crucified, just as Longinus—here a tiny figure on his horse—withdraws his spear.

A kind of counterpart to these jaws is to be found in the wide, crescent-shaped form just above Longinus with two round eyes. Is this the moon as Juan Larrea suggests?[21] We saw a moon and a sun in the 1927 drawing. Are they recreated here? Larrea's suggestion is that the strange masked figure with rays about it at the right is the sun. Alfred Barr and Ruth Kaufman identify this latter figure as the Magdalen, an identification that I think our studies of the drawings support.[22] The strange realistically three-dimensional object levitating in the upper right is usually interpreted as the vinegar-soaked sponge.

Mary the Mother may be the figure with vesicle-shaped face at the right of the cross. Her profile is turned to the right but it has again an interlocking profile, with blunt nose and protruding lips. The triangular dark-light zone that encloses both of these faces locks them together in a play of opposites, but the resulting image has an archetypal gravity.

It is quite certain, simply from the evidence of the drawings which have been published, that Picasso made many more studies. When these are all known, we may have a record of the genesis of the painting, and the step-by-step metamorphosis of the imagery in the painting that will clarify some of the perplexing problems of identification which remain.[23]

Not only will Picasso's still unpublished drawings provide further insights into the meaning of the imagery, his writings may help as well. We know from Picasso's friends and associates that during the heyday of Surrealism, he did a great deal of writing. His published Surrealist play, "Desire Caught By the Tail," is one known example, but it is reported that there is much more written material. Gertrude Stein said that he stopped painting at intervals between 1927 and 1935, the period when these *Crucifixion* compositions were done. She went on to say that since "it was impossible for him to do nothing, he made poetry, but of course it was his own way of falling asleep during the operation of detaching himself from the souls of things."[24]

But in another sense to fall asleep is to dream. The dream was the great primal source of subject matter for the Surrealists. But whereas Picasso's contemporaries dreamed of and painted metamorphic subjects from nature like Juan Miro's *Person in the Presence of Nature* (1935: The Philadelphia Museum of Art) or oedipal desire, as did Salvator Dali in his *Oedipal Complex* (1930: The Museum of Modern Art, San Francisco) or the passive voyeurism seen in Delvaux's painting, Picasso's most sur-realistic painting is this intense, complex, brilliantly colored, puzzling, suggestive painting of the *Crucifixion*.

In a group of drawings which he did in 1959, Picasso alluded to another

ancient Mediterranean myth of a differing origin. He chose to set his Christ on the cross at the heart of the drama of the *corrida*, known in English as the bullfight. The two themes of the crucifixion and the corrida, united by Picasso in this group of drawings, had been treated previously but separately by the artist.

As for the bullfight theme, it has been treated again and again by Picasso throughout his long and productive career. The principal antagonist of the fete, the bull, has been represented in ever-changing artistic and symbolic form by Picasso; so much so, indeed, that in the vast literature on the artist we have many interpretative writings and one entire book on the subject.[25] The artist lived in southern France for many years and refused to return to his natal land, Spain, until its fascist regime was defeated.[26] The festival of the corrida is still enacted at the ancient towns of Nimes and Arles, and there Picasso and his family and friends went to participate in this ancient ritual.

The renowned bullfighter Luis Miguel Dominguin had long been a close friend of Picasso's, and when the group of drawings in which the crucifixion series appears was published, it was accompanied by a thoroughly engaging little essay by Dominguin. The bullfighter's introductory essay does more to make vivid the significance of the corrida than do many learned essays on the subject. He remarked: "If we fail to invest the bullfight with transcendental and necessary meaning it ceases to seem at all serious." It is indeed a life-and-death struggle of a bull and a man.

For Dominguin the historical and the mythical significance of the bull gives the beast a certain grandeur and dignity that is woven into the fabric of the corrida. Spain, as well as Rome, has ancient statues of Mithra killing the mythic bull. Among the classical Greeks, the bull was a cult beast of Poseidon, whose kingdom was the surface fabric of the earth, both the land and the sea. One of the labors of Heracles was the taming of the Cretan bull who was a dread killer. The bull was a sacrificial animal among the Indo-Aryans, as among the Jews. In more benign form the bull is the animal associated with St. Luke and is used symbolically to represent the Evangelist. Thus the bullfighter in vanquishing the bull reenacts the myth, "charged with the past and heavy with the future."[27]

What did Picasso make of this peculiarly Spanish compounding of ancient classic Mediterranean myth and Christian event? He began a succession of studies of the *Corrida Crucifixion* theme on March 2, 1959, and on that day completed some nineteen sketches, some in charcoal, some in ink, and some using both media.[28] The following day an additional eight drawings were made in ink, also on this theme. The two series have been handsomely reproduced in the fine volume *Pablo Picasso: Toros y Torreros*.

The first sketch of the series presents the conception that we see elaborated later, where a figure with arms outstretched, as if on a cross, clasps in his right hand a length of fabric which is at once a bullfighter's cape and a loincloth. With it he draws the charging bull away from a figure fallen beneath a horse. The original sketch shows this group as if in the distance, small in size at the upper left. The foreground at the right is occupied by two studies of the upper torso of the figure brandishing the cape-loincloth. The next sketch again deals with the torso and outstretched arms, and Picasso added a large stigmata at the center of the open palm of the left hand of the Christ. This stigmata is ovoid in form with a dark, pupil-like area which converts it into a wide-awake, staring eye within the wide, sturdy palm. The next studies are of the animals—the bull with arched neck, charging away from us, the horse crumpled upon the ground, its legs a tangle of abrupt and broken forms, its neck craning backward and upward in anguish.

The fourth drawing suddenly takes up another subject and we see in a handsome, dark, fully realized drawing, the features of Picasso's wife, Jacqueline, represented as the Mater Dolorosa. She is represented as Mary the Mother, who weeps for Christ and all humankind; she wears a crown, an elaborately patterned mantilla or veil, and a bejeweled neckpiece, beneath which we see her heart pierced by seven swords. The meaning of the pierced heart originates in the scriptural passage in Luke's Gospel where it is told that old Simeon, a man "righteous and devout," took the child Jesus in his arms when his parents brought him to the temple to present him to the Lord and spoke the words that became the *Nunc Dimittis*, of the liturgy, lines which conclude with the prophecy:

> *Behold, this child is set for the fall and*
> *rising of many in Israel,*
> *and for a sign that is spoken against*
> *(and a sword will pierce through your own*
> *soul also),*
> *that thoughts out of many hearts may be revealed.*[29]

Picasso was certainly familiar with the traditional form of the Mater Dolorosa, as these devotional images are to be seen in many Roman Catholic churches and homes, as well as in art museums, and the painting collections in Spain.[30] Some of these images show Mary the Mother either with one sword piercing her heart in reference to Simeon's prophecy, or with seven swords in reference to the Seven Sorrows of Mary that are the alleged episodes in her life in which the passion of Christ is foretold. Picasso, numerically faithful to the traditional iconography, has repre-

sented the Mater Dolorosa with seven swords piercing her heart. The presence of this powerful drawing in the *Corrida Crucifixion* series suggests another interpretation for these piercing instruments. They might also be the *pic*, the lance used by the picadors who open the bullfight, irritating and enraging the bull but not disabling him. This double allusion to the bullfight and the Seven Sorrows is consistent with the complex imagery of the entire series of drawings.

The fifth drawing has several very cursory scrawls above the lines which we tend to interpret as the crossbeam of the cross. In traditional representations of the crucifixion this area contains the titulus and mourning angels, or, in earlier art, the moon and sun, symbolic of the half-veiled light of the synagogue and the full light of the church. But from a study of the other drawings of the series, it is clear that Picasso intended this area to be the setting for the event of the *Corrida Crucifixion*. The line above the arm and head of Christ is the edge of the stadium and above are the spectators, the women with their high combs and mantillas, for whom the bullfighter chooses to fight, as Dominguin said, like the medieval knight, "not simply in carnal terms, rather as a symbolic image of the aspiration toward happiness that every man has within him." Thus, the cursory lines may refer to the spectators and, in particular, to the woman for whom the bullfighter chooses to fight, the Mater Dolorosa, who as witness of the *Corrida Crucifixion*, weeps for the loss of her child and for the sins of the whole world.[31]

Looking now at these drawings in particular, we note in *Drawing V,* March 2, 1959 (fig. 121) that the outline of the Christ figure is one continuous line that describes the arms, neck, and head, then moves down along one side, abruptly delineating the legs and blocky feet. The line itself has a spontaneous, freely moving quality. We sense the varying pressure of the artist's hand holding the charcoal; our eyes follow the naked immediacy of the act of creation as his hand hesitates, moves quickly on, leaps across the white nothingness of the paper, describing the forms, smudging the whiteness, converting it into a setting, a place.

It is difficult to describe the peculiar quality of the linear pattern and the line in this drawing and in others of the series. What makes these sketchy studies—records of the metamorphosis of an idea—into works of art? The lines seem blunt and rough, sometimes attenuated, sometimes turgid and swollen. If we recall the undulating grace of Sandro Botticelli's line or the incisive power of Michelangelo's lines, we notice that Picasso's line seems more random, more varied, more spontaneous. It is ugly also—"supremely and magnificently ugly"—to use Roger Fry's words.

Roger Fry, English critic and one-time curator at the Metropolitan Museum of Art in New York, aptly put the difference between our two

uses of the word *beauty:* one to indicate sensual charm and the other to mean the appropriateness and the intenseness of the emotions aroused, though what is depicted may be extremely ugly.[32] The sharp junctures, sudden changes of direction, and the lumpishness of the shapes bounded by these rough lines, give a raw crudity to the design, but in this crudity we still sense Picasso's purposeful hand. The random and spontaneous movements are the product of the artist's hand, exhibiting a lifetime of experience behind each movement. We have only to compare Picasso's sketch with an artistically illiterate work to be conscious of the difference.

Perhaps the earliest extant representation of the crucifixion is a kind of caricature executed in the early third century and known as the "Blasphemous Crucifixion," or *Alexaminos Worships [his] God* (3d c.: Terme Museum, Rome) (fig. 122). It is a graffito, or sgraffito, which is the technique of scratching or incising a design or motif on a whitewashed or plaster-covered wall, cutting through the outer layer and exposing the darker material beneath. The technique was used decoratively on sixteenth-century Italian architecture, but it has been used by all kinds of persons throughout the ages on public walls, city edifices, and latrines for the random inscriptions and pungent caricatures created by the populace. This graffito was scratched upon the walls of the Domus Gelotiana on the Palatine Hill at Rome, presumably by a pagan deriding a Christian friend. It shows a figure with the head of an ass, with arms extended, attached to a tau-shaped cross. His feet are placed on the suppedaneum, and the ass's head is turned toward a figure standing at the left who has his hand raised in the antique gesture of adoration. Under the group is an inscription written in Greek: "Alexaminos Adores [his] God."[33]

This drawing communicates to us through its literary content. Its strongly derisive impact is felt only by those whose associations are already well established. For those who deem the ass to be the most stupid and lowly of beasts, and the crucified to be the divine Son of God, the amalgamation of the two is offensive and it is, indeed, a blasphemous drawing. For those who are not predisposed in regard to either of these images, the compounding of them is meaningless. Judged simply as a drawing, the formal characteristics of this third-century graffito are negligible; the line and space relationships have little communicative power. The lines are the mere tracing of contours that identify the subject matter. Picasso's lines, for all their freely composed character and simplified, distorted forms, still communicate a vitality and a pathos.

Returning to *Drawing* V, the cape-loincloth which Christ as matador flourishes before the charging bull is described by a line continuous with the torso of the Christ figure, almost as if it were a part of the body (fig. 121). One of his hands remains affixed to the cross, which is not indicated

in this drawing but remains invisibly present in the posture of the figure as it stands upon the suppedaneum. At the lower left, the bull charges into the cape. His buttocks and waving tail are seen from behind; the arching line of his back, shoulders, and lower neck are one continuous line with a springlike tension in its curvature. The bull's plunging movement, with lowered head, exposes the animal's withers and the tiny vital spot, aimed at in the matador's final death-dealing blow, which is known as the "cross."[34] Two frame-shaped horns spring from this "white bullock of the crescent shaped brow."[35] His forelegs are drawn under him as he makes this last desperate charge.

The Christ-matador figure has drawn the bull away from the picador, who lies half beneath his fallen horse, supporting himself upon his elbows and looking up toward the Christ. The picador is the man who from horseback places the pic (a pole with a shaft and a triangular steel point) in the bull's upper back under the direction of the matador, the objective being to cause the bull to lose some of his force. Ernest Hemingway said of the picador, "Of all the ill paid professions of civil life I believe it is the roughest and most constantly exposed to danger of death, which fortunately, is nearly always removed by the matador's cape."[36]

The horse cranes his neck upward in anguish and, with one leg at right angles to his body and the earth, he helplessly paws the ground. The recumbent figure of the picador with his horse is reminiscent of the iconography for another New Testament event—the conversion of Saul. Though the account in Acts 9:3 makes no mention of a horse, it was assumed that Saul, the persecutor of Christians, would have journeyed to Damascus by horseback and that he had fallen to the ground from the horse when a light flashed from heaven and a voice was heard saying, "Saul, Saul, why do you persecute me?" In paintings of the subject the horse is sometimes seen standing near the fallen figure, and sometimes it too sprawls next to the recumbent Saul.

The fallen picador in Picasso's drawing looks upward toward the Christ figure. He, too, has outspread arms, but they have a supportive role. The lines of this figure are so entangled with the lines of the two animals' bodies that it is difficult to read the positions of the three. They form a mass of conflicting movements, a chaotic coalescence of living, struggling bodies. The arching line of the bull's purposeful plunge is balanced by the attenuated, broken curve of the horse's neck and jaw. Between these two beasts, one the aggressor and the other the victim, lies the crumpled form of the fallen man.

The next drawings reiterate the central theme as seen from near and far. Two pages are devoted to studies of the horse—one, his fallen position with upthrust head; another, studies of the head alone. One page brings

us close in upon the fallen picador with his broken pic still in his hand. These pages show a more descriptive line and more anatomical detail than Picasso used in the previous sketch. *Drawings IX* through *XVI* are in ink and show dramatic blacks contrasted with the gleaming white paper.

In the *Corrida Crucifixion, Drawing XVI* (fig. 123), we are brought in close to the figure on the cross, with only the head of the bull and the head of the horse visible. The Christ figure and face are represented in greater detail. A great, spiny crown of thorns encompasses Christ's head, becoming intermeshed with his dark hair and his thick black beard, finally lost in the inky shadows along the right side of his head. His eyes are wide open and attentively fixed upon the lowered head of the bull. The cross, a thick tau-shaped structure, is clearly defined. Christ's left arm stretches forth, and the blunt, truncated end of the arm is held fast to the crossbar by a large, dark nailhead. The other hand is out of the picture area, but the gesture is clear, for again the right hand holds the cape-loincloth that is flourished before the charging bull. The head of the bull is delineated by bold lines, the powerful movement of the massive head being contrasted with the delicate curvature of the death-dealing horns. The lines that describe the horse are more broken and erratic, giving an ill-kempt look to the animal. He stares at his adversary, his nostrils wide and his mouth open. As Marrero remarked, "The horse is the most innocent, defenseless participant in the *corrida*, ancient and hopeless and impotent jades," the polar opposite of the bull with its brute force.[37]

This drawing has a sparkling richness in its dark and light pattern. The basic structure for the composition, the cross with its burden, forms a tilted, slightly off-center horizontal. The crossbar tilts slightly downward to the spectators' left, and against this the gesturing right arm of Christ makes another diagonal. The heads of the two animals create wedge-shaped diagonals in the lower corners, and these forms contain the movement and thus claim our attention. But one of the strongest movements of the drawing is the spiral which makes a strongly three-dimensional curve about the body of Christ. It is formed by the cape which comes from behind the torso of the Christ and moves across his loins; at one juncture it seems to merge with the head of the bull and yet to flow on behind it; then it continues, changing from a white form bounded by heavy black contours to a dark swirl, terminating within the palm of Christ. A dark shadow above the right arm of the Christ continues the movement until it is halted at the edge of the crossbeam.

The composition of this drawing, its movement and disposition of form has a breathtaking beauty of design. The torso of the Christ with its incisive yet delicate *linea alba*, which moves from breastbone to navel, has the rib cage indicated with a succession of dark strokes that must have

123. Pablo Picasso, *Corrida Crucifixion, Drawing XVI*, March 1959. Ink on paper; 14 × 12 in Musée Picasso, Paris. Photograph courtesy of Réunion des Musées Nationaux, Paris.

124. LEFT: Pablo Picasso, *Corrida Crucifixion, Drawing XVIII*, March 1959. Ink on paper; 14 × 12 in. Musée Picasso, Paris. Photograph courtesy of Réunion des Musées Nationaux, Paris.

125. RIGHT: *Christ* detail from Diego Velázquez, *Christ on the Cross*, 1631–32. Oil on canvas. Prado, Madrid.

been sketched in an instant but which have a relationship analogous to a line of musical notes which we hear as melody. The head of the bull, too, is drawn with great skill; the curves of the horns, coiling inward then upward, contrast with the powerful, sharp definition of the head along the left contour; the eye with its black ovoid form becomes part of the dark profile. Thus we get the kind of asymmetrical, yet perfectly balanced interlocking of lights and darks that is found in the Oriental oviform called the yin-yang symbol.[38]

The oviform, with its interlocking opposites of dark and light, is a symbol peculiarly appropriate for Picasso's bulls, which are most often represented as aggressive and brutal, but also possessed grandeur and dignity. Their power is the raw strength of brute nature. Picasso never saw these bulls as Ahab saw the white whale in Herman Melville's *Moby Dick*, as a malevolent enemy in whom all the forces of evil and destruction were incarnate.

Drawing XVIII (fig. 124) isolates the head and centers our attention on the facial features and expression of the Christ of the *Corrida Crucifixion* series. It is a fascinating drawing, for though the type of Christ is remarkably similar to traditional Spanish representations, the iconography is new. If we study it vis-à-vis the Velázquez *Christ on the Cross* (1631–32: Prado, Madrid) (fig. 125), we find the physiognomy to be remarkably akin to that of the seventeenth-century Spanish artist's representation. The brow, the slender nose, the deep-set eyes, the moustache and beard which clings about the lips, but do not wholly conceal them, are characteristic of both. But Velázquez's *Christ* has his head bowed and eyes closed. Despite the crown of thorns, the somber face communicates the sense of serene acceptance and quietude. Quite the opposite is true of Picasso's *Christ*, whose eyes are brilliant and alert with a terrible urgency, whose brow is furrowed and jaws tense. Part of the extreme animation of this face is achieved through the jagged, clashing, staccato lines of the crown of thorns, the reiterated, slashing lines of the beard and hair. But the real focus is in the eyes. They seem dilated to the point where we see only enormous pupils, coal black with glistening highlights.

These eyes also show another expressive artistic device, an exaggerated asymmetry of the placement of the two eyes. If the left half of the face is covered, the eye at the right appears to be glancing upward and has a somewhat unfocused, inward-looking expression. If then the right half of the face is covered and the left side alone is studied, the left eye appears to be intensely focused, looking sharply downward to our left. This side of the face also appears flatter, wider, and more frontal. Now as we look at the entire drawing, it is apparent that these disjunctions communicate a

sense of vivid immediacy; it is the moment written on this face, the moment of confrontation with the death-dealing adversary, the bull.

What is the meaning of the bull for Picasso? This is a question which has been the subject of much speculation.[39] Picasso's famous painting *Guernica* (fig. 112) has the bull as its dominant and most imposing form. This bull stands impassively astride the wreckage and suffering about him: the shrieking mother with her dead child in her arms, the dead warrior with a wounded horse, an anguished, weeping woman, another who leaps from the window, her body aflame. In *Guernica*, the horse is also shown as pitiful, wounded, and suffering. In conversations with friends and critics, Picasso was asked about the meaning of the bull. Conflicting statements by the artist were reported. On one occasion he said, "The bull there [in *Guernica*] represents brutality, the horse, the people."[40] His interlocutor, Jerome Seckler, pursued the interpretation, referred to fascism as causing darkness, brutality, death, and destruction, inferring then that the bull symbolized fascism. Picasso shook his head as Mr. Seckler talked. "Yes," he said, "you are right. But I did not try consciously to show that in my painting. If you interpret it that way, then you are correct, but still it wasn't my idea to present it that way. . . . I don't know why I used those particular objects. They don't represent anything in particular. The bull is a bull, . . . the lamp is a lamp, . . . that's all. But there is definitely no political connection there for me. Darkness and brutality, yes, but not Fascism.[41]

If Picasso had been questioned about the series of drawing we have been discussing and had been asked about the meaning of the Christ on the cross who draws the malevolent bull away from the helpless horse, he would no doubt have given the same kind of answer. For Picasso,

a picture is not thought out and settled beforehand. While it is being done it changes as one's thoughts change and when it is finished, it still goes on changing, according to the state of mind of whoever is looking at it. A picture lives a life like a living creature, undergoing the changes imposed on us by our life from day to day. This is natural enough, as the picture lives only through the man who is looking at it.[42]

We are invited by the artist to see the work of art as a living, changing thing. Picasso rejected an interpretation of symbols that demanded a verbal counterpart for each visual symbol. To interpret the bull as symbolizing evil and the horse as pitiful humankind, and the gesture of the Christ as an act of salvation which is to be equated with the sacrificial

death upon the cross, is to verbalize and decode that which has its expressive power in the integrity of the visual image. There are analogies between the two, but the work of art, the visual image, stands by itself. Even the artist cannot limit its meanings or translate them into words, or into another universe of discourse.

1969, 1972

Notes

Editor's Preface: "Vision Does Not Perish"

The title of this introduction is adapted from the Book of Proverbs 29:18, "Where there is no vision, the people perish."

1. Rainer Maria Rilke, *Letters on Cézanne* (New York: Fromm International Publishing, 1985), p. 19. The letter is dated October 3, 1907.

2. Louis Danz, *Personal Revolution and Picasso* (New York: Longmans, Green & Co., 1941), pp. 2, 4–10, 17–18, 24, as excerpted in Ellen C. Oppler, ed., *Picasso's Guernica* (New York: Norton, 1988), pp. 276–80.

3. Conversation with the author, May 1985.

Looking for Style and Content in Christian Art

1. Bernard Berenson, *Aesthetics and History* (Glasgow: Pantheon, 1953), p. 80.

2. Ibid., p. 69.

3. The seven gifts of the Holy Spirit are named in Isaiah 11:1–3; they are wisdom, understanding, counsel, strength, knowledge, piety, and the fear of the Lord. See also Revelation 5:6.

4. Luke 24:44.

5. Luke 1:35.

6. Isaiah 11:1 Douay.

7. St. Ambrose (340[?]–397) was a well-liked governor of Milan who was made bishop by popular demand in 374. He wrote many theological works, and his preaching helped convert St. Augustine.

8. Acts 10:39 KJV.

9. St. Bernard of Clairvaux (1090[?]–1153) was a French churchman, author of theological works, and founder of the Cistercian Order.

10. Isaiah 7:14 KJV.

11. For further discussion, see John L. Ward, "Hidden Symbolism in Jan van Eyck's *Annunciations*," *The Art Bulletin* 57 (1975): 196.

12. Isaiah 66:1 KJV.

13. Robert Goldwater and Marco Treves, eds., *Artists on Art* (New York: Pantheon Books, 1945), p. 69.

Chapter 1 / Eve, the Mother of All Living

The title of this essay, Eve, the Mother of All Living, is taken from Genesis 3:20.

1. John Phillips, *Eve: The History of an Idea* (New York: Harper and Row, 1984).

2. The iconography of this sarcophagus is also discussed in "The Appearance and Disappearance of God in Western Art" in this collection.

3. For an interpretation of the iconography of this figure of God in the *Dogmatic* or *Theological Sarcophagus,* see "The Appearance and Disappearance of God in Western Art."

4. Genesis 1:29–30. The sheaf of wheat and the lamb also suggest offerings to the Lord by Cain, "a tiller of the soil," and Abel, "a herder of the flocks." See Genesis 4:2–4.

5. For a scholarly discussion of the evolution of the serpent into a half-female, half-animal figure, and for a helpful discussion of the medieval interpretation of the Adam, Eve, and Lilith relationship in art, see Jeffrey M. Hoffeld, "Adam's Two Wives," *Metropolitan Museum of Art Bulletin* (June 1968): 430–40.

6. For another discussion of the imagery and iconography of the sarcophagus of Junius Bassus, see my essay, "George Segal's *Abraham and Isaac:* An Iconographic Study," in *Art, Creativity, and the Sacred: An Anthology in Religion and Art,* ed. Diane Apostolos-Cappadona (New York: Crossroad, 1984), pp. 105–24.

7. An early illustrated manuscript of *Genesis,* which was made for Charles the Bald, a great-grandson of Charlemagne.

8. This figure of Christ has been identified by scholars variously as Christ, as God, and as the Trinity. See for example, Elisabeth Dhanens, *Hubert and Jan van Eyck* (New York: Tabard Press, 1980); Lotte Brand Philip, *The Ghent Altarpiece of Jan van Eyck* (Princeton: Princeton University Press, 1980 [1971]); Erwin Panofsky, *Early Netherlandish Painting,* Volume 1 (Cambridge: Harvard University Press, 1971); and Carol Purtle, *The Marian Paintings of Jan van Eyck* (Princeton: Princeton University Press, 1982), esp. pp. 16–40.

9. A study of the artistic, iconographic, and theological dimensions of Michelangelo's Eves would fill a book.

10. Psalm 110:3, Book of Common Prayer.

11. Robert A. Koch, *Hans Baldung Grien: Eve, the Serpent and Death* (Ottawa: National Gallery of Canada, 1974), exhibition catalogue, pp. 22–29.

12. Genesis 2:17.

13. Koch, *Hans Baldung Grien,* pp. 22–29.

14. For a provocative and scholarly discussion of the image of Eve, especially in terms of the painting of Hans Baldung Grien, see A. Kent Hieatt, "Eve as Reason in a Tradition of Allegorical Interpretations of the Fall," *Journal of the Warburg and Courtauld Institutes* 43 (1980): 221–35, esp. 224. I am grateful to Diane Apostolos-

Cappadona for bringing this essay to my attention. See also A. Kent Hieatt, "Hans Baldung Grien's Ottawa *Eve* and Its Context," *The Art Bulletin* 64.2 (1983): 290–304.

15. Genesis 2:9.

Chapter 2 / The Magdalen: Reflections on the Image of Saint and Sinner in Christian Art

1. Jean Leclercq, *Monks on Marriage: A Twelfth-Century View* (New York: Seabury Press, 1982), pp. 92–93.

2. Elisabeth Moltmann-Wendel, *The Women Around Jesus* (London: SCM Press, 1982), pp. 66–67, 82.

3. Marina Warner, *Alone of All Her Sex: The Myth and Cult of the Virgin Mary* (New York: Alfred P. Knopf, 1976), pp. 234–35.

4. Luke 7:47.

5. Mark 16:1, 9.

6. Mark 16:9. KJV.

7. Jacobus de Voragine, *The Golden Legend*, trans. and adapted by Granger Ryan (London: Longmans, Green and Co., 1941).

8. Kurt Weitzmann, ed., *Age of Spirituality: Late Antique and Early Christian Art, Third to Seventh Century* (New York: Metropolitan Museum of Art, 1979), pp. 404–5.

9. See also *The Golden Legend*, 2:357.

10. Meyer Schapiro, *Late Antique, Early Christian and Medieval Art* (New York: George Braziller, 1979), p. 164.

11. Leclercq, *Monks on Marriage*, p. 94.

12. Victor Saxer, *Le Culte de Marie Magdalene en Occident des Origines à la fin du Moyen Age* (Paris: Clavreuil, 1959), p. 182.

13. Jacobus de Voragine, *The Golden Legend*, 2:357.

14. Jane Dillenberger, *Style and Content in Christian Art* (New York: Crossroad Publishing, 1986 [1966]), p. 95.

15. Osbern Bokenham, *Legends of Hooly Wummen*, ed. from MS Arundel 327 (London: Early English Text Society, 1938).

16. In my original research on the Magdalen, this particular painting was dated as 1500. The Philadelphia Museum of Art, the owner of this predella, now dates it to c.1470–1475. They note that it is possibly for an altarpiece believed to have been executed for the Augustinian convent of Sant' Elisabetta delle Convertite of Florence.

17. Giorgio Vasari, *Lives of the Most Eminent Painters, Sculptors, and Architects* (New York: The Modern Library, 1959), p. 159. This text is based on the *Lives of the Most Eminent Painters, Sculptors, and Architects* in ten volumes and published by the Medici Society, Ltd., London, n.d.

18. Otto Benesch, *The Art of the Renaissance in Northern Europe* (Cambridge: Harvard University Press, 1947), p. 10.

19. Pseudo-Bonaventura, *Meditations on the Life of Christ: An Illustrated Manu-*

script of the Fourteenth Century, trans. I. Ragusa and R. B. Green (Princeton: Princeton University Press, 1961), p. 246.

20. Ibid.

21. Neil Maclaren, *The Spanish School* (London: The National Gallery, 1952), pp. 74–75.

22. *The Vatican Collections: The Papacy and Art* (New York: The Metropolitan Museum of Art, 1983), exhibition catalogue, p. 164.

23. Moltmann-Wendel, *The Women Around Jesus*, pp. 66–67.

24. William B. Jordan, *El Greco of Toledo* (New York: New York Graphic Society, 1982), exhibition catalogue, p. 234.

25. Jaroslav Pelikan, ed., *Luther's Works* (St. Louis: Concordia Publishing House, 1956), 21:323.

26. *The Vatican Collections*, p. 164.

27. Thomas Robinson, *The Life and Death of Mary Magdalen: A Legendary Poem in Two Parts, about A.D. 1620* (London: Trench Trubner & Co., 1899).

28. Émile Mâle, *Religious Art from the Twelfth to the Eighteenth Century* (New York: Pantheon Books, 1949), p. 178.

29. Ibid., p. 172.

30. David Douglas Duncan, *Picasso's Picassos* (New York: Ballentine, 1968). All of these drawings, including either the original works, photographs, and/or photocopies, and the painting *Crucifixion* are in the collection of the Musée Picasso, Paris.

31. Herschel B. Chipp, ed., *Theories of Modern Art* (Berkeley: University of California Press, 1968), p. 272.

32. Anna Jameson, *Sacred and Legendary Art* (London: Longmans, Green and Company, 1866), 1: 352.

33. Henry Adams, *The Education of Henry Adams* (Boston: Houghton Mifflin Company, 1918), p. 388.

34. Elisabeth Schüssler Fiorenza, *In Memory of Her* (New York: Crossroad, 1983), is an excellent study by a distinguished biblical scholar, which includes a discussion of the role of Mary Magdalen.

Readers of this essay will perhaps be interested in Ruth Wilkins Sullivan, "The Anointing in Bethany and Other Affirmations of Christ's Divinity on Duccio's Back Predella," *The Art Bulletin* 67.1 (1985): 32–50.

Chapter 3 / The Mirror in Art

1. Charles Baudelaire, *The Mirror of Art* (Garden City, N.Y.: Doubleday Publishing, 1956), p. xxi.

2. Émile Mâle, *Religious Art in France, The Thirteenth Century: A Study of Medieval Iconography and Its Sources* (Princeton: Princeton University Press, 1984).

3. For an alternative interpretation of both this painting and its symbolism, and Erwin Panofsky's theory of "disguised symbolism," see Jan Baptist Bedaux, "The Reality of Symbols: The Questions of Disguised Symbolism in Jan van Eyck's *Arnolfini Portrait*," *Sinnolus, Netherlands Quarterly for the History of Art* 16.1 (1986): 5–28. I am grateful to Thomas Devonshire-Jones for calling this recent essay

to my attention. Panofsky's original essay, "Jan van Eyck's Arnolfini Portrait," is found in *The Burlington Magazine* 64 (1934): 117–27.

4. For another interpretation of the meaning of the gestures of Giovanni and Giovanna Arnolfini, see Lucy Freeman Sandler, "The Handclasp in the Arnolfini Wedding: A Manuscript Precedent," *The Art Bulletin* 66 (1984): 488–91. This article was brought to my attention by Diane Apostolos-Cappadona.

5. Erwin Panofsky, *Early Netherlandish Painting*, Volume 1 (Cambridge: Harvard University Press, 1953), p. 203.

6. Exodus 3:5.

7. Panofsky, *Early Netherlandish Painting*, 1:203.

8. Baudelaire, *The Mirror of Art*, p. xiii.

9. Philip Hendy, *Giovanni Bellini* (Oxford and London: Phaidon Press, Ltd., 1945), p. 31.

10. In the recent exhibition catalogue, Beverly Louise Brown and Arthur K. Wheelock, Jr., have indicated both a different title for this painting, *Vanity*, and the fact that the recent x-ray study of this painting reveals that the artist intended an entirely different presentation.

> Instead of a mirror, the woman held a book, her head was more erect, her gaze was more frontal, her dress more revealing, and her left hand was raised toward her shoulder where it caught her flowing tresses.

See Beverly Louise Brown and Arthus K. Wheelock, Jr., "Entry #3: Titian, *Vanity*," *Masterworks from Munich: Sixteenth- to Eighteenth-Century Paintings from the Alte Pinakothek* (Washington, D.C.: The National Gallery of Art, 1988), exhibition catalogue, pp. 75–78. I am grateful to Diane Apostolos-Cappadona for bringing this catalogue entry and a description of the recent cleaning of this painting to my attention.

11. Matthew 6:19.

12. Helen M. Franc, *An Invitation to See* (New York: The Museum of Modern Art, 1973), p. 76.

Chapter 4 / Images of Women in American Art

1. James Thomas Flexner, *First Flowers of Our Wilderness* (New York: Dover Publishing, 1962), pp. 46–49.

2. Marvin S. Sadik, *Colonial and Federal Portraits at Bowdoin College* (Brunswick, Maine: Bowdoin College Museum of Art, 1966), pp. 49–51.

3. Albert Ten Eyck Gardener and Stuart P. Feld, *American Paintings: A Catalogue of the Collection of The Metropolitan Museum of Art, Painters born by 1875*, Volume 1 (New York: The Metropolitan Museum of Art, 1965), p. 6.

4. This portrait of Mary Hopkinson is attributed to Benjamin West by the National Museum of American Art, whereas in Alan Staley and Helmut von Erffa's *Benjamin West* (New Haven: Yale University Press, 1986), it is not included in West's oeuvre.

5. Gardener and Feld, *American Paintings*, p. 46.

6. Nina F. Little, *Paintings by Provincial New England Artists* (Boston: Museum of Fine Arts, 1976), p. 116.

7. Gardener and Feld, *American Paintings*, p. 144.

8. Washington Allston, *Lectures on Art and Poems (1850), and Monaldi (1841)*, with an introduction by Nathalia Wright (Gainesville: Scholars Facsimiles and Reprints, 1967), p. 335.

9. Erwin Panofsky, *Studies in Iconology* (New York: Harper and Row, 1962 [1939]), p. 7.

10. Gardener and Feld, *American Paintings*, p. 190.

11. I have chosen to use the spelling of Hiffernan rather than the more popular spelling of Heffernan. In this, I am following David Park Curry, *James McNeill Whistler at the Freer Gallery* (Washington, D.C., and New York: The Freer Gallery, Smithsonian Institution, and W. W. Norton, 1984).

12. Catalogue entry, "The White Girl (Symphony in White, No. 1)," in *From Realism to Symbolism: Whistler and His World* (New York: Columbia University Press, 1971), exhibition catalogue, p. 40.

13. Virgil, *Aeneid*, as cited in Georges Rouault, *Miserere* (New York: The Museum of Modern Art, 1952 [1948]), Quotation #27, n.p.

14. Gordon Hendricks, *The Life and Works of Thomas Eakins* (New York: Grossman Publishing, 1974), p. 244.

15. Dorothy W. Phillip, *A Catalogue of the Collection of American Paintings in the Corcoran Gallery of Art*, Volume 2 (Washington, D.C.: The Corcoran Gallery of Art, 1947), p. 26.

16. Isadora Duncan had some of the fervor of a reformer and influenced other American artists, and also the great French sculptor, Auguste Rodin.

17. Helen M. Franc, *An Invitation to See* (New York: The Museum of Modern Art, 1973), p. 120.

18. Ibid.

19. Ibid., p. 131.

20. Robert Rosenblum, *Alfred Leslie* (Boston: Museum of Fine Arts, 1976), exhibition catalogue, n.p.

Chapter 5 / The Appearance and Disappearance of God in Western Art

1. See also the discussion of this same sarcophagus in "Eve, the Mother of All Living" in this collection.

2. Ezekiel 37:1.

3. Exodus 15:6.

4. Parenthetically, let me call attention to the existence of a wealth of artistic material produced and used by the Jews in the Late Antique period that includes wall painting and floor mosaics that were decorated with representational and narrative art often with biblical subject matter. The discovery in our century of the Synagogue at Dura-Europos, which had an extensive cycle of biblical subjects of which the Ezekiel fresco is but one, has revolutionized our understanding not only of Jewish art but of the art of the Greco-Roman world in late antiquity. For

example, see Erwin R. Goodenough, *Jewish Symbols in the Greco-Roman Period* (New York: Bollingen Books, 1964), and Bezalel Narkiss, "The Jewish Realm" in *The Age of Spirituality*, ed. Kurt Weitzmann (New York: The Metropolitan Museum of Art, 1977), p. 366.

5. Louis Réau, *Iconographie de l'art Chrétien. Iconographie de la Bible: Ancien Testament*, Volume 2, Part 1 (Paris: Presses Universitaires de France, 1956), p. 6.

6. *Religious Symbolism in Illuminated Manuscripts* (New York: Pierpont Morgan Library, 1944), exhibition catalogue.

7. Daniel 7:9.

8. Charles De Tolnay, *The Art and Thought of Michelangelo* (New York: Pantheon Books, 1964), p. 45.

9. See also the discussion of the *Isenheim Altarpiece* in "Northern and Southern Sensibilities in Art on the Eve of the Reformation" in this collection.

10. Nikolaus Pevsner and Michael Meier, *Grünewald* (New York: Harry N. Abrams, 1958), p. 38.

11. Blake's *Elohim Creating Adam* is a color print finished in pen and watercolor.

12. Job 38:19, 16.

13. Hebrews 4:14, 16.

14. Erwin Panofsky, *Early Netherlandish Painting*, Volume 1 (Cambridge: Harvard University Press, 1953), p. 169.

15. John 1:1–3a.

16. See Revelation 5:6–12; 7:2–12.

At its center is the majestic figure, formerly understood as God by Albrecht Dürer in his *Diary* of 1521; then interpreted as the King of Kings and the Trinity itself by Erwin Panofsky, *Early Netherlandish Painting*, 1:215; and recently identified as Christ by Elisabeth Dhanens, *Hubert and Jan van Eyck* (New York: Tabard Press, 1980), p. 106; and as the Logos by Lotte Brand Philip, *The Ghent Altarpiece and Jan van Eyck* (Princeton: Princeton University Press, 1980 [1971]), pp. 110–11.

17. Panofsky, *Early Netherlandish Painting*, 1:215.

18. Ibid., p. 220.

19. Jonah 2 and 3.

20. Psalm 22:1.

21. The complete statement by Newman is reproduced in "*The Stations of the Cross* by Barnett Newman," in my *Secular Art with Sacred Themes* (Nashville: Abingdon Press, 1962), pp. 99–116.

22. Thomas Hess, *Barnett Newman* (New York: New York Graphic Society, 1971), p. 99.

23. Lawrence Alloway, *Barnett Newman: The Stations of the Cross* (New York: The Solomon R. Guggenheim Museum, 1966), exhibition catalogue, p. 13.

24. Ibid., p. 36.

25. The Rothko Chapel (1970: Houston, Texas). Mark Rothko proposed the octagonal plan of the chapel and worked closely with the architects.

26. For the history and controversy of Pollock's black-and-white paintings and

the chapel, see E. A. Carmean, Jr., "Les peintures noires de Jackson Pollock et le projet d'eglise de Tony Smith," *Jackson Pollock* (Paris: Musée d'Arte Moderne, Centre Georges Pompidou, 1982), exhibition catalogue, pp. 54–77; and, idem., "The Church Project: Pollock's Passion Themes," *Art in America* 70.6 (1982): 110–22. The opposition is represented by Rosalind Kraus, "Contra Carmean: The Abstract Pollock," *Art in America* 70.6 (1982): 123–31, 155. I am grateful to Diane Apostolos-Cappadona for making me aware of these essays.

27. See for example, *Genesis* (1946: Private Collection); *Abraham* (1949: The Museum of Modern Art, New York); *Eve* (1950: The Tate Gallery, London); and *Joshua* (1950: Mrs. Harriet Weiner, New York).

28. Conversation of the author with Thomas Messer, former Director of the Guggenheim Museum, New York.

29. For example, Leo Steinberg, *The Sexuality of Christ in Renaissance Art and in Modern Oblivion* (New York: Viking/Pantheon, 1983); and Barbara G. Lane, *The Altar and the Altarpiece* (New York: Harper and Row, 1984).

Chapter 6 / Northern and Southern Sensibilities in Art on the Eve of the Reformation

1. See Wilhelm Worringer, *Form in Gothic* (London: G. P. Putnam's Sons, 1927).

2. The most recent analysis of the Sistine Ceiling in terms of both art historical and Christian theological studies is Esther Gordon Dotson's "An Augustinian Interpretation of Michelangelo's *Sistine Ceiling*," *The Art Bulletin* 61.2 (1979): 223–56; and 61.4 (1979): 405–29. Her convincing argument for the Mariological emphasis of Michelangelo's design will be reevaluated with the cleaning of the ceiling. A more recent theological interpretation of the ceiling is found in John Dixon, "The Christology of Michelangelo: The Sistine Ceiling" *The Journal of the American Academy of Religion* 55.3 (1987): 503–36.

A definitive study of Michelangelo's paintings was offered by Leo Steinberg in his series of eight lectures on the topic "The Burden of Michelangelo's Paintings," which were the 1982 A. W. Mellon Lectures, The National Gallery of Art, Washington, D.C. Professor Steinberg's lectures will be published through the Bollingen Series, Princeton University Press. I am grateful to Diane Apostolos-Cappadona for sharing with me her notes from these lectures.

3. The research and revision of this manuscript were completed before the publication of Ruth Mellinkoff's scholarly study *The Devil at Isenheim* (Berkeley: The University of California Press, 1988). In her analysis, Professor Mellinkoff both identifies the presence of the Lucifer in the altarpiece and its fundamental northern medieval symbolism. Her study is premised on the thesis that the concern with the symbolism of physical illness and suffering in Grünewald's work is a twentieth-century phenonmenon, that the artist's contemporaries were in fact fundamentally concerned with spiritual illness and suffering. Diane Apostolos-Cappadona brought this new monograph to my attention.

4. Kenneth Clark, *The Nude* (New York: Pantheon Books, Bollingen Series XXXV.2, 1956), p. 63.

5. Ibid.

6. Paul Hindemith, *Mathis der Maler*, 1933–1934. His opera of the same title was completed in 1935.

7. An interesting essay, Colin Eisler, "The Athlete of Virtue: The Iconography of Asceticism," in *De Artibus Opuscula XL: Essays in Honor of Erwin Panofsky*, ed. Millard Meiss (New York: New York University Press, 1961), 2:82–97, was brought to my attention by Margaret R. Miles. Professor Eisler identified the nude figures as athletes, "the motif of extraordinary physical strength as the externalization of spiritual strength," p. 92.

8. Luke 2:13–14.

9. Recent research has suggested another explanation for the description of the ecstatic states that we see in the incandescent colors of the *Angel Choir* and the *Resurrection*. After an outbreak of St. Anthony's Fire in our own century (Pont-St.-Esprit, France, in 1951), it was discovered that the fungus causing the disease induces hallucinations, vision, and delusions very similar to those caused by LSD. Grünewald was depicting what the diseased patients of the Antonite Hospital had ·themselves experienced. See Warren Dotz, "The Arts in Dermatopathology: St. Anthony's Fire," *The American Journal of Dermatopathology* 2.3 (1980): 249–53.

10. Andrée Hayum, "The Meaning and the Function of the Isenheim Altarpiece: The Hospital Context Revisited," *Art Bulletin* 59.4 (1977): 501–17.

11. Margaretta Salinger, *Michelangelo: The Last Judgment* (New York: Abrams, 1955).

12. Dante, *Inferno*, Canto III, Verse 109. This painting is discussed in another context and Dante's text is cited in full in "The Image of Evil in Nineteenth- and Twentieth-Century Art" in this collection.

13. Salinger, *Michelangelo: The Last Judgment*.

14. Sydney Freedberg, *Painting in Italy* (Baltimore: Penguin Books, 1971 [1970]), p. 104.

15. Otto Benesch, *Art of the Renaissance in Northern Europe* (Cambridge: Harvard University Press, 1947), p. 29.

16. John 19:31–34.

17. John's Gospel records that "one of the soldiers pierced his side with a spear" (19:34), but early writings refer to this soldier as Longinus, the name probably deriving from the similar Greek word for a spear or lance.

18. As cited by Benesch, *Art of the Renaissance in Northern Europe*, p. 29.

19. Hayum, "The Meaning and the Function of the Isenheim Altarpiece," p. 516.

20. From "The Order for Holy Communion" from *The Book of Common Prayer* (New York: Thomas Nelson and Sons, 1944), p. 83.

21. Charles de Tolnay, *Michelangelo*, Volume 2, *The Sistine Ceiling* (Princeton: Princeton University Press, 1949), p. 63.

22. Benesch, *The Art of the Renaissance in Northern Europe*, p. 34.

23. Paul Tillich in conversation with the author, November 7, 1956.

24. Kenneth Clark, *Landscape into Art* (London: John Murray, 1952), p. 38.

Chapter 7 / Lucas Cranach, Reformation Picture-Maker

1. Werner Schade, *Cranach, A Family of Master Painters* (New York: G. P. Putnam's Sons, 1980), p. 27.
2. Cranach's first portraits of Luther date from 1520.
3. Genesis 3:1.
4. "And God blessed them, and God said to them, 'Be fruitful and multiply, and fill the earth and subdue it.' " Genesis 1:28.
5. Genesis 1:28.
6. Luke 23:43.
7. Mark 15:39 For additional information on legends regarding Longinus in this volume, see "Picasso's Transformations of Sacred Art."
8. Luke 23:46.
9. Pierre Descargues, *Cranach* (New York: Harry N. Abrams, 1961), p. 67.
10. Mark 15:39; Luke 23:46.
11. Descargues, *Cranach*, p. 64.
12. It is thought that Cranach's paintings of Albrecht are based on Dürer's engraving rather than done from life. See Descargues, *Cranach*, p. 67.
13. Ibid., p. 65.
14. Quoted from copy of catalogue entry in National Gallery of Scotland, Edinburgh, which was included in a letter from Hugh MacAndrew, Keeper, to the author in 1982.
15. Carl C. Christensen, *Art and the Reformation in Germany* (Columbus: Ohio University Press, 1979), p. 129.
16. Christensen, *Art and the Reformation*, p. 135. Christensen is dependent here upon Christine Kibish, "Lucas Cranach's 'Christ Blessing the Children': A Problem in Lutheran Iconography," *Art Bulletin* 37 (1955): 196–203.
17. Luther's treatise of 1528, "Concerning Rebaptism," as cited in Christensen, *Art and the Reformation*, pp. 135 and 237.
18. *Luther's Works*, Volume 23, entries ix–xi, p. 310, as cited in Christensen, *Art and the Reformation*, pp. 132, 237.
19. John 8:7.
20. *Luther's Works*, Volume 23, entries ix–xi, pp. 318–19, as cited in Christensen, *Art and the Reformation*, p. 133.
21. Egbert Haverkamp-Begemann, *Wadsworth Atheneum Paintings*, Catalogue 1, *The Netherlands and the German-Speaking Countries, Fifteenth-Nineteenth Centuries* (Hartford: Wadsworth Atheneum, 1978), p. 126.
22. Jakob Rosenberg, *Die Zeichnungen Lucas Cranach d.a.*, (Berlin: n.p., 1960), p. 93.
23. Rosenberg says that Hans Cranach had adapted himself to his father's style virtually to the point of relinquishing his own identity. Rosenberg, *Cranach*, p. 93.
24. The attribution to the aged Cranach rather than his son, Lucas, has been disputed but the Berlin-Dahlem curators see it as a late work of the elder Cranach. *Picture Gallery, Berlin, Catalogue of the Paintings*, trans. Linda B. Porshall (Berlin: Berlin-Dahlem, 1978).

Chapter 8 / The Image of Evil in Nineteenth- and Twentieth-Century Art

1. The artist of this engraving is known by the initials that appear just above the lower margin of the print. The Master LCZ (Lorenz Katzheimer) flourished between c. 1480 and c. 1505 in the area of Nuremberg. Though we have only twelve engravings by him, he is one of the greatest engravers of the fifteenth century, and the first to include trees, animals, houses, and mountains of his own surroundings.

2. Luke 4:3.

3. Luke 4:5.

4. Luke 4:9–11.

5. This watercolor is also known as *He Cast Him into the Bottomless Pit and Shut Him Up*. The drawing has on the mat the reference to "Rev. Ch. 20, v 1 & 2."

6. Revelation 20:1–3a.

7. For further discussion of Tomoe, see "Picasso's Transformations of Sacred Art," in this collection.

8. S. F. Damon, *William Blake, His Philosophy and Symbols* (New York: Peter Smith, 1947 [1924]), p. 112.

9. J. P. Hodin, *The Dilemma of Being Modern* (New York: Noonday Press, 1959), p. 253.

10. André Malraux, *Saturn: An Essay on Goya* (London: Phaidon, 1957), p. 28.

11. Arnold Hauser, *The Social History of Art* (London: Routledge and Kegan Paul, 1951), p. 701.

12. G. F. Wingfield-Digby, *Meaning and Symbol in Three Modern Artists* (London, 1955), p. 47.

13. Reproduced in Libby Tannenbaum, *James Ensor* (New York: The Museum of Modern Art, 1951), p. 55.

14. Tannenbaum, *James Ensor*, p. 57.

15. John Donne, *Death's Duell* (Boston: David R. Godine, 1973), p. 17.

16. Denis de Rougemont, *The Devil's Share* (New York: Pantheon Books, 1956 [1945]), p. 140.

17. Ibid., p. 141.

18. Germain Bazin, "The Devil in Art," in *Satan*, ed. Père Bruno de Jesus-Marie, O.C.D. (New York: Sheed and Ward, 1952), p. 365.

19. For the most significant essay in understanding Picasso's *Les Demoiselles d'Avignon*, and one which also offers an alternate interpretation to mine, see Leo Steinberg, "The Philosophical Brothel," *October* 44.3 (1988): 7–74. This essay was originally published in *Artnews* 71 (1972).

20. Alfred H. Barr, Jr., *Picasso: Fifty Years of His Art* (New York: The Museum of Modern Art, 1946), exhibition catalogue, p. 56.

21. Paul Tillich, "The Existentialist Aspects of Modern Art," *Art and Architecture*, ed. John Dillenberger (New York: Crossroad Publishing, 1987), pp. 89–101. This essay was originally published in *Christianity and the Existentialists*, ed. Carl Michalson (New York: Harper and Row, 1956), pp. 128–47.

22. A. C. Ritchie, *The New Decade* (New York: The Museum of Modern Art, 1955), exhibition catalogue, p. 60.

23. A. C. Ritchie, *Masters of British Painting* (New York: The Museum of Modern Art, 1956), exhibition catalogue, p. 151.

24. "Prose Poems" and "The Generous Gamblers" from *Baudelaire, Rimbaud, Verlaine,* ed. Joseph M. Bernstein (New York: The Citadel Press, 1947), p. 135.

Chapter 9 / Picasso's Transformations of Sacred Art

1. William S. Rubin, *Modern Sacred Art and the Church at Âssy* (New York: Columbia University Press, 1961), p. 34.

2. A lively account of Picasso's relationship with the Communist party is to be found in François Gilot, *Life with Picasso* (New York: McGraw-Hill, 1946). His political and artistic activities in Paris during the war are documented in the article by Alfred H. Barr, Jr., "Picasso: A Digest with Notes," *Museum of Modern Art Bulletin,* XII (1945).

3. Gilot, *Life with Picasso,* p. 260.

4. Barr, "Picasso: A Digest with Notes," p. 2.

5. Rubin, *Modern Sacred Art and the Church at Âssy,* p. 51, note 19. The reference to the White House is probably an allusion to the personal taste of President Truman. Jean Cassou was the chief curator of the Musée d'Art Moderne in Paris and professor at the Ecole du Louvre. It was he who arranged the first large Picasso retrospective—seventy-four paintings and five sculptures—after the liberation of Paris in October 1944.

6. Luke 15:4–6.

7. Gilbert Cope, *Symbolism in the Bible and the Church* (New York: Philosophical Library, 1959), p. 205.

8. For this information and further details see the very interesting article by Paul Laporte, "The Man with a Lamb," *Art Journal* (1962).

9. Gilot, *Life with Picasso,* pp. 288–89.

10. Ibid., p. 289. In her account of the creation of this sculpture, François Gilot says it was made of clay. Wilhelm Boeck in Sabartes's book on Picasso, and Alfred H. Barr, *Picasso: Fifty Years of His Art* (New York: The Museum of Modern Art, 1946), describe *The Man with a Lamb* as being built up in wet plaster rather than in clay, like Picasso's other sculptures of that time.

11. Isaiah 53:8, 12, 3.

12. Eduard Syndicus, *Early Christian Art* (New York: Hawthorn Books, 1960), p. 22.

13. C. G. Jung, *The Spirit in Man, Art, and Literature* (New York: Pantheon Books, 1966), p. 138.

14. Ibid., p. 137.

15. Ibid., pp. 139–40.

16. William Rubin delimits this period of the "heroic" years of surrealism to the years between the First and Second Manifesto, 1924–1929.

17. John 19:34.

18. Mark 15:39.

19. Giotto, Schongauer, Ferrari, Lorenzetti.

20. John 19:23.

21. Juan Larrea, *Guernica: Pablo Picasso* (New York: Curt Valentin, 1947), p. 32.

22. Barr, *Picasso,* p. 167. Barr was the first one to identify some of the symbolism; Anthony Blunt added some interpretations in his little volume *Picasso's Guernica* (New York: Oxford University Press, 1969). Ruth Kaufmann of New York University has done a fine, scholarly study, "Picasso's Crucifixion of 1930," *The Burlington Magazine* 111(1969): 553–61.

23. Since the research and publication of these essays, additional preparatory drawings and sketches of the crucifixion have been exhibited and studied. The majority of these works belong to the Musée Picasso, which also has a complete photographic archives of all Picasso works. This information was brought to my attention by Diane Apostolos-Cappadona.

However, it is to be noted that the most current scholarly studies of these drawings are in terms of their relationship with or influence upon the development of *Guernica,* not the 1930 *Crucifixion.* For example, see Lubos Hlavahek, "K obsahovemu vykladu Picassova obrazu Guernica (Meaning of Picasso's Guernica)," *Umeni* 29:6 (1980): 542–64; and Frank D. Russell, *Picasso's Guernica: The Labyrinth of Vision* (Monclair: Allanheld and Schram, 1980). Diane Apostolos-Cappadona presented a new iconographic interpretation of Picasso's crucifixion series and its relationship to *Guernica,* "The Essence of Agony: Grünewald's Influence on Picasso," American Academy of Religion 1988 Annual Meeting, Chicago, November 20, 1988. A revised version of her study is scheduled for publication in the forthcoming collection of essays, *The Human Body in Sacred and Secular Art: Essays in Honor of Jane Dillenberger,* ed. Doug Adams, Diane Apostolos-Cappadona, and Margaret R. Miles (Berkeley: Center for the Arts, Religion, and Education, forthcoming 1991).

24. Gertrude Stein, *Picasso* (Boston: Beacon Press, 1959), p. 47.

25. Vincent Marrero, *Picasso and the Bull* (Chicago: Henry Regnery, 1956).

26. Picasso died in 1973 and *Guernica* was returned to Spain thereafter (as he had requested), to mark the return of democracy to Spain.

27. Marrero, *Picasso and the Bull,* p. 12.

28. All these sketches are in the collection of the Musée Picasso, Paris; and are reproduced in *Pablo Picasso: Toros y Torreros,* text de Luis Miguel Dominguin (New York: Alpine Fine Arts Collection, Ltd., 1980).

29. Luke 2:34–35.

30. Picasso, in absentia, had been appointed director of the Prado Gallery in Madrid by the republican goverment of Spain.

31. Drawings 9, 12, and 17 of the series of March 2 shows the spectators, as do drawings 5 and 6 of the series of March 3.

32. Roger Fry, "An Essay in Aesthetics," *Visions and Design* (Gloucester, Mass.: Peter Smith, 1947), p. 20.

33. For additional information, see Cabrol and Leclercq, *Dictionnaire d'archeologie chretienne et de liturgie* (1941), III, 3051.

34. Jacques Boudet, *Man and Beast* (New York: Golden Press, 1964), p. 231.

35. Miguel de Unamuno, *The Christ of Velasquez* (Baltimore: The Johns Hopkins University Press, 1951), p. 36. The line is from the poem entitled "Bullock."

36. Ernest Hemingway, *Death in the Afternoon* (New York: Charles Scribner's Sons, 1932), p. 466.

37. Marrero, *Picasso and the Bull,* p. 74.

38. This figure is made by first drawing a circle, bisecting it with a diameter, then creating a semicircle on either side of the diameter. If the diameter is then erased, the figure remaining is divided into two interlocking halves that are complementary and congruent. This oriental symbol shows one of these halves as dark, the other as light, and they refer to polar opposites—light and dark, good and evil, male and female.

39. Vincente Marrero's book *Picasso and the Bull* gives the Spanish national setting and backgrounds in myth, literature, and poetry for the bullfight. Juan Larrea, in his book on Picasso's *Guernica,* provides an elaborate psychological and political interpretation for all the component parts.

40. Typescript of "Symposium on Guernica," The Museum of Modern Art, New York, November 25, 1947, p. 16.

41. Ibid., p. 18. The reference is to a painting made one year after *Guernica* and having some of the same symbols, the *Still Life with Bull's Head* (1938: The Museum of Modern Art, New York).

42. "Conversation avec Picasso" in *The Spanish Masters of Twentieth-Century Painting* (San Francisco: San Francisco Museum of Art, 1948) exhibition catalogue, p. 52.

Bibliography of the Writings of Jane Dillenberger

Books

Editor with John Dillenberger. *On Art and Architecture* by Paul Tillich. New York: Crossroad Publishing, 1987.

Style and Content in Christian Art. New York: Crossroad Publishing, 1986. [reprint of 1966 edition].

With Joshua C. Taylor, Richard Murray, and Regina Soria. *Perceptions of the Spirit: The Art of Elihu Vedder.* Washington, D.C.: Smithsonian Institution Press, 1979. Exhibition catalogue.

With John Dillenberger. *Perceptions of the Spirit in 20th-Century American Art.* Washington, D.C.: Smithsonian Institution Press, 1977. Exhibition catalogue.

With Joshua C. Taylor. *The Hand and the Spirit: Religious Art in America, 1700–1900.* Berkeley: University Art Museum, 1972. Exhibition catalogue.

Secular Art with Sacred Themes. Nashville: Abingdon Press, 1969.

Style and Content in Christian Art. Abingdon Press, 1966.

Articles

With John Dillenberger. "To Clean or Not to Clean [the Sistine Ceiling]," *Bible Review* 4.2 (1988):12–20.

"Looking at Style and Content in Christian Art," *Bible Review* 3.4 (1987): 24–31.

"The Spiritual in Art," *Faith and Form* 21.3 (1987): 18–20.

"Reflections on the Field of Religion and the Visual Arts." In *Art as Religious Studies,* edited by Doug Adams and Diane Apostolos-Cappadona, 12–25. New York: Crossroad Publishing, 1987.

"The Bible and Its Painters," *Bible Review* 2.2 (1986): 14–17.

Introductory Essay in *Renaissance of Religious Art and Architecture in the San*

Francisco Bay Area, 1946–1968. 2 volumes. Regional Oral History Office, University of California, Berkeley, 1985.

"Images of God in Western Art," *Bible Review* 1.2 (1985): 26–36.

"The Magdalen: Reflections on the Images of the Saint and Sinner in Christian Art." In *Women, Religion, and Social Change,* edited by Yvonne Yazbeck Haddad and Ellison Banks Findley, 115–145. Albany: State University Press of New York, 1985.

"George Segal's *Abraham and Isaac:* Some Iconographic Reflections." In *Art, Creativity, and the Sacred,* edited by Diane Apostolos-Cappadona, 105–124. New York: Crossroad Publishing, 1984.

"Folk Art and the Bible," *Theology Today* 36.4 (1980): 564–568.

"Seeing is Believing," *Journal of Current Social Issues* 15.3 (1978): 68–73.

"Mormonism and American Religious Art." In *Reflections on Mormonism: Judeo-Christian Parallels,* edited by T. G. Marsden, 127–200. Provo: Bringham Young Press, 1978.

"Visual Arts and the Seminary" in *ARC Directions.* New York: ARC, 1974.

With John Dillenberger. "Picasso's Crucifixion." In *Humanities, Religion, and the Arts Tomorrow,* edited by Howard L. Hunter, 160–184. New York: Holt, Rhinehart and Winston, 1971.

"The Abstraction of Agony: Barnett Newman's 'Stations of the Cross'," *Religion and Life* 38.3 (1969): 183–197.

"Contemporary Art and the Church in Italy," *Liturgical Arts Quarterly* (1961): 26–28.

"Image of Evil in Art," *Drew Gateway* (1958): 152–167.

Index

207